The L

of the L

The story of an English river,
visiting:

Longnor
Hartington
Ilam
Okeover and Mapleton
Mayfield
Ashbourne
Norbury and Ellastone
Alton
Cheadle
Rocester
Uttoxeter
Needwood Forest
Doveridge
Sudbury
Hanbury
Tutbury and Hatton
Marston and Rolleston
Egginton

by

David J Ford

CHURNET VALLEY BOOKS
© David J Ford and Churnet Valley Books 1999
ISBN 1 897949 56 1

Printed in Malta by Interprint Ltd.

*This book is dedicated to the memory of
Bill and Elsa Ford, my parents,
who gave me the ability to enjoy our
beautiful countryside.*

ACNOWLEDGEMENTS
The author would like to recognize the generous assistance received from the following:

Dr Jenny Alexander
Alton Towers
Nancy, Lady Bagot
Sir Anthony Bamford
The Bamford Estate
British Gypsum
Mrs Betty Clark
Mr S.W. Clarke. C.B.E.
Mr and Mrs.J. Chapman
Coun. J. Cottier
Dairy Crest Ltd
Mr L.Davies
Derbyshire Libraries
 and Heritage Service
The Duchy of Lancaster
Mr K. Ellis
Sir Henry Every. Bt
Rev P. Fitzpatrick
Tony Gardner , photographs
Rev T. Ganz
Mr R. Gent
Georgian Crystal Ltd
Mr N. Handley
Mr J. Hardwick
Mr M. Lawrence

Mr H.K. Marshall
Rev A.Murphie
The National Trust
Mr R. Nicklin
Mr M. Oakton
Mr R.W. Pye
Dr Jennifer Rowley
Hon. Rosemary Seymour
Mr P. Shaw
Rt Hon. The Earl of Shrewsbury & Talbot
Mr D. Smith (photographs)
Mr J. Sneyd
Lord Stafford
Mr R. Stafford
Staffordshire Arts and Museum Service
Staffordshire County Council
Mr J. Taylor
Mr W.E. Thornewill
Mr A. Tipper
Tutbury Crystal Ltd
Sir Peter Walker-Okeover. Bt.
Mrs Hazel Williams
Mr R.D. Williams
Mr G. Wilson
Mr R. Whitebrook

CONTENTS

All original photographs are the authors except where credited.

BIBLIOGRAPHY

Ashbourne News Telegraph
Bess of Hardwick. Durant. 1977
Blithfield Hall. Nancy, Lady Bagot. 1956
Burton Daily Mail
Caves and Caverns of Peakland. Porteus. 1950
Chatsworth. Duchess of Devonshire. 1997
Compleat Angler. Izaak Walton. 1653
Copper and Lead Mines of Ecton Hill. Robey and Porter. 1972
Country House at War. Robinson. 1989
Derbyshire; Buildings of England. Pevsner. 1953
Derbyshire; Kelly's Directory. 1891
Derbyshire; Kings England. Mee. 1937
Derbyshire Tourist Guide. Rhodes. 1837
Dove Catchment Management Plan. N.R.A. 199
English Country House Party. Barston. 1989
Fly Fishers Flies. Woolley. 1938
Highways and Byways in Derbyshire. Firth. 1908
Histoire de L'Eglise St Pierre Sur Dives
Historic Staffordshire. Dent and Hill. 1896
History and Antiquities of Staffordshire. Shaw. 1798
History of Burton-on-Trent. Underhill. 1941
History, Gazetteer and Directory, Derbyshire. White. 1857
History Laid Bare. Zacks. 1994
History of Mary Stuart. Prof. Petit. 1873
History of the Meynell Hounds. Randall. 1901
History of the Town of Uttoxeter. Redfern. 1865
History of Tutbury. Sir O. Mosley. 1832
History of Tutbury and Rolleston. Underhill. 1949
Language and History in Britain. Prof. Jackson. 1953
Lead Mining in the Peak District. Ford and Rieuwerts. 1968
Marie, La Reine d'Ecosse. Flandre. 1871
Mary Howitt. Dunnicliffe 1992
Mary Queen of Scots. Lady Antonia Fraser. 1970
Mary Queen of Scots in Captivity. Leader. 1880
Medieval Tutbury. Rev. N. Edwards. 1949
My Life. Sir O.Mosley. 1968
Natural History of Tutbury. Sir O. Mosley. 1863
Needwood Forest to the Weaver Hills. Sowerby and Farman 1995
Peak District. New Naturalist Series. Edwards. 1964
Peakland Roads and Trackways. Dodd and Dodd. 1974
Picturesque Staffordshire. North Staffs. Railway. 1908
Pugin, A Gothic Passion. Atterbury and Wainwright. 1994
Road to Chartley. Foley. 1998
Staffordshire; Buildings of England. Pevsner. 1974
Staffordshire; Kelly's Directory. 1892
Staffordshire; Kings England. Mee. 1937
Story of Egginton. Henderson. 1970
Sudbury Hall. National Trust. 1994
This Costly Countess. Eisenberg. 1985
Thrumpton Hall. Seymour.
Topograhical History of Staffordshire. Pitt. 1817
Tutbury Castle. Somerville. 1960
Uttoxeter Advertiser
Y Geriadur Mawr. Efans and Tomos. 1987

FOREWORD

The River Dove, like Tennyson's brook, babbles along at first, progresses sedately as it moves southwards, welcomes the Manifold and the Churnet, and finally meanders into the Trent at Newton Solney. In one of our most attractive regions, the ever broadening valley, the contrasting surrounding hills and the spectacular countryside portray the story of human development with all its successes and tragedies.

David Ford has a lifelong association with the river and has spent years exploring the ground with acute observation. Supplemented as this is by meticulous and extensive research and with the willing cooperation of many local informants, the result is here for you to enjoy. Enjoy it you certainly will. Every aspect of life past and present in the valley is covered and understood with knowledge and humour, and his wide interests ensure that there will be much to please us in our own sphere and much to learn in many others.

It is all here, the development of the valley, the story of stately homes, large estates, royalty, industrial enterprises and sports, all faithfully recorded and spiced by the author's attractive style, and enhanced by some first class illustrations.

Reginald W Pye, Anslow.
January 1999.

The Fount of the Dove.

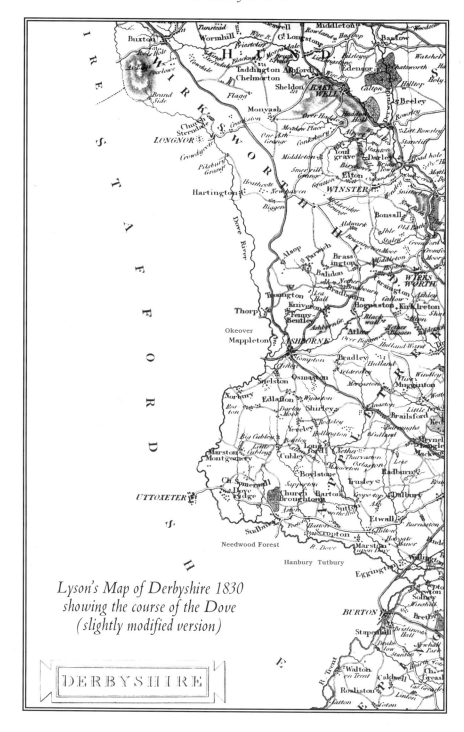

Lyson's Map of Derbyshire 1830
showing the course of the Dove
(slightly modified version)

DERBYSHIRE

INTRODUCTION

I will lift up mine eyes unto the hills, from whence cometh my help.
Psalm 121

The River Dove is born in the dark gritstone moors of the southern Pennines. From these bleak lands she flows southwards to join the River Trent in central England after a course of nearly 60 miles. Like the psalmist, our eyes are forever drawn to the wild profile of the hills with their mystery and power. Though later peaceful and pastoral, the Land of the Dove can never forget its wild land of birth. The country of the Dove is throughout of great beauty and interest. The course of the river is forever the basis of the boundary between Staffordshire and Derbyshire, two counties which meet on these idyllic banks. Far away are the industrial areas, which in the minds of many characterize the two counties. How wrong are those impressions, for here is a land which contains some of the most glorious rural scenery in England.

Below the high moors, the river also divides the two Peakland massifs of the invigorating limestone from the romantic millstone grit, before being taken within the limestone. Yet it is the river that in fact has created her own confinement there by cutting through the rock to reveal the secrets of countless millions of years. In its journey through the famous Dales our route finds sublime natural beauty and especially the evocative sound of the river set against the infinity of geological time.

The Dove emerges from the Dales into a new dawn as a vigorous and spirited nymph. Firstly secretly, she gains power to dominate the developing Vale where the finest phrasing of her rich symphony can be appreciated. It is here that the peace and security of the words from J.S.Bach's aria "Sheep may safely graze" become abundantly manifest. Henceforth, much of the saga of rural England can be found in the great Lower Valley. Possibly this is best epitomized by Doveridge which stands as a sentinel at the opening of a land of rich pastures and water meadows below omnipresent open skies. To the north lies the sloping pastoral "Country below the hills", a land of serene villages and old churches which proclaim faith as well as character and history.

This route along the Dove is essentially an English journey! The aim of the book is not a gazetteer, but a journey concentrating on the history, natural beauties and influences against the background of the development of rural England. It also concentrates on some of the literary and other characters who have marked the past. Some of these will be well known, while others, although accomplished and having had noteworthy lives, remain unknown outside the area.

There is no intention for this book to be a historical guide, though the writer has concentrated on the influences which have moulded the Land of the Dove. Few have been more important than the past powers and glories of Tutbury, which for centuries dominated the whole valley. In fact a visitor throughout medieval times could have been aware of visiting the capital of another realm.

In these closing moments of the millennium it is appropriate to reflect on the tides of change that have swept over English country life during the twentieth century. Probably the greatest influence has been the demise of the great estates which controlled every aspect of life in the lower valley of the Dove and the Needwood Forest. These grew from the feudal lands into those estates whose mansions, with their lavish interiors and grand society, dominated the age. None in the land was greater than the vast palace of the Earls of Shrewsbury at Alton. However, following the First World War, the tide had fatefully turned. The effects of taxation, death duties and non-availability of staff caused their continual decline. Today they are a memory. Only Okeover remains as the seat of the family, while Sudbury Hall remains maintained by the National Trust. It is sad, because the negation of tradition and integrated estate management have caused a decline in the rural base. Throughout the nineteenth century the countryside became progressively enriched by the advancement of farming. This created a secure rural society that was exemplified by the yeoman farms of well endowed families. Due to changes in agriculture, largely from political incompetence, both the countryside and the small towns are in a sad decline. In those times of growth, Uttoxeter rose in prominence, but now it is sadly waning with the decline of the small family farm in particular. The rise of agriculture also contributed to the clearance of the wild and mysterious Needwood Forest. The spirit of the dark forest remains only in profile as the rising escarpment still presents a foreboding face.

The Dove has always been a border land. Forever it has been the divide between the North of England and the lowland Midlands, while today it has become a divide between rural England and the growth of suburbia. Before Roman times it was the border between Celtic kingdoms whose earth fortresses remain, while the Romans continually felt obliged to regard this as border territory. Following the withdrawal of the Romans, the river became the divide between the Celts and the invading Saxons. These later people were to endure some of their own medicine at the hands of the Vikings who followed the course of the river.

The derivation of the river's name is Welsh. For long the Britons maintained a enclave in the lower reaches of the river before being absorbed by the Saxons in medieval times. This could explain the ancient Welsh meaning of

the river's name which echoes the lost Celtic world. Those former British inhabitants spoke a variety of dialects which became influenced and unified under their Roman masters. That derived language was to become the basis of the Welsh language. In the authentic Welsh dictionary "Y Geriadur Mawr" one finds "dwfn" as deep and "dwfr" for water. The latter is now considered obsolete being replaced by Dwr. In "Language and History in Britain", Prof. K.Jackson confirms the Welsh meaning as "dark waters". This is most descriptive when one contemplates the fury of the river when in flood! This derivation could explain the different local pronunciations of the name. For most of the Dove's course the pronunciation of Dove as in "love". However below Uttoxeter, the traditional pronunciation is as in "stove"! The explanation of the later could be the influence of the longer pronunciation of the Welsh vowel. It is interesting to note that in 1235 the river north of Ashbourne was spelt Douve. This form of the name was recorded in the Okeover Mss. until 1567. This is probably derived from the Welsh "dwfr", which is also the derivation of the name of the Kent port, Dover! A similar Welsh derivation can be found in the name of the nearby River Derwent, "derwen" being Welsh for the oak tree.

It is intended that the book will be of interest to those who know the area as a background to their existing knowledge; and also to the wider public who are not resident. It is hoped that particularly the latter will find the book an anthology of English rural life. Much has already been written about the recognized joys of the Peak District, but fewer writers have given attention to the beauties and interest of the lower Dove. Many residents possibly do not appreciate the richness of their locality. It is in this direction that particular emphasis has been given.

"Pity the man who can travel from
Dan to Beersheba and cry
'T'is all barren".

L. Sterne

The Land of the Dove

Washgate: Memories of the pack way.

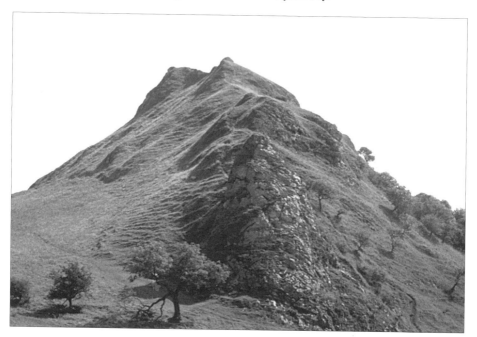

Parkhouse Hill: Reef limestone rising like a dinosaur.

CHAPTER 1
THE HIGH ROOF OF ENGLAND: BIRTH OF THE RIVER

The Turn of New Life

The Dove is a child of the Pennines. Her cradle is some 3 miles south west of Buxton on the brooding gritstone moorlands that mark the converging borders of Staffordshire, Derbyshire and Cheshire. This land acknowledges loyalty only to the continuous bulk of the Pennines. This country is unquestionably part of the North of England; a wilderness where nature reigns supreme; a crucible into which the forces and elements of nature are distilled. The vitriols neutralize and dissolve all incompatible and alien intrusions.

In winter, an abject and utter desolation pervades the area; there is no colour, no sound, save that of the merciless wind and ever soaking rains. The most feared of nature's legions are the blizzards that turn the moors into a terrifying land of death, numbing and entombing man and beast in a lonely and silent grave. With the infinite moors sterilized, and the lonely roads blocked, the remote hand of man is eliminated.

With the lengthening days, winter's vice-like hold is gradually relaxed. The retreating raiment of snow, though clinging tenaciously to sheltered folds, reveals a closely cropped and bleached pasturage. In the emerging sunshine of the infant spring the air is still and crisp ,as the tentative warmth creeps forward. Though the land still bears witness to the long reign of winter, the guttural crowing of the grouse and the bubbling call of the curlew proclaim again the song of spring. As the first gossamer threads of light rise above the horizons and penetrate the dark mantle, one can survey the wide vistas and competing cloud masses, which project their shadowy images across the hills. This is the high roof of England whose endless wild acres seem to stretch to infinity.

The Fount of the Dove

From Axe Edge, a forbidding gritstone crown rising above the infinity of the moors, emerge the rivers Goyt, Dane, Wye, Hamps, Churnet, Manifold and Dove, the children of Axe Edge. Most of them flow away swiftly in differing directions, but the Dove and Manifold are cradle companions, who flow, hand in hand, hardly bearing to be out of each other's sight. The Dove rises beneath the dominating line of Axe Edge, near the bleak village of Flash, the highest village in England. The flanks of Axe Edge are incised by a multitude of dark riverlets that fray the peat masses to reveal root skeletons of the forest of oak, rowan, alder and hazel, that flourished in the milder and drier days that pre-date mankind. From the deep beds of peat, dark water oozes with an oily hue.

The true source of the Dove lies in a matrix of springs that lie below Axe

Edge. Here is found one emblematic spring, enclosed by a stone cistern. This spot can be approached by a flagged path from the Buxton-Leek road, opposite a house appropriately named Dove Head. The capping stone of this symbolic fount of the Dove is inscribed with the entwining monogram of Charles Cotton and Isaac Walton. It became cracked during the severe frost of 1903.

So great are the outpourings of the earth, that within a few hundred yards, a powerful stream enters a valley which soon enfolds the young river. The steep sides are clothed with vegetation whose colour changes with every season; thick clumps of sallow, their dusty golden catkins lit up by the crisp spring sunshine; groves of birch, in their full glory in the bare days of winter; rowans, their humble gnarled branches forgotten when in glorious bloom, or with deep rosy red berries in the lazy autumn sunshine. Scabious, gently waving, harebells and foxgloves in profusion, clothe the drier slopes which are periodically penetrated by eruptions of oozing peat. In summer, they are studded with the firm spikes of marsh orchids, with detailed veins of dark blue, a crescendo of subtle fragrance and beauty. A continuous carpet of heather and bilberry provides, a backdrop to the lush growth of ferns that line the waters edge.

Washgate

Within these pristine confines lies Washgate. Here above the meeting of two streams, stands a single-arched packhorse bridge which formerly carried a route across these lonely hills. Before the railways, pack trains transported the products of the newly emerging industrial areas. Even into the middle of the 19th century, the pack routes of the Peak District were still commonly used. The loads were usually carried in panniers, slung on each side of the saddle.

Many a wandering Pack Man, or Jagger, would call at the isolated hamlets and farmhouses of the Moorlands, bringing wares and news from the outside world. The larger concerns operated in trains of upto 50 mules or packhorses. Their harness carried little bells to warn others of their approach; across the uplands could be heard the tinkle of a myriad of such bells. One operator, James Pickford, was the founder of the famous removal firm. The pack ways were often paved to provide an easier passage for the horses, as at Washgate, where remains of the paving can be seen as the old way ascends from the bridge.

Adjacent to the bridge, the remains of a long abandoned homestead, its garden lost in the growths of dog rose and trees. Once the house of some independent Moorlander, its fate is similar to many others on these hills.

The Moorlanders

Beneath the edges of the moors, lying in the folds and valleys, gaining whatever shelter they can, lie the typical Moorlanders' homesteads. They are buildings of dark gritstone, with roofing of huge slabs, the great weight of which has caused

the roof to subside, giving a profile suggestive of the swell of the sea. These are grim, lonely and austere dwellings, whose heavy gable ends display the only hint of decorative extravagance The buildings reflect the frugal lives of the thrifty-minded people who built them; people who survived the winter on a form of porridge known as Lumpy Tums, an unexciting dish prepared by stirring oatmeal into boiling water. The thin round oatcakes they cooked on a griddle are still a favourite local food. The thrift of the Moorlanders influenced the growth of the building society movement, which became strong in North Staffordshire. The dark low homesteads have retained a rich heritage of heirlooms, so that a perusal of their contents makes a rewarding experience both for the lover and the dealer in antiques.

Today, the life of the moorland farmer is still dominated by the relentless struggle with the elements, despite improved services. Below Axe Edge, the homesteads lie conspicuous in their isolation, often sheltered by a sycamore tree. The character and colour of the fields change markedly with the variation of the soil types. Dry well drained soils supporting soft grasses, and pock marked with black conical mole hills, give way to rush flushes and frizzy brown tufts of browsed heather. While rough grazing dominates the scene, each holding possesses a few fertile acres of deep soil, enclosed by a high dry stone wall. Some of these enclosures zealously snatch all available land, sweeping down the valley sides, while others stand in seclusion.

The farms stand aloof from the road system, their only access being seemingly endless tracks that follow the contour of the landscape, and at each farmstead one is greeted by the barkings of that essential incumbent of every hill farm. An overgrown track sometimes leads to a deserted farm, enveloped in conquering scrub which has seized it back for the wilderness. The stark roofless gables rise into the driving rain and relentless winds, memorial stones to the rigours of prizing a frugal living from a cold and unproductive soil.

Hollinsclough and the Rise of Methodism

Below Washgate, the Dove continues its secretive journey, hidden from view by gorse, bracken and continuous groves of rowan, hawthorn and birch, before emerging into a natural amphitheatre, the gritstone hamlet of Hollinsclough and its low-lying pastures encircled by the hills. The acid pastures give way to marshland and bog that richly abound with orchids. The fields are alive with springs that produce a myriad of rills that rush to join the Dove.

Hollinsclough Church, described by the Edwardian traveller J.B.Firth as *"the baldest structure wherein a dull sermon was ever preached"*, is now an educational residential centre. The severe lines of the building do not reflect the pastoral zeal of the Established Church at the time of its construction. In the late eighteenth century the Moorlanders adopted an austere form of the emergent

Methodism. This commitment to a rigid faith pervaded their daily lives and moulded their attitudes. At that time the Church had become associated in the minds of many in the rural community with laxity and privilege. So lax had things become that records exist of Peakland parsons taking services in an inebriated condition. It was into this spiritual vacuum that the Methodist evangelists carried their crusade. The rural artisans hereabouts embraced this new devotion with zealous fervour and simple piety. The release of latent conviction spread from hamlet to hamlet, often carried by a local convert. The formal fabric of religion could not counter such spontaneity and only awakened after many of its flock had strayed to the new fold.

Methodism came to Hollingclough through the St Paul-like conversion of John Lomas, an itinerant hawker. One wild winter's night, his wife expressed the desire to attend chapel at Flash, to hear the visiting preacher, a Mr Castledean. As Lomas belonged to the Church, he tried to discourage his wife with the excuse that the night was too wild to venture out; in turn his wife, accused him of attempting to prevent her from worshipping. Behind an abrupt facade he was a charitable man and eventually he yielded to her entreaties and agreed to accompany her. Attiring themselves in their warmest clothing, they ventured into the wild night. As they trod over moorland tracks, John was expecting the night to confirm his cynical attitude towards the new religion; but this was to be his road to Damascus. In the humble chapel, by the light of flickering candles, as he listened to the booming sermon, his cynicism gave way to receptiveness and then to response. When the service ended, and the simple congregation filed out into the dark of the wild moorland night, his wife enquired with trepidation how he had reacted to the preachings. She was very surprised by his reply, *"Either the preacher or I myself must be very wrong."*

From that day, his heartsearching led him to join the Chapel. He was not content with his own conversion, but travelled the area in the service of his newly found convictions. A fitting memorial to his life was the chapel which he was instrumental in establishing, and in which his earthly remains were interred. Built in 1804, it remains to this day in lovely condition. It stands four square, and like its dedication, Bethel, is reminiscent of the chapels of Wales.

Contrasting Hillscapes

The scene at Hollingsclough is dominated by the wild profile of the hills that rise sharply above the Derbyshire bank of the river. This is a high range of hills, each of which is individual and represents a differing geological hinterland. The heavy gritstone landscape yields to the elongated shale form of Hollins Hill which rises majestically above the valley; soft in profile, but dark in character. In striking contrast, and visually unique, rises the neighbouring limestone Chrome Hill, a climax of angularity and crowned by a defiant mass of vertically

bedded limestone, supported by castellated outcrops and dry glacier-like flows of scree. These crenellations are not of the great carboniferous limestone mass of North Derbyshire, but are fossilized coral reefs. The skyline resembles the dorsal profile of some giant dinosaur. The profile falls and rises again with Parkhouse Hill, a similar outcrop, though on a smaller scale, whose upper wind-blasted peaks resemble the dentures of a fearful beast, and where, in legend, the Prince of Darkness tried to hang himself and, unsuccessful, returned to haunt the hills from midnight to daybreak.

Dowel Dale

Between the limestone reefs, an opening reveals a lowland scene of tranquillity presided over by a large Yeoman farmhouse. Immediately behind lie the narrow confines of Dowel Dale, a dark and silent elongation that leads to the limestone plateau above. Within the caves of this mysterious silent dale primitive man sought shelter and protection. These squat ancestors dwelt in a world of fear; fear of wild beasts, fear of physical disaster and fear of the cold that dominated their lives. Here in this narrow dale flickered a tiny flame of humanity; yet from such environs that flame grew into the all embracing fire of today. Excavations carried out in 1958-9 confirmed the presence of Palaeolithic hunters who inhabited the caves whilst following vast herds of migrating animals. The caves continued in use during the Mesolithic or Middle Stone Age (4000-5000 BC), when the evidence indicates a more permanent habitation, and these people had developed a greater range of skills, especially the skill of fishing. In Derbyshire, they were essentially river valley dwellers. The analysis of these Mesolithic finds suggests the presence of a marsh or lake nearby. The gap between Chrome and Parkhouse Hills is linked by a glacial moraine which resulted in the flat area becoming a lake. By the time of the late Neolithic Age, the caves of the dale were being inhabited by herdsmen, though hunting would also be practised.

Before the onset of the Great Ice Age, this area was the vast preserve of wild beasts including great herds of reindeer and bison which migrated through the passes of the High Peak to gain access to their pasturages on either side of the Pennines, like the Winnats, near Castleton and here on the Upper Dove. In the narrow confines of these passes, primitive man would ambush the herds. From time to time exploration of some dark cave reveals evidence of these long disappeared animals including grizzly bear, wolf, bison,elk and mammoth. Great changes in the Earth's climate eliminated most of these animals before hunting and habitat loss caused their final extermination.

Further remains are to be found in exploration of swallow holes (fissures in the ground) above the Dove. Here the animals came to drink. In one such hole at the base of Mam Tor were found the remains of 6,800 large animals. At the top end of Dowel Dale, where the narrow way arrives at the wide open

expanses, lies the Owl Hole. This eerie and wide-open pot hole is surrounded by sycamore trees. Through the debris one can just see the entrance to the cavernous depths where remains of long vanished animals have been found. The plateau above Dowel Dale is pock-marked with sudden, deep depressions; some of these sink holes have been excavated, but much awaits exploration.

Glutton and Earl Sterndale

Lying at the end of this ragged range of hills lies Glutton, a hamlet beside the silken stream. It contains some noteworthy period houses. Here the first mill powered by the Dove was situated, and until fairly recently a small factory produced Wensleydale Cheese. From Glutton a road leads steeply upwards through ivy-veiled crags to a land of parallel raised valleys, separated by wide rock-strewn hillsides. These are the continuing beds of the reefs. Even on a summer's day, walking across these fields can be wearisome because of the catacomb-like fissures, lined with a profusion of hart's tongue ferns and other limestone loving plants.

Nestling on one limestone terrace, like an oasis, is the village of Earl Sterndale. The low houses, clustering around pleasant open areas of grass, epitomize the charm of the limestone village, thankfully still to this day not threatened by thoughtless intrusions. Though sadly, how many of the young people of the village are able to afford to live in their native parish today? This surely is the greatest threat to village life, as the available houses are bought by outsiders with greater purchasing power, yet with little interest in the traditions of the village.

The two great institutions of village life face each other across the street separated by a wide spreading sycamore tree on the Green. On the sad night of 9th November 1941, the barn-like Victorian church fell victim to a stray attack by German incendiary bombs. The heat was of such an intensity that the Saxon font was cracked, though it has now been skilfully repaired. The monument to the fallen, a great column of polished granite, is strangely incongruous in this limestone land.

The village inn, oddly named 'The Quiet Woman' has as its sign a headless woman, with a proverbial caption "Soft Words Turneth Away Wrath". In the still, darkened interior, the clock ticks away the minutes, oblivious to the neurotically rushing world that lies beyond these hills. Here one may enjoy refreshment in surroundings which contrast sharply with the sham atmosphere of many a village inn, mutilated to please the suburban throng. Above the village, stands the high though gentle profile of High Wheeldon Hill, which was given as a memorial to the War Dead of Derbyshire and Staffordshire.

CHAPTER 2
THE UPPER VALLEY: THE IDYLLIC LAND

Below Glutton, the Dove flows through a rich valley, a land of simple delight between the enclosing hills. This is a happy land of small pastures, with herds of milking cows, contained sometimes by hedges, sometimes by walls, yet always in an intimacy of union. The fields are entered through gates hung on monolithic posts of limestone; while the cattle are frequently watered from troughs painstakingly hewn from blocks of gritstone and fed by emergent springs. Not wanting to trespass the precious grazing land, the houses, low and small, back abruptly to the rising hillside. They lie down lanes bordered by hedges of hawthorn, hazel and cascading dogrose. The whole scene is suggestive of the lanes of North Wales.

Crowdecote
At the head of these halcyon reaches is found Crowdecote, a hamlet of almost childlike symmetry. Interspersed amongst the humbler houses are those built by men of greater means, their elegant limestone frontages enlivened with gritstone dressings, reluctantly but tastefully ornate. From the simple arched bridge over the Dove, one can stand and contemplate the magnificence of the wild hillscapes, from which the river has now emerged. Beneath the bridge, grey wagtails enact their cocky interplay beside the sparkling butterburr-edged stream. In the midst of this delectable huddle stands the Packhorse Inn, surely named from the men who were customers in earlier times. The crags behind Crowdecote are fissured with innumerable caves that formerly gave shelter to prehistoric man; caves that now shelter bats and roosting jackdaws. One of the most impressive experiences is to stand on the bridge in the full glory of a September sunset, and hear the frenzied babble of the jackdaws reverberating from the rocks against the backdrop of the angular hills.

From the Derbyshire bank rises the land of limestone, while the landscape on the Staffordshire side continues to be gritstone. The young river remains detached from both as it flows through the developing upper valley on bedded shale. This gives the waters a distant and romantic character, so gentle and clear that they hardly seem to move between the trailing veils of water crowsfoot, until the current strikes raised bedding which causes the silken flow to break into a complexity of currents. It is as though the high black shale banks, sometimes over 30 feet in height, are conveying the river in seclusion from the greatly differing worlds on either side. These banks are decked in early summer with a multiplicity of ferns and a festival of colour with waving heads of foxgloves and cascading throngs of herb robert. Here in this upper valley, the

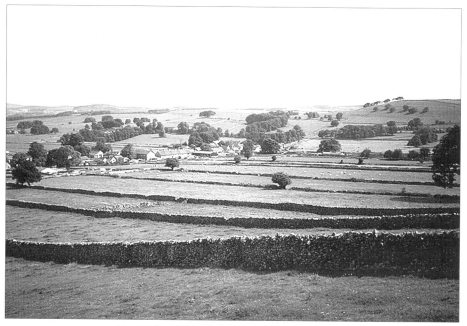

The White Peakland: Limestone plateau scenery.

The Dark Peakland: Millstone grit scenery.

Dove gains her passions of excitement and rhythm. Through a virtually continuous veil of alders, the sun's rays are filtered, creating clear images in the mirroring waters. Here lies a special beauty in all seasons. Upon her grassy banks one may lie and dream beside the murmurings of the stream as soft and gentle as the touch of spring rainfall. How chaste are the scenes; a flash of royal blue as a kingfisher darts along the stream; the luxuriant fragrance of new mown hay; and the scents and sights of the flowers of the meadow.

The Limestone Peak

On the Derbyshire bank lie the ramparts of the carboniferous limestone plateau; a rolling land of wide unfettered views, rolling to infinity like the sea, the arbitrary sycamore shelter belts crowning the swell like the crest of the waves. The landscape rises and falls with invigorating freshness, accepting subservience to the vast expanse of the skies. Nowhere does the sunshine so dictate the mood; nowhere does the sigh of the wind so effectively promote a state of invigoration and freedom. This is a land from which one can take a deep draught from the distillate of true nature.

If contemporary man finds stimulation in the uplands, his predecessors had no such feelings. Seventeenth and eighteenth century travellers saw some beauty in the Dales, but the uplands wearied them. Charles Cotton contemptuously dismissed the land where, *"Nature suffers only in silence"*. This reaction was particularly common amongst those living in the lands below. Portraying these sentiments, George Eliot wrote, *"After this, the country grew barer and barer: no more rolling woods, no more branching trees near frequent homesteads, no more bushy hedgerows; but grey stone walls intersecting the meagre pastures, but dismal wide scattered grey stone houses on broken lands, where mines had been"*.

Much of the scene's pervading freshness is owed to the rich verdancy of well drained pasturages which has become manifest in a deeply rooted Yeoman pride. Most of the land is devoted to dairying, which gained its ascendancy over sheep in the nineteenth century.

Stone Wall Country

Defining these fields is a system of dry stone walls, frequently containing myriads of fossils. Since hawthorn does not satisfactorily thrive above 750 ft these walls provide the most effective means of enclosure. This system marks indelibly the character of the plateau at an average density of 24 miles per square mile. In building a wall one or two foundation courses are laid below ground level, upon which the wall is erected, with a rubble filling. The height averages 4ft 6ins but walls marking farm boundaries are invariably higher. To give stability, stones called "throughs" traverse the full breadth at regular

intervals, while the width is greater at the base than at the top. Flatter stones are placed edgewise along the top to form a coping. In many instances, to enable the passage of ewes and their lambs, apertures known as creep holes are positioned at ground level. For practical reasons, stone was quarried as close as possible, frequently from a series of small shallow depressions. These frequently form a sanctuary for wild plants, in what is nowadays an increasing monoculture of commercial grasses.

The character of the walls vary according to the nature of the stone locally available. In some districts small stones cut along the lines of natural cleavage give a close fitting, compact appearance, with an attractive coping layer. While in other areas, more dense, larger stones give an open effect, with light filtering through when viewed from the side. The gritstone country is also covered with walls, but the style and appearance are very different. The most skilled operators concentrate on the stone of their native area. While the structure of the walls varies, so does their layout. The earliest enclosures follow the lines of the original strip cultivation. This can produce elongated, slightly curving parallel fields. Good examples of this can be seen at Chelmorton, while on the gritstone there are spectacular examples near Longnor. Later enclosures are square, producing a patchwork effect. The majority of walling took place between the middle of the 18th century and the first quarter of the 19th century. Stone-walling is an activity of great skill, and many devoted craftsmen remain dedicated to its perpetuation.

The Peaklanders

In bygone days, the Peaklanders seized every opportunity for enjoyment. How they danced, ate and drank to extravagant excess! It was these bacchanalian abuses that gave them the reputation of being semi-barbarian. These excesses frequently followed sporting competitions. In the 18th century one traveller wrote, *"In the Peak they are all much given to dance, after the bagpipes; almost every town hath a bagpiper in it. For excesses they have an old recreation from among the Greeks, called the Naked Boy. With this in foote races, you shall have on a winter's day, the earth crusted over with ice, two antagonists, stark naked, run a foot race for two or three miles with many hundred spectators."*

Much of the Peaklander's individuality was lost with improved communications at the time of the Industrial Revolution; other customs and idiosyncrasies have been neutralized in the march of conformity. Life has developed along the lines perceived by William Howitt of Heanor, who in the mid-19th century sadly wrote, *"The times and the spirit of the times have changed; we are now sober people. England is no longer Merry England; but busy England"*

Field Sports

It is not surprising that the hill men developed an unquenchable thirst for blood sports. From time immemorial they had hunted the hare with hounds. The organized sport goes back to 1848, when the High Peak Harriers were founded. For 32 seasons, the Master was one Nesfield, who secured his cherished 1000th kill on his last day's sport. Formerly the western side of the Peak was hunted by an independent pack, the Dove Valley Harriers. Following a paucity of hares along their common border, the rival hunts amalgamated around 1896, when the Master was Frederick Cotton. He could walk, dance, run, fight, shoot, or ride with anyone, besides being able to sing a good song or act. His most amazing feat was walking for a challenge from Ashbourne to Auchlyne House in Perthshire in under a week. He achieved this feat with only four hours to spare. On arrival he requested a mere two hour's sleep, before setting out for the grouse moors! Later Cotton left these hills to become a M.F.H. in Ireland. Typical of his wild spirit, and in face of the strong anti-English feeling of the time, he displayed a wild disregard of the obstacles placed in the way of the hunt. Later, he went pioneering in New Zealand, big game hunting in America and plant hunting in the jungles of New Guinea!

Archaeology in the Peak

The first settlement in the Peak is thought to have been by men of the Middle Stone Age. They were followed by Neolithic men, who were herdsmen and who first developed trade, and had marked institutional and ritualistic tendencies. This is seen in their passage, or chambered, tombs and stone circles. Few of these tombs exist on the Derbyshire uplands, but the stark form of Minninglow is a good example. Arbor Low is a stone circle magnificent in its desolation; it remains a mystery from the impenetrable mists of time. Neolithic culture was overtaken by the arrival of the Bronze Age peoples whose memorials are the prolific round barrows, or lows as they are termed in Derbyshire. These tumuli crown many limestone hills and spread down into the Dove valley. All of them give unfettered views of the vistas and skyscapes for the last resting places of those princes from the dawn of mankind. When we examine the Ordnance Survey of the Limestone Peak and see the myriad of tumuli, it seems that the area was heavily populated in relation to the lowlands. One great mystery remains is why they are not similarly represented on the gritstone?

Lead Mining

The character of the Limestone Peak has been indelibly associated with the mining of the lead ore, galena. Though now virtually extinct, the industry had a major influence on the area's economic and social development for 1500 years. Galena, a heavy dark shiny ore, is found in veins within the limestone, having

been deposited in the molten state into fissures. Rakes form the major veins, huge linear infills of ore up to 20ft in width, with depths of 500ft which ran for distances averaging from one to four miles. These rakes have been subjected to intensive exploitation; early opencast operations were in turn followed by a series of shaft mines. Now long since worked out, the rakes still have a distinctive appearance; an arbitrary slash on the hillscape, edged by the lip-like banks of spoil. An example is to be seen above the Dove at Earl Sterndale, from the rear of the Silent Woman Inn.

The Romans first exploited the Peakland lead to satisfy the demand created by their extensive waterworks. By the time of Hadrian (AD 117-138), the mines of Derbyshire were in regular production. Much of the activity was surface production with dammed up water being released to expose the rock. With the Norman Conquest the silence of centuries was again broken to meet the demand for lead to roof the great religious houses. In the feudal period, although the miners held rights of extraction, the main ore fields were held by the King or the Duchy of Lancaster. A series of conflicts arose, resulting in the free miners petitioning Edward 1 to safeguard their interests. At the subsequent Inquisition of Ashbourne, in 1288, the miners' customs and rights were laid down in a statute. These rights, together with the accompanying code of feudal tribute, survived into the 19th century. Under the statute anyone was entitled to search for lead except within a churchyard or on a highway. When a seam was found, the claim had to be registered, together with a tribute of ore to the King or Duchy. To register claims, administer, adjudicate in disputes and carry out valuations, Barmote Courts were appointed in each Hundred with powers of punishment. The Barmote Court of Wirksworth still exists, though only as a tradition, long after the demise of its tutelage. A study of the Royal and Duchy purses during the 14th and 15th centuries reveals how remunerative these tributes were. There was a high level of activity in a series of shallow mines, which were situated closely together because of limited ventilation .

The zenith of mining was at the close of the 18th century. Higher production was facilitated by the working of larger and deeper seams, made possible through improved techniques in ventilation, extraction, and drainage with the advent of large steam engines. Drainage of the deeper seams was greatly enhanced by subterranean tunnels. However, these larger scale developments were in general concentrated on the high limestone plateau. On the edge of the Upper Valley of the Dove may be seen long closed adits; their dripping depths echo far away from the world of warmth and light. These were a particularly easy method of reaching the parallel seams on the perimeter of the limestone mass where smaller scale operations continued, using crude ladders and removal of the ore and water by hand.

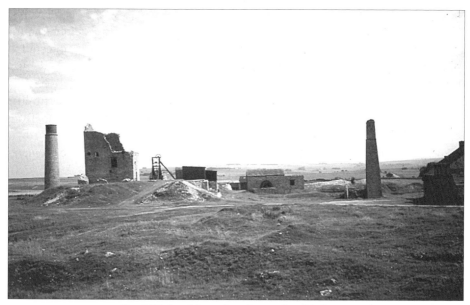

Lead Mining: Memories of a moribund industry

After 1850 a great decline set in, due mainly to growing geological restrictions and the availability of cheaper imported ore. By 1901, the number employed was a mere 285, compared with 2,330 in 1861. Apart from isolated attempts at re-opening mines, this decline has continued throughout this century. With the demise of mining a way of life died. The miners were brave staunchly independent individuals, with a loyalty code of their own. Daniel Defoe portrays an unenviable individual emerging from a shaft; *"We were agreeably surprised to see a hand, and then an arm, and quickly after a head, thrust up out of the very groove we were looking at..... this subterranean creature.... was a most uncouth spectacle, clothed all in leather... for his person, he was lean as a skeleton, pale as a dead corpse, his hair and beard, a deep black, his flesh lank, and as we thought something of the colour of lead itself"*

Today, the only tangible evidence to the wayfarer are the frenzied ground turbulence, treacherous shafts and lonely ruinous pit head buildings, that so indelibly leave a record of that army of Derbyshire men who spent their lives in search of the glistening Galena. Below lies their final memorial, an unchartable maze of tunnels whose magnitude defies present day survey.

The Millstone Grit World of Staffordshire
On the western bank of the river the dark gritstone landscape sweeps down, thrusting deeply southwards, attempting to cling to the young Dove, but unable to grasp her because of the protecting shale. Although the altitude falls, the

bleakness diminishes and the austerity softens, the wild spirit lives on. This country lacks the incandescent light of the limestone country. The fields are usually smaller, with walls of stone which vary considerably in colour from gingerbread to dark grey. They are higher and less dense than those on the limestone. The pastures in high summer here do not erupt with clumps of cranesbill, but are speckled with waving heads of harebells and pansies. A persistent ridge of gritstone draws a protective veil between the twin-like Dove and Manifold, which rises to a final redoubt at Sheen Hill. At 1,247ft the high wild blasted outcrop is a point of vision over a land of ecstatic freedom. Here one can survey the full panoramic magnificence of the Pennine declivity in which the Dove and Manifold have journeyed from the dark moors to the green oasis below. Travelling faithfully together, at times only half mile apart, they continue to be denied sight of each other by this septum like barrier.

Below Sheen Hill, as the gritstone promontory gradually falls away we find Sheen, which undoubtedly belongs to the Moorland world. This is a village of different coloured, shapely-gabled farms and cottages collected around the Victorian church. The young men of the village have for many years gained a notoriety from the success of their tug of war team. In the parish are to be found the remains of medieval crosses. One lies on the side of the road to Longnor. These crosses, dating from pre-reformation times, were similar to the wayside crosses still to be seen in Ireland or Brittany.

Longnor

Nestling on this divide lies Longnor, a former market town, where the atmosphere of former days still pervades. On arrival the visitor feels as if he has crossed a time barrier. The former Town Hall still exhibits the table of market tolls. The former market day was Tuesday; while a hiring fair was held on Boxing Day. Through the 19th century, as a result of the market, Longnor hosted many country-based trades. The cobbled Market Square, overlooked by the austere ruddy houses and inns, has the nonchalant relaxation of an Irish market town. Behind the square, humbler homes are approached through sandstone flagged alleys that resemble the wynds of some old Scottish town.

The grim exterior of the church resembles a 19th century chapel. On entry one is unprepared for the beauty of its presentation. A wide open nave is lit by rounded deep Georgian windows with elegant trimmings; the altar is surrounded by a back drop exhibiting a most subtle mixture of colour, white and pink mouldings against a grey background. The whole, so typical of that revolutionary style, is a tribute to the vitality and confidence, sobered by fine taste, that typifies that period. In the churchyard is buried William Billings, who following his birth in a cornfield, saw the capture of Gibraltar, suffered wounds

at the Battle of Ramillies and later saw action against the Stuarts in both 1715 and 1745. This illustrious old soldier finally expired at the age of 112 years.

Pilsbury

Below Sheen Hill, the attendant hills constrict the Dove Valley. This phenomenon has been utilised by early man to raise an earthwork castle of the Motte and Bailey type. The vast earthworks of this stand some 60ft above the river, and eventually become welded into a detached outcrop of the hillside. The earthworks, evidently of two different periods, are the more impressive since they are surmounted by a tumulus. Excavations were apparently carried out during the 19th century, but without any published results. It is tantalizing that the castle has never been excavated on a scientific basis. From the summit of these earthworks one can survey the course of the Dove from the land of her birth. Possibly this explains the mysterious origin of the castle as the guardian of the settled richer lands to the south. It is likely that Celtic tribes continued to live in the upper valleys long after the colonization of the south.

Below the castle lies Pilsbury, a three-storeyed symmetrical limestone yeoman farm, with voluminous attendant buildings sheltered by a sycamore and ash wood. This noble farm is typical of the growing agrarian affluence of the developing valley. Now houses of taller and wider proportions are adorned with gables and wide symmetrical windows facing confidently downstream. The still youthful stream glides sparkingly through these tranquil and valued pasturages. In late spring the hillsides erupt into an orchard-like blossoming of hawthorns.

Hartington

At the end of the valley lies Hartington, a fine example of the richness and stability of Yeoman England. It was formerly a vast parish of some 24,000 acres, but successive re-organizations have reduced this considerably. An elegant central square recalls its former days as a market town, its first Charter being granted in the days of King John. Possibly the most tangible reminder of these former civic days is the demonstrative Town Hall built in 1836. The central square, pond and green form a progression of cameos, nowhere more fulfilling than in the doorways, which exemplfy the elegance and flamboyance of Georgian times. Here at Hartington occurs the long awaited marriage of the two lands. The open valley bridges the contrasting lands that have flanked the banks of the Dove. While most of the buildings are of limestone, the cornerstones or quoins and roofs are of gritstone.

Above the Square stands the church, a fine cruciform creation of the early 14th century though with Saxon origins. Hartington was for long subject to the authority of the Honour of Tutbury, evidenced by the stone coffin of Margaret

de Ferrers. In 1959, restoration work revealed pre-reformation wall paintings on the north wall of the nave, and 17th century texts on the south. These relics of opposing theological views, now restored, gaze at each other across the nave. Above, on the rising hillside, we find the Hall. For long it was the home of the Bateman family, who came in the reign of Richard II. The family's fortunes rose like many of the minor squires after the Reformation, and in alliance with the Cavendish family. The Hall was rebuilt in 1611 and again in the 19th century. The family left in 1934. According to legend, the Hall was visited by Bonnie Prince Charlie in 1745. It is now a Youth Hostel, with field study facilities.

The Hartington of today is dominated by the tourist trade, but it is still very much influenced by dairy farming, which supports the cheese factory, the last remaining of several along the Dove and Manifold Valleys. Cheese manufacture was formerly the task of the farmer's wife and became industrialized here following the arrival of the railway. The manufacture of cheese here, mainly Blue Stilton, still maintains the best traditions of the past. The Duke of Devoshire established a creamery here in the 1870s. After a fire damaged the building. it was taken over by a Stilton maker from Melton Mowbray and now, under the ownership of Dairy Crest, the creamery makes about 20% of the country's Stilton,

Hartington:
Maturing Stilton.

CHAPTER 3
THE DALES: LOST FROM SIGHT

The opening of the valley at Hartington is destined to be short lived. As though the maiden river is not sufficiently mature to be exposed to open gaze, nature abruptly draws the curtain closed. The limestone hills surge across her path and take her within their bosom as a captive hidden from view. Limestone, a soft rock easily permeable by water is composed of myriads of sea creatures which lived over 280 million years ago. Aided by frost and rain, the river has excavated through successive layers of the rock to produce the most beautiful phrasing in the whole glorious symphony of the Dove.

Beresford Dale
Across the fields from Hartington, the Dove flows past abrupt limestone portals to enter Beresford Dale, the first section of a cave-like journey through a series of dales. A scene of indescribable beauty enfolds as one is led beside the glistening waters which break over little weirs. The elements of the scene change with the seasons, yet remain intensely consistent. So beautiful is the scene that one unconsciously walks with hesitant reverence as though walking through a cathedral nave beneath vaulting of soft greens.

In the fuller days of early summer, in contrast to the bright flowers and foliage, the river diminishes in clarity as the waters become charged with pollen. At all times beautiful, yet perhaps it is at its finest in late summer, when long shafts of hazy sunlight penetrate the morning mist and turn the river into a glistening beauty. Beneath the entwining branches, the light, colours and shadows interplay as if projected by some great hidden kaleidoscope.

Charles Cotton and Isaac Walton
The symphony reaches its most glorious at the Pike Pool, so beloved of Charles Cotton and Isaac Walton, who described it as the pool which all fishermen see in their dreams. The name is not derived from the freshwater fish but from the grey monolithic pike that rises from the waters of solitude.

Beresford Dale is inextricably associated with the immortal memory of that bizarre friendship which made the river famous. Charles Cotton was born in 1630 and inherited from his mother the Doveside Beresford Estate which had been in the family since the Conquest. Despite his aristocratic birth, his life was plagued by continual debt. On one occasion he was forced to hide in a cave above the river to escape his pursuers. This financial struggle finally led to the forced sale of his beloved estate. He was a lyrical poet of great sensitivity and perception and he earned fame with his lively translations of classical texts. His

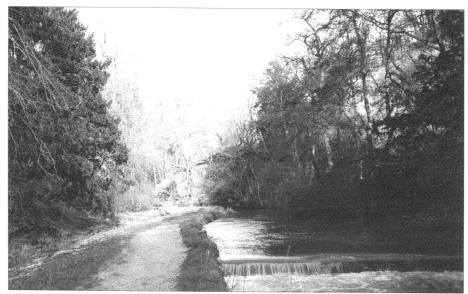

Beresford Dale:
Sublimity of mood and
beauty.

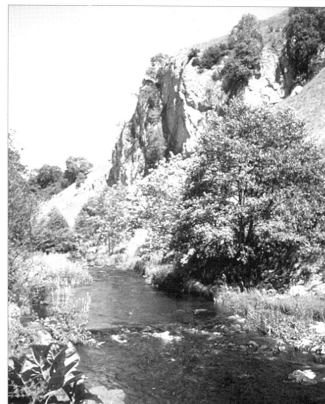

The Dales: Beloved by
Cotton and Walton.

love for the river has a lasting memorial in his song of praise, possibly the Dove's finest verse;

"O my beloved nymph, fair Dove,
Princess of rivers, how I love
Upon thy flowery banks to lie
And view thy silver stream,
When gilded by a summer's beam;"

Isaac Walton was born of farming stock in Shallowford near Stafford in 1593. He sought fortune in London and, after apprenticeship to an ironmonger, he founded a drapery business, in which he proved particularly successful, gaining the patronage of many of the literary and church figures of the time. As a royalist, following the fall of Charles I, he fled London to seek sanctuary in the houses of his friends, and after the execution of Charles I, he conveyed a crown jewel to an envoy of Charles II, risking certain death if discovered.

Above Beresford Dale, on the Staffordshire bank, stand the remains of Beresford Hall where Isaac Walton came to stay with Charles Cotton, some 40 years his junior. Walton's mature humility and deep conviction were a steadying influence on his young companion's impetuousness and instability. The friendship between such contrasting characters was based on a shared love of and curiosity about nature. In fact the two were the first to explore the whole course of the river and particularly the fishing that it afforded.

After each excursion, though tired, they would sit by a flickering log fire and reflect on the day's pleasures, before anticipating the joys of the morrow. These halcyon days stimulated Isaac Walton to write his famous instruction on the art of fishing, *The Compleat Angler, or the Contemplative Man's Recreation.* In this ever popular classic, Walton's character shines from the pages, across the years. The quaint yet sincere prose creates a pen portrait of their days in affinity and peace with nature. *The Compleat Angler* is the work of a countryman who loved his sport and the delights of the river. He did not profess to be proficient in all aspects of the sport and much of the information was gleaned from folklore; for example the use of the oil from ivy berries to make the bait more attractive. In addition to the art and its practice, the book details the various species of fish, with advice on their cooking and preservation.

The text is written in the form of a dialogue, where Viator is Walton and Piscator is Cotton. Although most of the information has long been outmoded, the text exudes the simplicity and sincerity of rural life. The following extract from The Milk Maid's Song provides a good illustration;

"Come live with me and be my love,
And we will all the pleasure prove
That valleys, groves or hills or fields,
Or woods and steep mountains yields.

> Where we will sit upon the rocks,
> And see the shepherds feed our flocks,
> By shallow rivers, to whose falls
> Melodious birds sing madrigals".

Beresford Dale is probably the most delightful spot along the Dales, where wildflowers grow in profusion down to the water's edge and birds sing their madrigals. In a secluded spot by the river stands The Fishing House, where the two friends smoked and discussed the fishing. It is a neat and trim stone structure, with a steep pyramidal roof of stone tiles and a charming chimney set jauntily on one side. A stone above the doorway appropriately declares, "Piscatoribus Sacrum". Possibly it is fitting to leave Beresford Dale with Isaac Walton's cheery farewell to their beloved stream, *"Well go thy way, little Dove! thou art the finest river that I ever saw, and the fullest of fish!"*

Wolfscote Dale

Leaving Beresford Dale the valley again fleetingly permits wider views before resuming its progress through the limestone canyon. Here, by a ford, legend says that the last local wolf was killed. Above Wolfscote Dale the regeneration of trees clings to the tors and crevices and from these a constant cascade of bird song falls. A rocky profusion of pinnacles and massive outcrops dominates the cascading grassy slopes, which, in the evening gloaming, rise like some ruined fortress. The abrupt magnitude of the dale reaches its zenith between the high masses of Gratton and Wolfscote Hills. From these bleak heights the river appears as a remote snake, deep below within the hold of the earth.

From the Staffordshire bank a track leads behind Gratton Hill into Narrowdale. It is picturesquely said that the northern orientation of this dale and its confines are so narrow that, *"The inhabitants there, for a quarter of the year, when the sun is nearest the Tropic of Capricorn, never see its face at all; and that at length, when it does begin to appear, they never see it until about one o'clock, which they call the Narrowdale Noon"*.

Along Wolfscote Dale lies the dry Biggin Dale. These dry tributaries are themselves dales in miniature, with tors and valley sides, exposing typical limestone mouldings, yet they are a world apart. In the absence of the singing Dove they have a quiet and melancholy stillness. The limestone beds of these dales allow the water to permeate and reach the river secretly below the earth.

Mill Dale

The first sign of habitation in the limestone dales is reached at Lode Mill in Mill Dale. The name reveals its early history in the smelting of lead. At all times this is a pleasant spot, but especially in those nurturing moments of the year when the grassy slopes are clothed with a radiant carpet of snowdrops, that sweet and

gentle flower whose serene and virginal qualities earn it the title of 'Our Lady's Flower'. Below Shining Tor a road sneaks in from below the woodland mantle and continues to the hamlet of Milldale as a companion to the river. Milldale is a clustered hamlet of square stone houses, below steeply wooded hillsides, with the child-like perfection of a fairy tale. In former days, two mills were working on the river here, one a corn mill, the other processing ochre mined at Wetton. Across the river stands the Viators Bridge of Charles Cotton and Isaac Walton, a narrow bridge rather surprisingly built of sandstone, and consisting of low flattened arches, clumsily projected, yet attractive to the eye.

Dovedale

We cross the bridge into Dovedale, to encounter the wild and romantic scenery that makes this the most famous of dales. Gently clothed crags rise on each side carrying ash saplings rooted in invisible crevices. Cascades of ivy and dog rose veil the the rock faces, their images reflected in the green clear waters which move serenely over a continuity of rocky dams, breaking this moving poem into its components of colour, song and rhythm. The entrance to Dovedale is marked by Ravens Tor, a sheer buttress rising from the Staffordshire bank - most of the spectacular limestone formations in the Dale are flamboyantly named by imaginations that sought to impose order over the rugged splendour.

Beyond Ravens Tor the valley sides become steeper, at times oozing with scree and invaded by scrub. The first showpiece is Dove Holes, two gaping caves set in a massive expanse of limestone. The vast proportions of their arches are disappointingly unmatched by their depth. Below, the river changes course, and is confined, before flowing without warning into a wide arena with lush lawn-like swards. The river hesitates for us to enjoy wider panoramas before it reachies the next rock-congested, seemingly impenetrable passage. The power and appeal of Dovedale lies in the paradise of wild rock and idyllic tranquillity, with a sweeping mantle of woodland, which is fully appreciated beneath Ilam Rock, a lichen-encrusted monolith towering above the river. Opposite, protruding through the sylvan mantle are the strange spire-like formations of Pickering Tor and its attendants. Between them flows the Dove with silken movement, investing the scene with life and the epitome of clarity, yet covered by a silken sheen so heavy that the waters scarcely seem to move.

At Ilam Rock the Dove enters a narrow passage aptly called the Straits. Here long thrusts of currents become lost in calmer areas of serenity, then break down into a cascade of sparkling confusion. Beneath one's feet pulsate springs and streamlets, outpourings of the limestone hills, a vast fountain that nurtures the Dove. In this narrow passage rises the formation of Lion Rock, named because of its extraordinary likeness to the King of Beasts.

The most distinctive denizen of the Dale is the dipper, a jauntily rotund

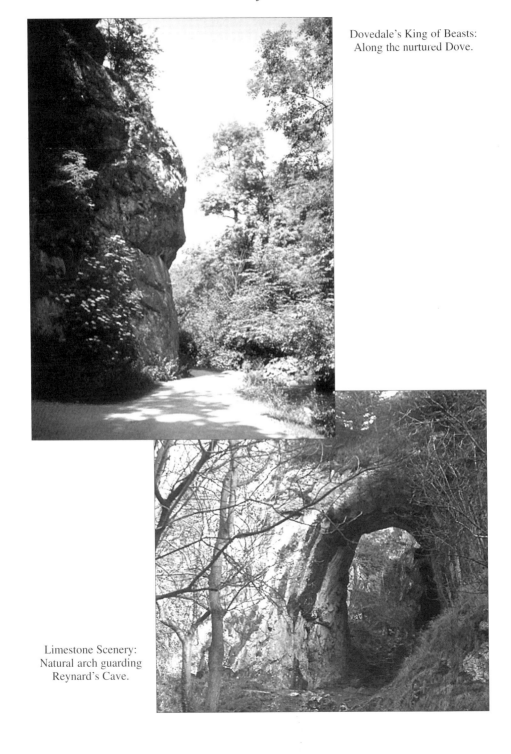

Dovedale's King of Beasts:
Along the nurtured Dove.

Limestone Scenery:
Natural arch guarding
Reynard's Cave.

white-breasted bird resembling a big wren. Throughout the year each bird remains on the same stretch of water, bobbing about spasmodically perched on a rock and then plunging into the water and remaining submerged to feed. The dipper makes a large globular nest in the crevices among the rapids of its reach of the river. So happy and youthful in habit is this jolly fellow, that its sight lifts many a heart from melancholia. The bird, sadly due to pollution of our rivers, has in recent years become scarcer; the pure waters of the Limestone Peak are a stronghold, though the writer has still detected a worrying reduction.

The woodlands that clothe the slopes of the ravine are one of the finest panoramas in the land, and a climax of natural regeneration. Much of the richness comes from the dominance of the graceful ash. In summer the sunlight filters through the incised leaf patterns to permit a rich and varied ground flora. Interspersed amongst the ash is wych elm, while from the crags, seemingly deprived of soil and water, yews hang tenaciously. Protected by the crags the whitebeam and other sorbus species grow and between the trees, clinging to the banks of the river, we find groves of dogwood and alder, buckthorn and blackthorn, straggling masses of guelder rose, elder, hawthorn and hazel.

In these dense woodlands one can explore some of the richest floras in England. Down to the water's edge the flowers cascade; herb robert, forget-me-not, stitchwort, throngs of dogs mercury and ramsons. Yet perhaps the most lovely flower, because of its pervading fragrance, is lily of the valley. These enchanting white flowers are followed by poisonous red berries, said in the folk lore of old England to be tears shed for the dying spring. It is easy to understand the pathos of this commentary as the year sweeps along without a care for a heart that clings for the memory of some lingering happiness. It is said that much of the success of the Methodist Revivalists in the Peak was because they drew analogies from nature in their preaching. One frequent and appropriate text was, "Consider ye the lily". In those days the flower grew in great abundance; today the preachers would be obliged to find a more relevant text. Advancing agricultural practice and removal for suburban gardens has restricted their range to these precipices. Some ninety years ago two clergymen botanists identified the very rare madder here, a strange plant that scrambles over rocks and bushes by means of prickles on its leaves and stem. Some introduced plants are also naturalized, like red-lipped musk and alpine currant.

High above the river in Derbyshire lies Reynard's Cave, an appreciable cavern, with an attendant, Reynard's Kitchen. Both of these caves are guarded by a huge natural arch, clothed like a ruin in vegetation and studded with dark tufts of yew. From the mouth of the main cave, one surveys the full proportions of the gorge. Opposite, far above on the skyline, stands the solitary Air Cottage, perched precariously on the very edge, looking down on the gorge's architect

and creator, the river. The cave is said to be named after one Reynard, a local brigand, who made the cave his refuge. An authentic tragedy did occur here in July 1761 when Dr Langton, the Dean of Clogher in County Tyrone, was in a party exploring the Dale on horseback. Fortified by a picnic on the banks of the river, the clergyman endeavoured to give a girl in the party a pillion ride up the cave's approach., but the path was far too steep for the over-burdened horse, which fell, throwing both riders to the ground. The Dean was killed, but his fair companion was saved by her flowing hair which become entangled in a bush.

Though bats and jackdaws still find sanctuary in these caves, time has long passed since wolves reared their cubs within and brown bear entered the murky confines for cover. It is still felt that the numerous caves of Dovedale hold finds yet undiscovered for the explorer and archaeologist alike. Many of the early explorations in the dales were led by Rev G.Wilson, who in his *Cave Hunting Holidays in Peakland* concluded that there remained many promising sites around the heights of the Dove awaiting discovery. Sir Arthur Conan Doyle describing the Limestone Peak wrote, *"All this country is hollow. Could you strike it with some gigantic hammer, it would boom like a drum!"*

Downstream lies Lovers Leap, a massive conical outcrop from which one can survey the rugged splendour. It is said that it is named after a rejected maiden who committed herself to the precipice; again it is said that the bushes saved her fall, though she spent the rest of her life in perpetual seclusion. In these stretches are to be found many romantically named crags and pinnacles that have been formed by the erosion of the surrounding softer rock.

As if nature senses that the human mind has had a surfeit of this wild grandeur of limestone scenery, the river now flows forward with new found serenity, at total peace after her previous turbulences and convulsions, scarcely a ripple breaks the rich mantle-like sheen. Beside the river lies a grassy promenade, shaded by wide-crowned alders, known as the Sow Sitch. Here at the abrupt end of the daleland journey are found the famous Stepping Stones, where the waters divide and swirl around the limestone blocks. Below the Steeping Stones, the river flows out, as though relaxing after her many exertions, into the open world and a scenery reminiscent of parkland above which stands the Isaac Walton Hotel.

The fame of Dove Dale has long been established. In earlier days, the dale scenery was treated with the same contemptuous distaste as the high moors. Sampson Erdeswick in his *Survey of Staffordshire* in 1603 wrote of Dovedale, *" The Dove flowing past Alstonfield for three to four miles without any matter worth noting."* The Dale's rise to fame coincided with the heyday of the romantic author. To the Dale came the literary greats of the day to praise its scenic delights. Byron wrote to Tom Moore, *"I can assure you there are things*

in Derbyshire as noble as Greece or Switzerland". Ruskin described the Dale as, *"An alluring first lesson in all that is beautiful"*. Although the great came and recorded their thoughts in prose, few transcribed their thoughts; perhaps the task was beyond even their abilities. Wordsworth came and apparently left without a verse. However his memories of beauty, or perhaps some secret love, remained dormant in his heart. Many years later his memory of a distant love found a resting place when he wrote these verses to a maid called Lucy,

> "The stars of midnight shall be clear
> To her; and she shall lean her ear
> In many a secret place
> Where rivulets dance their wayward round"
>
> *"She dwelt among the untrodden ways*
> *beside the springs of Dove,*
> *A maid whom there were none to praise,*
> *And very few to love.*
>
> *A violet by a mossy stone*
> *Half hidden from the eye*
> *Fair as a star, when only one*
> *Is shining from the sky"*.

The late Georgians and the early Victorians delighted in wild scenery which they found analogous to their own romantic sense of expression. The real popularity, however, came with the advent of the railways and the social changes of the late Victorian era which allowed great numbers, particularly from the northern towns, the opportunity of taking a day in the country. J.B. Firth at the turn of the century, wrote contemptuously of the new tide that was flowing. In his *Highways and Byways in Derbyshire* he comments on the recent closure of the Beresford Dale Fishing House - *"One is almost resigned to the thought of how the Fishing House of Walton and Cotton would suffer at the hands of the barbarian halfday visitors. Better closed than destroyed"*

By the end of the Railway Age, Dovedale had become one of the most famous beauty spots in England. Many were the thousands who arrived by train at Alsop en le Dale Station to walk the length of the Dale, before departing at the end of the day at Thorpe Station. Now, in these days of mass motoring, many are the times when the approaching roads are impassable with crawling traffic as the more popular reaches are swamped by a seething mass of humanity - until, with the solitude of eventide, the fullness of its beauty returns unimpaired.

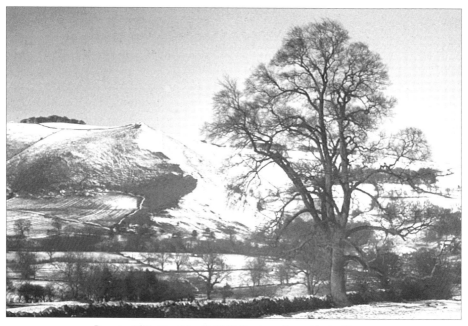

Bunster Hill: The Manifold Valley in union with the Dove.

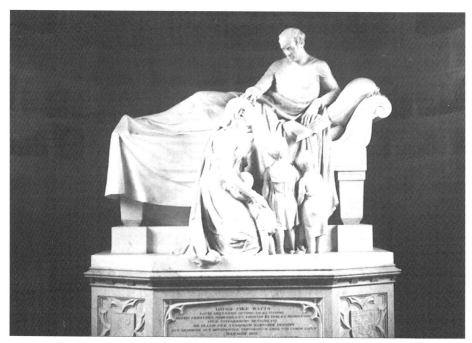

Ilam: Chantrey's depiction of the deathbed.

CHAPTER 4
THE MANIFOLD: FAREWELL TO THE LIMESTONE WORLD

The Meeting of the Rivers

After emerging into an open world, the long promised marriage with the River Manifold is consummated below the southernmost end of the Pennine hills. The waters meet swiftly in a harmonious union and from there dance away together. The Manifold is in fact the larger of the two rivers, the greater flow being easily appreciated during winter along the road which leads to the village of Ilam where the Manifold still flows with the sound of an upland river.

Ilam

Ilam is a village of unrivalled beauty; though of ancient foundation, its outward and visible signs are Victorian. The great Hall and a new village were started by Jesse Watts Russell in the 1820s after he had made a fortune in industry. The estate had previously been in his wife's family, after centuries of ownership by the Port family. The first sight, on entering the village, is the fine stone imitation of an Eleanor Cross, raised in memory of Russell's wife. This monument, which now shows signs of weathering, gave Sir Gilbert Scott his inspiration for the Martyrs memorial in Oxford.

Ilam Hall was a large and spectacular mansion whose turrets and battlements rose to dominate the valley. The vast pile, which encased the medieval house, was designed by Trubshawe. This architect was also engaged on the building of Alton Towers and Ilam's vast entrance and the great hall were suggestive of Alton. When Watts Russell died in 1875 it passed to the Hanbury family, until it was sold for a restaurant in the 1930s. This initiative was a financial failure, after which the mansion was sold for demolition. The grounds were originally laid out with walks, groves and a park planted with many interesting trees. Now in maturity, they are a pastoral oasis below the soaring hills.

The radical thinking of the 19th century may be judged by the attitude to ancient buildings; those not replaced were so comprehensively restored as to remain unrecognizable. The ancient church was in fact rebuilt by Sir Gilbert Scott in a form analogous to the adjoining great house. In a specially constructed octagon stands Chantry's giant monument to David Watts, father-in-law to Jesse, a monument less to the deceased than to the pride of the family. Self assured may have been its sponsor, but an artistic genius was its creator. The huge white monument, so superbly displayed and lighted, depicts vividly the pathos of the Death Bed. In meticulous detail and perfection of form, David

Watts is seen to rise and bid a last farewell to his daughter, who is kneeling with her tearful children.

Sir Francis Chantry was born in 1781 in a Peakland village now overtaken by Sheffield's suburbia. From these humble origins, he rose to wealth from the patronage of the wealthy. Not only was Chantry famous for his sculptures and funereal monuments, his paintings and sketches were highly prized; particularly fine were a series of sketches of Dovedale. The great man would have been very familiar with this area when staying at the Hall.

In an archway in the church there is a link with former customs; faded paper wreaths and gloves, which in Derbyshire were traditionally carried on the coffin of a village maiden. They were the mark of a young life cut off in the fullness of youth. It was the also the custom for a handkerchief or glove of the girl to be left with the garland. Another example of this custom can be locally seen at Trusley.

The Bequest of Ilam

Following the demolition of most of the Hall in 1934, Robert MacDougall, of the milling family, bought the majority of the estate including Dovedale. This he presented to the National Trust to secure the natural beauties of the area. He also ensured that the remaining portions of the house were retained to become the finest Youth Hostel of that time. The present building retains the gatehouse and great hall, so that we can still form some impression of its former grandeur.

MacDougall's benevolence had enlightened as well as conservationist intentions. During the 1930s there was a spontaneous growth of the Youth Hostel movement through which the young and lower paid became able to turn their backs on the northern industrial towns and set out on self-sufficient journeys of discovery into the countryside.

Saint Bertram of Ilam

The origins of Ilam lie in the times of the first Saxon Christians. The Faith came here in the 9th century with Saint Bertram, who is believed to have had connections with the royal family of Mercia. For some reason, probably to study, he travelled to Ireland and while living there he married a beautiful princess who was a devout Christian. During their return to his native land, they were travelling through deep forests in Wales when she gave birth. Bertram went away briefly, possibly for help or to search for food. On his return, he found that following an attack by wolves, both mother and child had died from a terrible savaging. Following this tragedy the grieving Bertram renounced the world to spend the remainder of his life as a recluse in these dales, teaching and preaching the Gospel. The sanctity of Saint Bertram transcended the ages until

the Reformation. His shrine, a portion of which remains within the church, was a venue for pilgrimage; the devout would prostrate themselves in the hope of physical cure or eternal peace. Today it is still visited and it is unusual to see Intercessional Prayer cards in an anglican church. Saint Bertram's Well is to be found below a giant ash tree on the slopes of Bunster Hill, though it now serves cattle rather than the faithful. The churchyard also has two Saxon crosses, one of which stood to an elegant 8ft.

The Literary Associations of Ilam

The setting of Ilam Hall is so magnificent that one may fancy it to be paradise. From the once stately terraces one may wander unfettered along the leafy glades that adjoin the cascading river, to a score of visual delights set against the ever green hills. It is not surprising that Ilam has had a rich literary history. Watts Russell was in fact a relation of George Eliot, the novelist, who drew heavily from her connections along the Dove. Paths lead to the grotto where Congreve, the great restoration dramatist, wrote his play, "The Old Batchelor" while recuperating from illness. The work was an instant success, which launched him on a successful career. Samuel Johnson also loved, and was inspired by, the grounds of Ilam. It was here when virtually destitute, that he wrote in the tranquillity of a single week his only novel; it was written to pay for the cost of his mother's funeral. He retained an attachment for this lovely place, and returned many years later with the inevitable Boswell.

The Secret Waters of the Manifold

The reappearance of the torrent of the River Manifold from darkness at Ilam Hall is one of the great natural phenomena of our land. Boswell recorded how he and Johnson had wondered in disbelief at the spectacle of the Manifold cascading again into light at the end of its subterranean journey. His belief was only assured, "at the attestation of a gardener". Here the waters surge upward from the side of the river bed like some giant spring. This is called the Boil Holes. In the valley confines at Wetton Mill, five miles away, the river disappears through fissures, called The Swallets. Sir Thomas Wardle, a Victorian industrialist, of Swainsley Hall tried to defeat this phenomenon by blocking up the holes with concrete: nature was not so easily defeated as the pressure within the cavities blew the concrete out. Later, he tried again, by having pipes drilled through to relieve the pressure, but this was also unsuccessful. This failure was surely fortunate, for in these silent reaches one can appreciate the mystery of nature as the secret waters flow in the darkness of unknown galleries below.

The rock strewn dry bed of the river is a silent, serene and pastoral land;

though in periods of very wet weather the "dry" bed carries a flow of water. To explore this strange land one must cross field, wood and hillside, for no path or track follows the river until its confluence with the Hamps.

Throwley Hall

In medieval times the centre of the area was Throwley Hall. This stands high on the lonely ridge that separates the Hamps and the Manifold, with views into the depths of the dales. This is a wild and romantic ruin, which would benefit from detailed research and survey. For long it was the seat of the Meverell family, one of whom, Arthur, was the last Prior of Tutbury. The last Meverell, Robert, found his last resting place in Ilam Church in 1626, The finely cut alabaster tomb gives a good illustration of early 17th century dress. Robert's daughter married Lord Cromwell, a relative of Oliver. While the Cromwells were in possession of Throwley a strange religious sect, the Muggletonians, flourished in the area. It appears that the Cromwells lent books to one Tomlinson, a son of a tenant, from which he learnt of the sect. He joined and became its leader, which increased its strength locally. One of the sect's beliefs was that God had made his last revelation not to St John the Divine, but to his cousin. One of Tomlinson's contributions was a momentous poem of 26 stanzas, entitled," Joyful news from Heaven, for the Jews are called".

The Manifold Valley Railway

The confluence with the River Hamps, an appreciable tributary, is hidden within the underground caverns as the lower reaches of the Hamps are also dry and silent most of the year. The valley of this tributary runs due north, after a long looping course from the High Moors. Through the valley runs a metalled path that follows the course of the ill fated Manifold Valley Railway, a narrow gauge line that met the North Staffordshire Railway Company's (NSR) line at Waterhouses. The railway ran through the Hamps Valley to join the Manifold Valley for its full length to Hulme End, where open countryside is reached. The line was first promoted by the Leek MP, Mr Charles Bill, who wished to provide an outlet for dairy produce from the Moorlands. The first sod was cut by the Duke of Devonshire at Waterhouses in 1899. The project was backed by the NSR, the County Council and the Treasury; and further financed by the speculative and hopeful. It was opened on 27th June 1904 to the optimistic acclaim of its backers and the local populace alike. Fate did not fulfil their hopes; a particularly severe blow was the failure of the former Ecton mines. Neither the NSR nor their successors, the London, Midland and Scottish Railway, could make the line pay. Closure was inevitable and the last chocolate brown engine hauled the little yellow coaches through the valley on 28th

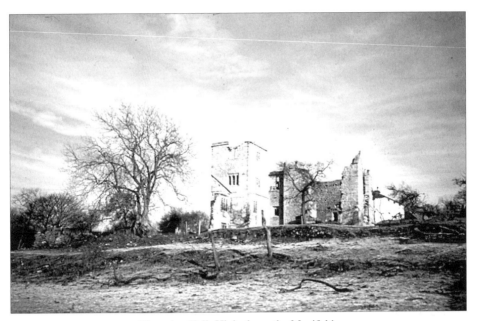

Throwley Hall: High above the Manifold.

Manifold Valley Railway: A lost delight.

September 1934. One can only speculate that if it could have survived until now it might have become viable. Following closure, a Staffordshire County Council initiative converted the track into a walkers' path. This was a revolutionary concept at the time which has proved a spectacular success.

The Caves of the Manifold Valley

The caves of the Manifold are particularly rich in archaeological interest. No view in the whole valley is more dramatic than that from Thor's Cave, whose great arch commands the whole wooded ravine. The huge cavernous interior has given shelter to mankind continuously from the Middle Stone Age, through Neolithic and subsequent civilisations until late Saxon times. It seems likely that many dramatic finds await discovery. The greatest concentration of caves is in the area of the confluence with the Hamps. The oldest remains date from over 25,000 years ago, though the most active period was during Mesolithic times, when the valley was extensively used by hunters. Excavations have shown that for 9000 years Wetton Mill Cave was used by early man. Tools of bone, flint, and bronze with some leather have been revealed. However the most interesting cave find has been the bone of a dolphin which is thought to have been a charm or the result of some Bronze Age rite. Remains of burials, including children, have been found, particularly in the cave entrances. Excavations have also revealed the remains of other inhabitants long since vanished from this land including elk, reindeer, brown bear and hyena. At Beeston Tor Cave in 1924 was discovered a hoard of 50 Saxon silver coins of the dates AD 871-4, 2 silver broaches and three gold rings. These are thought to have been hidden for safety at the time of the Danish invasions. Quantities of Romano-British pottery and implements were also found in the cave.

Thor's Cave: Murders Most Dreadful

In 1874 Thor's Cave was the scene of two particularly horrific murders. For long the world remained ignorant of the dark secret until a Mr Hawkins, when exploring for rock specimens, encountered an opening in the cave floor. On shining his light into the chamber below, he saw the terribly decomposed remains of a young woman and a man. Their fate would have remained a mystery if closer examination had not revealed that in his last grasp, the man was holding a notebook in which he recorded his agonizing last hours. Let us recall these dreadful events, *"My name is Henry T.Brown, now visiting this country for a holiday, but my home is in Ontario. I have been wilfully pushed into this pit by an unknown man and left to die a lingering death by starvation and misery, having had both legs broken in the fall".*

While exploring he heard the piercing scream of a woman calling for help,

followed by a man's curse, a dull thud and then silence. A gallant investigation to assist the unfortunate woman had brought Mr Brown into contact with a man who pushed him into the pit along with the already dead woman. His pitiful memoir concludes, *"This is the fifth day of my plight and now I have no pain in my limbs at all. I can feel them icy cold and they seem dead. O for a drink to cool my parched mouth..... Sixth Day, O when will death come to end these sufferings, my throat is on fire. My...."*. Here the writing suddenly stops. Only a few parts of the bodies were removed for the purposes of the inquest. The chamber became their official grave, as the pit was forever sealed with rubble. Early in the narrative of his last days, the

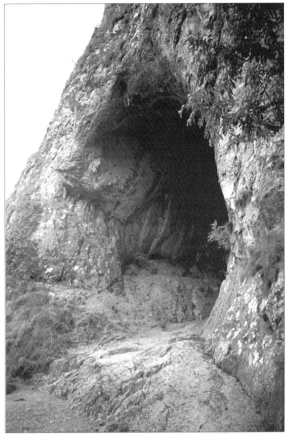

Thor's Cave: Commanding the valley.

condemned writer warns of the dangers of exploring alone in these darkened caves; a warning we should still heed now. Even in overcrowded England the lone traveller may encounter an immobilizing injury. Alone on a craggy hillside, or perhaps down some abandoned mine shaft, the prostrate victim can be assured of a lonely and terrible fate, as assistance lies beyond range of pitiful cries.

Ecton Hill Copper Mines

Above Wetton Mill the scenery, though pleasant, lacks the wild appeal of Dovedale. The northern portion is dominated by the heaving form of Ecton Hill. This hill was once famous for its rich copper mines; in fact this isolated seam was for long the most valuable in England. In addition to copper; lead, zinc and quantities of silver were produced. Mining at Ecton started in pre-Reformation

times, when the area was controlled by the Benedictine monks of Tutbury. With the Dissolution, these monastic lands and entitlements were transferred to the Cavendish family. In 1660 a successor, the future Duke of Devonshire, started mining on his own account and successive Dukes exploited the fabulously rich Ecton Pipe. This cylindrical formation of easily-mined ore ensured their future prosperity for 165 years. Under their enlightened management the miners and their families enjoyed wages and other benefits such as education and injury benefits. Activity reached a peak at the close of the 18th century, when over 400 persons were employed. Within the hill lay a vast underground complex. Entry by an adit from the river level led to a maze of workings which included internal shafts and a series of subterranean canals.

By 1795 the mine had reached a depth of 1,300ft. To facilitate such deep workings below river level the famous engineers Boulton Paul were engaged to build a vast steam driven pump within the hill. At the time this was the world's largest, being commissioned from the famous Coalbrookdale Company in Shropshire. This fantastic system of workings, with the bands of glistening quartz, became a tourist attraction. The scientist Sir Joseph Banks described his visit in 1767; *"They seem to be working on a seam that is a Pipe, which instead of going horizontal, is set upon its head and goes directly perpendicular. It is of an immense size and a very irregular figure, so that the chambers of the mine are so magnificent as scarcely to be equalled by the finest buildings"*.

When the great pipe seam became exhausted mining became a more speculative business. The Duke of Devonshire closed the mine in 1825. So profitable had been the operation that it is claimed that profits from one year were sufficient to build the Buxton Crescent. Mining on Ecton Hill was carried on until the end of the 19th century, by a series of speculative companies, the majority of which closed with losses. Rumours of latent seams have continued to the present day, but were particularly rife at the time of the opening of the Manifold Valley Railway. Without doubt, amounts of ore remain, but in quantities which would be unprofitable to mine in current circumstances.

The Upper Manifold Valley

Above Ecton, lies the upper valley of the Manifold which replicates that of the upper Dove. We have already observed from the redoubt of Sheen Hill the vast inviolate expanse of the valleys that lie below the High Moors. Here rises a glorious song of freedom, that only the most obscene intrusion can impair. Through this upper valley the swift flowing Manifold has been harnessed in the past to power water mills.

The Last Glimpse of the Limestone Uplands
Within the depths of the dales one remains oblivious to the remote world that lies above. Similarly when walking across these lush upland pastures one is always filled with surprise and awe on reaching the edge of the dale's abyss where far below lies the river. This land of the White Peak has been the nurturing and protective raiment of both rivers. A land of wide skies and rolling pastures which in summer erupt with buttercups interspersed with orchids, yellow rattle and the daintily trepid, meadow saxifrage. In summer these are vigorously fulfilling days, indeed a far cry from the stark days of winter when the mists, dampness and darkness hold the land in their heavy grip. Here the limestone world is at its furthest extremity. As the edge of the plateau is neared, the rolling becomes more rhythmic as the scenery becomes more intimate: hedges become more profuse as the ash yields to the ascendancy of the oak.

Much of this land in pre-Reformation times was controlled by monasteries, who established large farm units called Granges. These were worked by lay brothers to supply and provide revenue for the Abbey. The Granges on the edge of the hills were primarily intended to produce wool. In many cases the traditional units have survived, usually as a large impressive farm house with voluminous buildings. On the plateau above Dovedale, lay Bostern and Hanson Granges, both in the possession of Burton Abbey. Tutbury Priory also maintained outposts on the high lands between the two rivers.

On these edges of the plateau the villages become more numerous; fresh, invigorating villages with an individualist charm that cannot be resisted. Alstonfield, lying between the Dove and Manifold, is a clustered village enveloped by groves of trees. Charles Cotton and Isaac Walton walked to the church across the breezy fields from Beresford Dale. Their pew and other interesting Jacobean woodwork can be seen in the church which, like most in this area, was begun by the Normans, although the Saxon cross remains indicate earlier roots.

Many of the villages retain relics of days long passed. Fenny Bentley, whose rural charms are in accord with its name, has a medieval towered manor house. This was the original manor of the Beresford family. In the church of St Edward is the memorial to Thomas who fought at Agincourt. An Elizabethan successor lies with his wife, their effigies remarkable by being portrayed in bundled shrouds. Against the tomb chest, their numerous children are to be seen upright and similarly attired, a weird and grotesque concept!

Tissington: the Derbyshire Well Dressing
Of all these villages, none has a more justifiable claim to fame than Tissington. Again we find a church with a solid Norman tower and other contemporary

remains, the most noteworthy being the font. This is curiously ornamented by crudely incised allegorical figures representing wolves, bears and paradoxically the Agnes Dei. Below the church, midst grassy banks and greens, the village is punctuated by clear living water. The pervading peace is in accord with Tissington's great contribution to the folk culture of England, the Well Dressings.

This custom is found in many limestone villages, but Tissington stands out for quality and continuity. This delicate presentation is in sympathy with Ascension Day, that mystical Feast in spring, when religious and seasonal manifestations merge. In the days prior to the festival, loving hands prepare clay filled panels into which are pressed flower petals and mosses. Like the individual bluebells of a shimmering woodland carpet, they merge together to make a magnificent picture. The origins of this custom are lost in mystery. Some say that Well Dressing is of pagan origin redressed with a Christian mantle; others contend that the custom began as an offertory following escape from the Black Death; another theory suggests that the offering was in return for deliverance from a devastating drought in 1615, when, with the exception of a shower in May, no rain fell from March to August! The true explanation is for ever lost. In fact all the theories may contain an element of truth.

Much of Tissington's tranquillity is due to the tenure of over four centuries by the FitzHerbert family. The pleasant multi-chimneyed Jacobean hall can be seen gazing across the Green to the little church standing on the grassy eminence. This is an English scene at its best, where the family has protected the rural community to preserve continuity. This branch of the famous Derbyshire family became Anglicans, though the Hall was garrisoned during the Civil War for the King and the family were possibly Jacobite in sympathy. At this time the spelling of this branch of the family became slightly differently spelt. It later provided hospitality for Dr Johnson and the faithful Boswell on their visits to the area.

Thorpe

Finally to Thorpe, the other village which rivals Ilam as the gateway to Dovedale. From its eminence the village presides over the Dove's departure from the hills. Delectably grouped around the Green lie the same friendly cottages that we have seen throughout the limestone land, though many indicate a greater inherent wealth. The Church, so obviously Norman in origin, has the typical asymmetrical signs of Saxon work in the squat tower. The pasturages on the hills around Thorpe, and particularly Thorpe Cloud, that flat topped hill which forms a portal of Dovedale, were held by a curious form of land tenure. Known as Thorpe Pastures, the open areas of grazing were divided into Gaits,

measurements of potential stock, which could be bought and sold.

On the slopes of Thorpe Pastures are to be seen some well preserved examples of Lynchets. These Celtic fields are some of the oldest relics of agriculture to be seen, and occur commonly in the lower Peak. They consist of parallel horizontal terraces on the lower slopes of the hillside. At times they require some imagination to locate, but in winter sunshine they are well defined and transcend the centuries in sharp relief. Precisely how they were formed and when, remains a mystery. Further along the Dove more lynchets can be seen overlooking Okeover Park. Both of these examples are for some strange reason facing north, though southerly facing lynchets can be seen along the Manifold at Castern. These were relatively small areas of intense human activity. Surrounding them are seen the widespread lants of later periods, which run vertically up the slopes.

The Stepping Stones: End of the daleland journey.

The Secret Valley: Emerging from the protection of the hills.

Okeover Hall: 18th century entrance gates by Robert Bakewell.

CHAPTER 5
THE EMERGING DOVE: THE SECRET VALLEY

Emerging from the protection of the limestone Peak at Ilam, the Dove now enters a countryside which remains imbued with the spirit of the hills. A secret valley carries her to the open world beyond, a valley of steep sides, clothed with thorn, elder and groves of hazel. In the warming days of spring, the groves erupt with gently scented violets and clusters of dainty fragrant primroses. Tucked away within these woodland dells stands Coldwall Bridge. Any anticipation of human activity is delusory, as on reaching the bridge we find only solitude, the bold arches standing in glorious retirement. Built in 1726, the bridge formerly carried the Turnpike Road from Derby to Cheadle, indeed on the way to Thorpe, may be seen a forsaken milestone pronouncing "Cheadle 11 miles". The appearance of abandonment is starkest on a snowy day, when the white carpet lies unbroken except for the imprints of those animals that have used the forsaken crossing.

As the fields become surrounded by a mixture of walls and hedgerows, the softening contours become progressively more lowland in character. The river is drawn over fishing dams which recreate a sparkling illusion of youth over the finely pebbled bed. The dark forms of the attendant alder trees whisper soft murmurings, indistinguishable from the omnipresent cadences of the river.

Okeover and Mappleton

In a lowland oasis forgotten by time lie the twin villages of Mappleton and Okeover. At many locations along the river we find two complementary villages on opposite banks, in different counties. Mappleton is a clustered village, predominantly eighteenth century, with a contemporary, quaintly domed church. The mood is of stability and peace as continual generations have looked over the serenity of the unchanging scene. Across the sharply arched bridge lies the great estate that has been the source of their well-being and security. On New Years Day a fearsome boat race is held on the river between competing teams. The course is downstream over the weir which was built to power the corn mill and culminates at Mappleton Bridge. There as a finale, the competitors are compelled to jump from the parapet into the depths below.

Okeover is not so much a village, but the seat of one of Staffordshire's oldest families; the Okeovers have held the estate ever since the arrival of the Normans. An illustration in Plot's "History of Staffordshire" in 1686, shows a multi-gabled moated manor house typical of Elizabethan times. A rebuilding in the mid-18th century has given Okeover its present Georgian appearance. In 1880 the Okeover estates comprised 2,939 acres in Staffordshire. Unlike many

other estates, which have suffered from changing times, Okeover remains in superb condition. The lovely mansion and its service buildings have been fully restored to their present excellent condition. As part of this renewal some Victorian additions were demolished to conform with the intended layout of 1760. At the same time compatible extensions were added to restore the unity of the house. This process of renewal is due to the previous owner, Sir Ian Walker-Okeover. The estate is presently owned by Sir Ian's son, Sir Peter Walker-Okeover.

The delightful mansion is surrounded by meticulously maintained formal grounds, which in turn give way to unfenced rolling parkland sweeping down to the river, while above, well managed woodland helps to blend the parkland with the folds of the presiding hills. Everywhere an air of the detachment of bygone days pervades the scene. Here surely is the most beautiful and peaceful place along the whole River Dove.

At the main entrance to the Hall courtyard there is a fine wrought iron balustrade with magnificent entrance gates. These were the work of Robert Bakewell who carried out much work at Okeover, including the main staircase, between 1736-49. A son of Derby, he was an artist of unequalled skill and vivid expression. Many were his creations in Derbyshire during the period up to his death in 1750. The finest work of this brilliant craftsman is probably the sanctuary gates in Derby Cathedral.

In the shadow of the Hall stands the centuries old church of Okeover. Following "restoration" by Sir Gilbert Scott, this assumed a typical 19th century look. It is possible that the great architect would ride over the hills from Ilam to oversee the work. Surely many lovers of English ecclesiastical architecture would wish that he had stayed away! The actual work was carried out by William Evans of Adam Bede fame. Until the 1970s the family possessed a magnificent set of china comprising over 100 pieces, each piece proudly bearing the family's coat of arms. These were made in China for Leake Okeover who had the Georgian mansion built. This kind of service from China was a status symbol in eighteenth century England following the opening up of trade to the Far East. A drawing would have been sent to China with details of heraldry and a few years later the finished service would be returned by tea clipper. Still at Okeover is the original design together with the bill dated 1750, forwarded by the Captain of the clipper 'Prislowe'. It is sad that Sir Ian Walker-Okeover felt obliged to sell the majority of this magnificent china.

Blore Ray

High above the elegant terraces of Okeover Hall lies the bleak hamlet of Blore Ray, once home to the Bassett family. This parish is situated in the folds of the

Blore Ray: The pervading peace of a lonely church.

limestone declivity, with splendid views of the emerging Dove. The Church, though of Norman origin, dates mainly from the 15th century and is surmounted by a quaint squat 14th century tower, typical of this area. Inside, nine hundred years of social and ecclesiatical history are distilled in the pervading peace, the stillness of the ages. So many old village churches have been updated to confirm to the transitory and passing styles of the time. In recent times a simple stone interior reflects the national mood, yet prior to the Reformation worship would have been dominated by colour and ceremonial. Here can be seen the remains of the stoop from which worshippers would cross themselves on entry, the magnificent oak rood screen which separated the priest from the congregation and the narrow squint that enabled the Bassett family to witness the Elevation during Mass. The two decker pulpit is Jacobean, and represents a later change in the liturgy, when the Vicar would require the responses of the verger during reformed worship. During the late 16th century the Vicar was never sure of the theological loyalty of his congregation; in fact he was obliged to submit evidence that the state religion was being supported. These were difficult times for all. While the Bassets were to be seen at the service, they continued to practise Catholicism in the privacy of the nearby Hall.

Probably the most beautiful treasure to be seen is the 14th century glass in the south window of the Chancel. Here Our Lady is portrayed as a little girl being taught to read by her mother, St Ann. The colours of the English medieval glass are superbly rich but not garish. The soft pastel colours of her dress match the innocent beauty in her face. This is a magnificent portrayal, so typically English in its simplicity and sincerity. St Ann is a rare subject for devotion in

England, though for some mysterious reason the same theme is portrayed at nearby Norbury. The Bassett family lived in the moated medieval manor. This was until recently a farm, but now serves as a hotel. The principle monument to the family is the immense 17th century tomb erected to William Basset by his daughter, which has recently been restored. This Elizabeth was the last of the line; she left here on marriage to became chatelaine at Welbeck, where she became renowned for extravagant banquets.

Outside the Church can be seen the gravestone of one James Yates who according to this stone, had his priorities correct. The far off mason of this sincere memorial mis-spelt "loved" and then inserted a correction, a touching example of bucolic sincerity for ever vanished,

> *"Whose soul is with God*
> *Who in life time loved*
> *a gun, a dog and a fishing rod."*

Mayfield

Two miles below Okeover the river flows under historic Hanging Bridge and a southerly cross-Pennine route. Now over 500 years old, it started life as a packhorse bridge and about 300 years ago was widened to allow for the passage of carriages. Finally in the 1930s it was redressed for the motor age. It was here on the county boundary, that the condemned of both counties were brought for the ultimate punishment and subsequently display. The unconsecrated burial ground of these victims has recently been discovered by the river.

Hanging Bridge lies at the entrance to Mayfield, a group of communities which though of ancient origin, wear the dress of industry. Here lie the castellated outposts of "Cottonopolis", that great industry which came to the swift flowing Pennine rivers following the success of Richard Arkwright in harnessing the Derwent in 1770. At its peak the industry along the Derbyshire rivers vied with Lancashire. On the Dove, mills were erected at Mayfield, Rocester and Tutbury. At one time four mills were operating at Mayfield alone. The cotton mills with their familiar uniform red brick proportions, pierced by regimental ranks of windows, were not the only intrusion that allowed no compromise with the established fabric of the past The mill village itself remained an alien community, with terraces of brick cottages, and the typical three storey rows that allowed the facility of out-working.

The church of Mayfield is of Norman foundation, being originally attached to Tutbury Priory. The tower was added in 1515 by one Thomas Rolleston, a member of the minor squirearcy who became involved in the plots to release Mary Queen of Scots. He also owned the corn mill on the river here. The greatest attraction of the church is the superb Jacobean communion rail.

Also reflecting that period, there is fine wooden altar table which formerly served as a farmhouse table. In fact the depressions caused by constant resting of tired feet can still be seen on the stretchers below. The length of Hanging Bridge was necessitated by the river being divided into a mill race and a weir.

Thomas Moore at Mayfield

Between the years 1813-1817, Mayfield was the home of the wandering Irish poet, Thomas Moore. He was a close friend of Lord Byron, who encouraged him to move here. In these pastoral surrounds Moore wrote his great work, an oriental extravaganza, which proved a financial success. However a more widely known memorial to his emotional inspiration, was "Collection of Irish Songs and Melodies". Moore once wrote that the Irish never fought well on their native soil, but he might have added that they never portrayed the true emotion of Ireland when at home. It is difficult to appreciate that such lingering songs which convey the pathos of Ireland such as, "The Last Rose of Summer" and the "Minstrel Boy", were written here at Mayfield. Thomas Moore was appreciated by contemporary society and in fact was received at Chatsworth. Moore once wrote to Byron describing how his tempestuous spirit had found tranquillity; *"I have got a pretty stone built cottage in the fields, about a mile and a half mile from the sweetly situated town of Ashbourne ... the beautiful capabilities of which make it, I fear, a dear little spot to me. I could not possibly have a more rural and secluded corner to count the muses in".*

This idyllic life cruelly ended in the death of his little daughter, Olivia. What greater tragedy can overtake any family than the death of a child? In this depressed state, the omnipresent peace became too much to bear and Moore and his wife left for London, leaving their little girl lying in the churchyard. In his sadness he was able to contrast the beauty, joy and pathos of life, as he wrote these tragic lines written at the end of his days by the Dove:

> "Those evening bells! Those evening bells
> How many a tale their muses tell
> Of youth, and home, and that sweet time
> When last I heard their seething chime.
>
> Those joyous hours are passed away
> And many a heart that then was gay
> Within the tomb now darkly dwells
> And hears no more those evening bells
>
> And so't will be when I am gone
> That tuneful peal will still ring on
> While other bards shall walk these dells
> And sing your praise, sweet evening bells!

Ashbourne

The bells of this poem were Ashbourne, echoing as a soft rhythm on the wind across the pastures of the secretive valley. Though Ashbourne stands in view of Mayfield, it lies a mile away on the banks of the Henmore Brook, the fast-flowing tributary which collects a number of upland streams from the limestone plateau. This hinterland includes the great Carsington Resevoir and runs up to the edges of the Derwent gorges in the heart of the former lead mining areas.

Ashbourne is surely one of the most pleasant country towns of England, with some of the atmosphere of a frontier town. While it stands on the edge of the limestone massif, below lie the rich lowlands. Here the Midlands and the North meet in a town with the characteristics and traditions of both. The main street, which creeps along the base of rising ground, is a continuity of period buildings with the great church spire at its conclusion. Probably the oldest building is the Elizabethan Grammar School, but the whole street is dominated by meritorious though unpresuming Queen Ann and Georgian town houses. Above this street stands the attractive cobbled Market Place from which leads the steep road that crosses the "border" of the Peak and onwards to Buxton.

To Ashbourne in summer came Dr Johnson with the inevitable Boswell, to visit his old friend Dr Taylor at a large period house near the church. Here the eccentric but mentally active men would spend hours of relaxed conversation in the rear gardens which are so typical of Georgian town houses. On these visits Boswell was greatly impressed by the Green Man, the old coaching inn on the main street. He, forever a womanizer, was further impressed with the landlady, who must have been particularly attractive or able, since Johnson described Ashbourne as, *"The town with the worst ale in England"*!

The Entry of Bonnie Prince Charlie 1745

The town has seen the passage of Royalty, but strangely many of their visits seem to have been clouded with despair. Charles I came for a short stay when the course of the Civil War was flowing strongly against him. It is said that he attended Matins in church and afterwards talked in a relaxed and gracious way to the Vicar, not betraying the hopelessness of his cause.

A century later the town was entered by the Jacobite Army led by Prince Charles Edward Stuart. The main army, led by the Prince, crossed the White Peak from Buxton to Ashbourne. An impressive ceremony was held on 3rd December 1745 in the Market Place, to declare his father King James III, and himself as Regent. We have no reports of the Stuart entry to Ashbourne, which would have been a dramatic occasion. An account by the Town Clerk of Macclesfield however describes the entry into that town, which must have been similar, *"There was a profound silence among the townspeople and nothing was*

to be seen on the countenances of the bystanders but horror and amazement."

Problems in the resolution of the leadership were already beginning to surface. The Stuart army was principally composed of Scottish clansmen, who had been united in feudal loyalty to the Stuart King. In the invasion of England the Prince had been encouraged by the "Drinking Jacobites" of the north but the army had passed through Lancashire without any appreciable growth of support. It is probable that they had been previously wounded by loyalty to the House of Stuart. The Prince covertly decided on his own initiative to canvas the support of the local Jacobite and Catholic squires. A legend exists that from Ashbourne he visited the Batemans at Hartington Hall, a secretive visit with the Prince in disguise. Little did he realise that he was to spend much of the following year as a disguised fugitive within the Scottish Highlands.

The Prince stayed at Ashbourne Hall, of which truncated portions remain. After a few days break for rest and victuals, the army plodded wearily on; the colourful throng of zealots wandering through an alien land. The Prince, seeing the resolve of his officers weakening, again set out in secret in an effort to rally support. It is known that he visited Radbourne, where a meeting was held with the local Jacobite gentry, and the Meynells at Meynell Langley were probably also visited. Although George II had little moral support, the essential help did not arrive. The turning point had been reached. In a Council held in Derby it was decided to return to their native land. The Prince opposed the decision, but at a muster in Derby only four recruits enlisted; while not for the only time the French proved to be unreliable allies. The Derby Mercury described an army which had lost much of its glamour, though it was probably safer to write in such a disparaging way after the Scots had left the city; *"They were a crew of shabby, lousy, pitiful looking fellows mixed up with old men and boys, dressed in dirty plaids thrown over their shoulders. They appeared more like chimney sweeps than soldiers."* Within a short time the Highlanders were back at Ashbourne, but the tide had turned. Derby had been the end of a tragic story. The final battle the following year at Culloden would be the graveyard of most of those brave but badly led men.

Mayfield was paid unwelcome visits by the Jacobite army. To avoid the Georgian army, contingents came down the road from Leek, before rejoining the main contingent in Ashbourne. At Hanging Bridge the innkeeper, an unfortunate Mr Brown, refused to hand over his horse, for which he was immediately shot. On hearing of this and other outrages, the fearful villagers rushed for sanctuary in the church. The Highlanders gave pursuit to its very doors. Though of another faith, they were fearful of violating sanctuary, yet they fired their muskets through the west door - the holes remain to this day.

The Scots also ventured up the valley as far as Okeover. Due to the

rebuilding, Leake Okeover was away and the Vicar had been left in charge. In a letter to his master, the clergyman ruefully recorded how both the house and the church had been pillaged. Under threat of death all the staff, including himself had been robbed. The Vicar was especially sad because his silver tobacco box had been taken, while all the estate harness had been requisitioned. To be fair to the Stuart army, most of them were Highlanders to whom pillage and living off the land had been a traditional necessity.

St Oswald's Church

The views across the lower Henmore Valley are dominated by the magnificent 212ft spire of Ashbourne Church, which is known as the Pride of the Peak. It is surely one of the greatest architectural monuments in our land. This was acknowledged by George Eliot, who described it as *"The finest parish church in the Kingdom"*. While Boswell's description was, *"One of the largest and most voluminous churches that I have seen in any town of the same size"*. When viewed from the valley, the church with its great spire and attendant aisles looms like a great sailing ship lying at anchor.

This masterpiece is Early English, largely designed in its entirety. The consecration is recorded to have taken place in 1241. It is from this singular coherence that the soaring tower are balanced harmoniously by the nave and aisles. Inside one is confronted with the strange effect of the non-alignment of the nave with the chancel. This chancel is superb, being dominated by the vast Perpendicular east window; the whole effect is a poem in stone, glass and light. The magnificent east window, a gift of the Kniveton family, is a cascade of colour and light. The heraldry, which forms the upper panels, represents the

St Oswald's Ashbourne: Pride of the Peak.

noble families that were domiciled within the Honour of Tutbury. The dramatic effect of the chancel is to lessen the influence of the nave. High within the tower are hung the bells that so inspired Thomas Moore. They are rung from the central crossing with a very long draught. In full view of the congregation, they present a harrowing experience for the ringers. In former times as if to compensate for their conspicuous labours, tunics of office were worn when ringing for the services.

Penelope Boothby

In the North transept of St Oswald's lie monuments of the medieval Lords of the Manor. Amidst this war-like throng lies the tomb of Penelope, the daughter of Sir Brooke and Lady Suzanne Boothby. She was a beautiful little girl who had a remarkable personality and vitality. Yet like so many children in the late 18th century, she fell ill and died just before her 6th birthday. So great was their grief, it is said that the couple parted forever at her graveside. At her funeral, her pathetic little coffin was carried by six little girls and because of heavy rain, they were accompanied by six small boys holding umbrellas. What makes the death of this little girl so different? Surely, because her life, death and utimately her tomb, have inspired some of our most gifted artists.

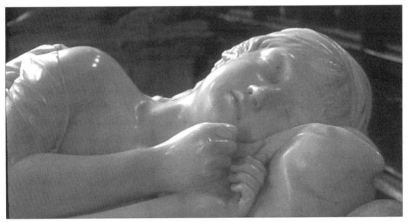

Penelope Boothby: Innocent beauty.

Her grieving father commissioned the sculptor Thomas Banks to create her memorial effigy. The result in white marble is a masterpiece. Here we see the little child lying in her final sleep. This is a superb portrayal of innocent beauty and a perfect monument to man's expressive interpretation of love and beauty. More than the depiction of form, the effigy radiates a beauty that dwells both in life and tragedy. In 1791 that great master of words, Edmund Burke, wrote her epitaph, the dreadful final lines of which added to the pathos, *"She was in form and intellect most exquisite. The unfortunate parents ventured all*

on this frail bark and the wreck was total".

On her 4th birthday Sir Johua Reynolds, who was a family friend, painted her portrait. She was in the habit of playing in his studio. A touching friendship had grown up between them, as the great man, in advancing years and with failing eyesight, drew life and inspiration from his little companion. In this portrait, Reynolds poured out all his love for beauty and life, yet it has a lingering suggestion of grief. In fact, this portrayal of his little friend was to be his last work. The enchanting painting is known to millions as the "Mob Cap". Penelope is seen wearing her grandmother's mob cap and gloves. The cruel irony was that shortly after his death, the little girl herself was struck down. The painting hung for many years in the family home, Ashbourne Hall.

The sculptor Francis Chantrey, possibly while staying at Ilam, visited the tomb. This gave him the inspiration for his famous tomb in Lichfield Cathedral, the Sleeping Children. That monument is of the two children of a cathedral clergyman who were killed by fire in 1812. The work is a masterpiece and takes as its dedication the assurance that they lie in beauty within the Kingdom of God. It is said that Chantrey later visited Lichfield every year for the rest of his life. This is without doubt a masterpiece and one of his greatest works, though, in direct comparison with Penelope, the Lichfield figures are heavier and more lugubrious. By a strange coincidence the glass in the Lady Chapel at Lichfield is 16th century and originally came from a Belgian abbey. It was rescued from the ravages of Napoleon and presented to the cathedral by the same Sir Brooke Boothby, by then a travelling man.

Fuseli, a powerful and dramatic artist, was also inspired to portray Penelope posthumously. His painting gave great solace to her father, as it showed the little girl secure in the arms of an angel. Sir John Millais, after visiting the tomb, found an echo of her charm in another little girl, whom he had met dressed in similar fashion. The result is his painting "Cherry Ripe".

In the early 19th century, when Ashbourne was a coaching centre of repute, the monument became something of a tourist attraction. On one occasion Prince Leopold of Saxe-Coburg, on alighting from his coach, asked of places of interest in the town. On being told of the tomb, he turned away in tears with the words, *"No! I have suffered too much already"*. The Prince had recently lost both his beloved wife Princess Charlotte (heir to George 1V) and child in childbirth. This was a rare love marriage for Georgian royalty. His grief persisted for many years; though he eventually left these shores to become King of Belgium, while a kinsman married Queen Victoria.

Is there some strange power in the memory of this little girl? Or is there some alchemy in that portrayal in white marble? Perhaps she arouses the beauty and pathos that lies in men's hearts? The mystery remains!

The Soldier Poet of Ashbourne

Another artistic association with Ashbourne comes from the sorrowing England of the Great War. All the grief of that time can be epitomized in the death, following wounds at Vimy Ridge, of the Vicar's son, Francis St Vincent Morris. He was a young man of deep sensitivity, faith and bravery, who anticipated the ultimate sacrifice. Before his own experience in the massacre, he wrote of his agonizing decision before enlisting. How could he remain while others gave so much? In these lines, he described the dilemma that had faced so many;

> "Is this to live? to cower and stand aside
> While others fight and perish day by day
> To see my loved ones slaughtered, and to say
> Bravo! Bravo! how nobly you have died!
>
> Is this to love? to heed my friends no more,
> But watch them perish in a helping hand
> Unheeded, and give no helping hand
> But smile, and say, how terrible is war!

Royal Shrovetide Football

One of the foremost traditions of Ashbourne is the Shrovetide Football., a relic of the pre-Lenten festivities of the pre-reformation times. The game bears the Royal prefix following the visit of the Prince of Wales in 1928, when he performed the opening ceremony. The wild event is played on Shrove Tuesday and Ash Wednesday between rival townspeople, traditionally known as the Upwards and the Downwards. The qualification depending on the particular side of the Henmore Brook to which one is native. Each day's proceedings commence with lunch at the Green Man Hotel, after which the starter is lifted high and the ball is "turned up", to be received by the assembled throng. The game proceeds as a vast melee throughout the whole town.

The goals were originally the wheels of the water mills at Clifton and Sturton, but now defined locations of these mills have to suffice. Being three miles apart, and considering the great mass of players, goals are rare events. In fact only in 1936 have four goals been scored by the same side, though in three consecutive years (1989-1991), three goals were scored each year. This paucity can easily be understood because most of the game is spent in a great unorganized scrummage called a Hug. In this, only the fittest can survive. To see the ball is a rare event: to hold the ball is the basis of reputations! As the Henmore is the traditional boundary between the two factions, much of the time is spent with the antagonists up to their waists in the brook. It must be remembered that the weather can be severe; frequently the Henmore carries water from the freezing Pennine hills or the banks of the brook are covered with snow. Even if the ball is free, it is rarely kicked. Many means have been used to

Courtesy of Ashbourne News Telegraph

In the hug: Ashbourne Shrovetide football.

carry the ball towards the goal, though transport by motor vehicle is specifically forbidden. From time to time the ball enters the buildings that line the main street. It is not unusual for the ball to be delivered through an upstairs window to the mob below.

To withstand such heavy treatment a special ball is essential. The ball is made out of shoulder leather filled with cork shavings rammed in with a crowbar and finally hand sewn and brightly painted. One of the sights of Ashbourne at Shrovetide are the boarded up shop frontages. It is a tribute to the wild young men and their following girls that there is no attendant disorder. Wisely, a protection society has to be ever vigilant in order to maintain this great tradition, and to secure its future. In fact in 1891 the Police ordered that the game would not be played. Tradition was not so easily defeated, for a woman named Mrs Woolley had other ideas. She had previously hidden the ball under her skirt, from where she produced it to throw into the frustrated crowd.

Traditional Fare

While the Shrovetide Football adds life to the local scene, the distinctive Ashbourne Gingerbreads. are another manifestation of strong tradition. It is maintained that the recipes have a French influence, dating back to the time of the Napoleonic Wars when French officers were housed in the town. Due to its isolation, a liberal form of parole was employed, with the officers being placed on trust, to wander beyond the town until evening. Then upon the ringing the curfew bell they returned, as honourable men, to town.

CHAPTER 6
THROUGH LOAMSHIRE TO STONEYSHIRE

Below Mayfield the Secret Valley continues unobtrusively through small meadows and pastures. Along this peaceful way the only sounds are the calls from grazing cows and sheep; the only habitations being mixed stone and brick built cottages, or small farms that cling to the rising hillside. Through this valley the Dove flows as a secretive stream of sparkling shallows festooned with water crowsfoot, which in turn flow into a dark and still pools.

Calwich Abbey

In the midst of these peaceful reaches lies Calwich, a place very typically English. The story begins with the early days of the Normans when Nicholas FitzNigel founded a monastery for a community of Augustine Canons, whose existence was recorded in 1148. Like many other rural religious houses the basis of its existence was self sufficiency. In this fertile valley they were richly blessed. A sheltered south-facing location, with fertile soil, would yield richly the fruits of their labours. Fish, that requirement of any monastery could be caught in the rich fisheries of the Dove and kept in a series of pools until required for the refectory. Evidence of these pools can still be seen as low depressions in the ground near the river. The Augustines, or Black Canons as they were known on account of their habit, forever retained the affection of the people. This was due to their continual rejection of wealth and influence, combined with adherence to their devotion and ministry. The dearth of information from these centuries indicates a reign of peace and confidence that remained uninterrupted.

These centuries of security were destined to end at the hands of Henry VIII. The abbey buildings and lands were obtained by John Fleeetwood who came from Lancashire. It is recorded that shortly after the Dissolution he was using the chancel as the parlour, the nave as the hall and the steeple as a kitchen. His son, Richard, had the dubious distinction of marrying a girl of six, and later burying their first born before his poor wife had achieved the age of thirteen. In the eighteenth century the estate became the property of Bernard Granville who demolished the old abbey to build a new mansion. He spent his energies on the house and particularly the great landscaping of the grounds. As a result Calwich became known as the most picturesque place in Staffordshire. Much of the present glorious landscape originates from this period. Below Calwich lies a enchanting lake the edges of which reflect the cascading foliage of the trees that

so effectively clothe the banks. At the end of the lake stands the Fishing Temple, a superb example of grandeur in a Georgian landscape. The finely proportioned structure is surmounted by a graceful dome crowned by a weather vane. The front of the building is magnificently Palladian, reached by two gentle bridges that cross the divided stream. The temple was dedicated in 1797 to the delights of both music and fishing on the Dove. At the far end of the lake lies a gently humped bridge so typical of that period. From here one can commune with the narcotic beauty and tranquillity of this man-made landscape.

Though Granville had the reputation as a rather cold and austere bachelor, his house became famous for the hospitality extended to the cultural giants of the time. So regularly did Handel stay at Calwich that he designed an organ for the house on which he composed several works. It is held that he actually finished the Messiah here before its first performance in Dublin. It must be wondered whether his Germanic formality became softened by the beauty and tranquillity of this glorious scenery. During his enforced exile at Wootton, Jean Jacques Rousseau frequently visited Calwich because Granville was the only person in the area able to speak French.

In Victorian times the estate was sold to the Duncombe family. The house through which the voices of the gifted had echoed, was demolished in 1848 to allow a new house to be built in the Jacobean style. This house was largely demolished in 1928, though parts remain as a crumbling shell, its prominent gables pierced by gaping windows. The Duncombe family became noted as

The Last Redoubt: The Shire Horse at Ashbourne Show.

breeders and exponents of the shire horse, a speciality of this area. During the latter development of the shire horse much competition came from other breeders, but the stud at Calwich remained paramount. The Ashbourne Shire Horse Show continues as the last great exposition of these power houses of yesterday's farming.

The Hayslope of Adam Bede

Below Calwich, clustering upon a knoll above the river, lies Ellastone, a village of stone cottages and previously well tended gardens. The church despite its medieval origins has a Victorian face, resulting from another all too thorough restoration of 1883. Around the village lie larger farms, their deep roots secure in the rich pasturages and lineage of this green and pleasant valley.

Ellastone and the valley of former years remain for ever recorded as the setting of Adam Bede in the great novel by George Eliot. This was the "nom de plume" of the novelist, Mary Ann Evans, 1819-80. She was the daughter of Robert Evans, who came from a family of carpenters and wheelwrights at Roston, a hamlet across the river. Her father sang in the choir at Norbury Church, while the altar in the north aisle is said to have been made by him. Her father was born in 1773 in a cottage on Roston Common. This now survives as the home of a business man. Writing in his "Highways and Byeways of Derbyshire", J.B.Firth records visiting the cottage to meet an old blind lady who remembered the Evans', but she could not understand why people were asking after one Adam Bede. Robert Evans left his native land and his daughter spent most of her life in Warwickshire. She won great acclaim for her writing, which was rather surprising for that time considering her co-habitation with a married man. It was only her literary talent that enabled her to bathe in the warmth of success and acceptance.

Adam Bede is essentially a love story set against the background of the Methodist Revival in the Dove Valley. Shining from the pages are cameos of the everyday world of the villagers. The slow progression of their daily lives was exemplified by the methodical tick of the church clock and the narrow confines of their workaday lives. Her vivid description of the congregation in church recall these forgotten people, *"Hardy old men, with bent knees and shoulders perhaps, but with all the vigour left for much hedge clipping and thatching; the tall, stalwart frames and roughly cut bronzed faces of the stone cutters and carpenters; or the half dozen well to do farmers, with their apple cheeked families; and the old women, mostly farm labourers wives, with their bit of snow white cap border under their black bonnets, and with their withered arms bare from the elbow, folded passively over their chests. For none of the old people held prayer books, why should they? Not one of them could read!"*

The characters in the plot are generally believed to be drawn from living figures. Adam Bede is accepted to be a characterization of her father. Throughout her childhood the author would have heard her father describe characters and scenes of his youth, with the clarity and confidence of the countryman. Her Uncle, Samuel Evans, was portrayed as Seth. The heroine, Dinah Morris, was also factual being the portrayal of Samuel's wife, Elizabeth. She was an evangelist with a wonderful interpretation of life and an exquisite compassion for the wayward and fallen.

The Tragic Tale of Hetty Sorrel

Elizabeth came to preach at Ashbourne in 1802. There she met Samuel, who had walked over the fields to hear her sermon. They later fell in love and married. In Adam Bede the early Methodists' antipathy to expedience and materialism seem strange in our compromising age. Few can now imagine the scorn and prejudice that were the wages of their zeal. The tragic fate of poor Hetty Sorrel for killing her baby, secretly sired by the heir to Calwich, is similarly factual. During Elizabeth's ministry in Nottingham she stayed in the condemned cell with one Mary Voce, who had been sentenced to death for poisoning her illegitimate baby. She brought solace to this wretched girl until the very end, in fact riding with her in the hangman's cart. Today we cannot appreciate the despair that afflicted these tormented girls. Elizabeth Evans later ministered in Tutbury amongst the mill workers who had become detached from institutional religion and were showing signs of moral decay. The chapel which resulted from her vigilant ministry still remains open in that town. Sadly, lady preachers were treated with disfavour; in fact she eventually found the chapel closed to her. Undaunted she continued her ministry in barns, cottages and at the very gates of the mill. The ecclesiastical historian, Rev Norman Edwards remarked, *"How little did Tutbury know that a great evangelist was in their midst. How soon the memory of her work has been forgotten."*

The Meeting of Loamshire with Stoneyshire

There are still scenes today that are recognizable from the descriptive prose of George Eliot, though the factual locations are shrouded by a series of pseudonyms. Ellastone is Hayslope; Ashbourne is Oakbourne; Norbury becomes Norbourne; Calwich is Donnithorne; while the Weaver Hills are the Binton Hills. It may be assumed that Derbyshire is Stoneyshire, while Staffordshire becomes Loamshire; however the writer suggests that George Eliot was referring to the two conflicting worlds that meet on these banks. The rich tranquillity of the fertile bowl below the hills, where the Secret Valley widens to become the great Vale, certainly is Loamshire. How softly this

landscape contrasts with the last ramparts of the Pennine Hills that lie above. The defensive barrier of the hills, open and pockmarked with stunted thorns, form the northern boundary of this Land of the Dove. This high land is for ever Stoneyshire. Here we have Eliot's description of how Loamshire meets Stoneyshire at Ellastone; thankfully some things never change!

"The broken line of thatched cottages (now gone) was continued to the church yard gate; but on the opposite, north western side, there was nothing to obstruct the view of the gently swelling meadow, the wooded valley, and dark masses of the distant hills. The rich undulating district of Loamshire to which Hayslope belonged lies close to a grim outskirts of Stoneyshire, overlooked by its barren hills as a pretty, blooming sister may sometimes be seen linked in the arm of a rugged, tall, swarthy brother; and in two or three hours ride the traveller might exchange a bleak, tree less region intersected by lines of cold grey stone. It was just such a picture as this last that Hayslope church had made to the traveller as he began to mount the gentle slope leading to its pleasant uplands, and now from his station near the green he had before him in one view, nearly all the other typical features of this pleasant land. High up against the horizon were the huge conical masses of hill, like giant mounds intended to fortify this region of corn and grass against the keen and hungry winds of the north; not distant enough to be clothed in purple mystery, but with sombre greenish sides visibly speckled by sheep...... And directly below them the eye rested on a more advanced line of hanging woods, divided by bright patches of pasture or furrowed crops..... Then came the valley, where the woods grew thicker, as if they had rolled down and hurried together from the patches left smooth on the slope that might take the better care of the tall mansion which lifted its parapets and sent its faint blue summer smoke among them. (Calwich Abbey). Doubtless there was a large sweep of park and a broad glassy lake in front of that mansion, but the swelling slope of meadow would not let our traveller see them from the village green. He saw instead a foreground which was just as lovely; the level sunlight lying like transparent gold among the gently curving stems of the feathered grass and the tall red sorrel, and the white umbels of the hemlocks lining the bushy hedgerows. It was that moment in summer when the sound of the scythe being whetted makes us cast more lingering looks at the flower sprinkled tresses of the meadows".

Stoneyshire

As the ground rises on entering Stoneyshire, the walled enclosures in turn are replaced by the brown open slopes of the hills. These hills, have their climax in the presiding mass of the Weaver Hills. This is the last glorious stand of the Pennines. The profile rises and falls with all the beauty of female form, as one

looks out from these exalted heights. The whole landscape below lies subordinate to these hills, apparently content to lie in their bondage. The hillsides are intersected by penetrating dry wooded valleys that reveal singing crystal streams and sunken lanes, the steep banks of which support a colourful profusion of forget-me-not, stitchwort, herb robert and primrose. On the damp acid upland pastures large collections of orchids thrived until so called agricultural "improvement" decreed their destruction. Where now are those "sprinkled tresses of the meadows"?

None is more typical of the bare hamlets on the flanks of these foothills than Stanton, a stark simple collection of gritstone cottages. As one climbs the sunken lane, one's first glimpse of the village is dominated by the large cross which serves as the War Memorial, a scene rather reminiscent of rural Ireland. The Church, austerely Victorian, has a distinction in the custom of men and women receiving Holy Communion separately. A similar community, on a high perch below the Weaver Hills, is Wootton. This is a hamlet of mellow sandstone with low elongated roofs, attractive gable ends and mullioned windows.

As the hills fall away, so ends the Symphony of the Pennines: not faintly, but abruptly in a triumphant crescendo! Below one's feet lie peace and silence. This is the silence of the peaceful pastures of Loamshire, with contented cows edging through deep lush pastures. Yet still the rhythm of the hills percolates the pastoral serenity down to very banks of the river. We hear the falling strings, yet their petering chords become the first bars of a gathering new symphony. Beyond lies the magnificent Vale of Dove. This land of Loamshire is a feast of English beauty; the beauty that is composed of an accumulation of so many beautiful little things.

Jean Jacques Rousseau

Wootton Hall, now demolished, was a mansion in the style of the Italian Renaissance, overlooking a deep and wildly romantic valley. A former house, the seat of the Davenport family, was for a time the refuge of Jean Jacques Rousseau. This undoubted genius was born in 1712. Although possessed of an advanced intellect, he displayed such contrasts of mood and eccentricities as to be considered unbalanced. So greatly did the flame of genius burn that his reason became detached from reality, and he finally died in 1778, completely insane. As the basis of a just society his social theories were years ahead of their time. Such views led to his exile from France and to his sojourn at Wootton. He was generous in his advice to all, but never followed it himself. He wrote of nature, but preferred the city. He preached virtue, yet himself was a boundless lecher. He railed against the aristocracy, yet continually enjoyed their patronage.

Here he was lonely and unable to converse with the simple rural inhabitants, who regarded the wild figure as mad. During his visits to Calwich

the morally dubious man showed a flattering affection for Granville's niece, whom he called "Little Shepherdess of Calwich". This led to a rift in the house as the girl's mother, herself a writer of some repute, found Rousseau's presence and influence undesirable. At Wootton during one bleak winter, he wrote his famous *Confessions*. For a long time these were more regarded for sensuality than for literary merit. In this book he records his debaucheries and escapades with Paris harlots whom he patronized, along with Dr Johnson's later companion Boswell. One wonders whether these former leching companions met here in their later years. Another example of his decaying mind was a series of bitter letters he wrote at Wootton, which exuded scurrilous abuse against the very man who had secured his exile. On a higher plane, he wrote here the *Letters of Botany*. He was a competent botanist, who collected much information in the surrounding countryside. On these plant hunting missions that the rustics would meet the wild eyed figure, flamboyantly dressed in flowing black gowns and speaking only French, and he soon became a local figure of fear and suspicion. However he loved the rural delights and wild beauty of the area. He once wrote, *"I would rather live in a rabbit's hole here than the finest rooms of London"*. While he found solace at Wootton, he took no comfort from his fellow mortals, whom he suspected of treachery. It was his obsession with being poisoned that finally drove him away; the fires of his fears stoked by his housekeeper who saw her way of leaving these desolate hills.

Wootton Lodge

Further to the west, lost in a sylvan girt craggy dale lies Wootton Lodge. This magnificent 16th century pile was designed by the great Inigo Jones for Sir John Fleetwood of Calwich. The Fleetwoods were to be severely penalised for their retention of Catholicism and loyalty to Charles I. It was the boast of Sir John that the mansion would also serve as an impregnable fortress. Fate was soon destined to test this boast, though death saved Sir John from final humiliation. As a staunch supporter of Charles I he had fortified the house for the royal cause. The Parliamentary army positioned a battery across the ravine at Alton and after a two days siege and bombardment the house was surrendered. After which Sir Richard Fleetwood and the garrison of 70 were roped together and marched away to Derby for imprisonment.

Over the main entrance of the house is carved the Red Hand of Ulster. This indicates that Sir John was one of that initial creation of baronets, raised in recognition of their contribution towards the raising of James I's Ulster Army. James I was a parsimonious monarch who, as King of Scotland, had raised a similar Baronetage to finance the colonization of Nova Scotia.

Wootton Lodge must surely be one of the most impressive mansions in the land. The tall commanding lines are climaxed by the minaret like chimneys,

which rise above the wooded ravine and rushing waters. The house is now fortunate in having been completely restored by Mr J.C. Bamford, the head of the local family of industrialists. It now awaits a further restoration in which the original integrity of the 17th century will be reinstated. The embellishment of the woods, lakes and estate have been so complete that the scale of the works would have rivalled the great landscape creations of previous centuries. This surely is Bamford land!

The dry foothills and valley below Wootton Lodge have sporadically been worked for copper; some of the gaping galleries may be found below the Lodge. It is recorded that in the 18th century Ellastone was a centre for the smelting of the metal along the River Dove.

To Ashbourne by Train

Through this delightful valley the North Staffordshire Railway in 1852 drove their branch line to Ashbourne from Rocester where it joined the Churnet Valley line. The single track was for ever a rural line. A visitor in 1911 reported, *"On market days the compartments were filled with passengers averaging three large baskets of eggs, butter and live fowls"*. The last passengers were carried in 1954 while the line finally fell to the Beeching Axe in the 1964. Shortly before that it had the distinction of having the first continental style crossing installed in Britain, near Rocester. The sponsored guide, "Picturesque Staffordshire", published in 1908, dismissed the natural and historic charms of Norbury, to describe at length the newly constructed iron bridge over the river. The thunder of trains crossing this great structure caused such noise as to disturb services in the adjacent church. The bridge had to be built to handle the increased traffic on the line which followed the extension of the railway beyond Ashbourne to Buxton at the zenith of the Railway Age.

Today the line lies forgotten. The iron superstructure has been removed and now the waters divide nonchalantly between the stone piers. The railway embankment is being won back by nature, as her front line troops encroach the once sterile way. For a length the line ran adjacent to the river, where an embankment now supports a plantation of trees in maturity. This example of early landscape modelling was constructed to screen the railway from the state rooms of Calwich Abbey. In maturity it is a delightful anachronism, living long after the demise of the railway engineers who created it. The station that once proudly proclaimed the name Norbury and Ellastone has become a private home while the railway has become its garden.

A Return to the River

Below the presiding line of the Weaver Hills, the Dove retains some of the exuberance of a mountain river as she continues her journey. At no time is the

joy more overwhelmingly expressed than in the fullness of spring when the exuberance of bird song reverberates over the waters. Daisies and buttercups start to intermingle with the new deep grass in which meadow saxifrage extends its gentle head and fragrance. By the river starry masses of ramsons and the upright smokey-headed butterbur fill the air with their musky smell. Yet as the sunlit days of summer, with their trailing masses of water crowsfoot, progress like an enfolding poem into autumn, the beautiful face of the Dove is transformed into a kaleidoscope of projected colour. From the wooded banks the yellow golds of wych elm, the deep bronze of the oak and the flickering cascade of beech filter the long mellow sunbeams that kiss the passing current. From the ancient stone bridge that links the complementary villages of Norbury and Ellastone, one may reflect upon the great panorama of beauty and peace. If Ellastone belongs to Stoneyshire, the roots of Norbury lie deep in Loamshire. Centuries of conflicts and intrusions have touched these roots, inevitably to recede, neutralized ignominiously by the forces of ordered time.

Norbury and its Church

Norbury remains as John Gisborne portrayed it in his "Vales of Weaver".

> *"Sweet Norbury, decked with rural smiles,*
> *Glems faintly through these sylvan aisles;*
> *Mid Gothic grandeur soar serene*
> *O'er bold varieties of scene."*

All the peace and beauty of those rural smiles and sylvan aisles find a fitting epitome in Norbury's finest glory, her church of St Mary and St Barlok. The latter was a Celtic saint, whose connection with the area is a mystery. Despite their squat towers and low profiles, Derbyshire has a rich heritage of rural churches and Norbury stands out as one of the finest. Though the church possesses two carved remains of Saxon crosses, the first record of the church is in the Domesday Book under the tutelage of Tutbury Priory. In 1125 the patronage was transferred to the Fitzherbert family and for the following four centuries its history was dominated and enriched by that family.

Inside, the contrasts are overwhelming; the simple though attractive nave is outshone by the vast chancel, the gift of Henry Kniveton, who was priest here between 1349-1395. The same family had been responsible for the east window at Ashbourne. The striking dominance of this chancel results from eight vast windows which are in turn subservient to the great east window. So brilliant is the illumination from the windows that the result has been described as "a lantern in stone". The side windows are filled with much of their original glass displaying an unusual series of heraldic devices. Now almost opaque, this priceless heritage fills the vast chambers below with an unreal and mysterious

light. The glass in the east window fell into terminal decay during the 18th century and was replaced with 15th century glass from other parts of the Church. This glass was thoroughly and expertly restored in the 1970s. The renewed effect is a glorious soft presentation of heraldry and figures, which contrasts with the side windows that await restoration. In a south aisle window, is found St Ann teaching Our Lady in her infancy to read, though this portrayal is not as beautiful as that at Blore.

The Fitzherbert Tombs

In the unreal light of the chancel lie two masterpieces from medieval England. On the south side lies Nicholas, the 11th Lord of Norbury Manor. He is seen in plate armour, his bare hands resting on his helmet surmounted by a gauntleted hand, this being the family crest. Around his neck hangs a collar of suns and roses, with a pendant lion. This is an authentic sign of his support of Edward IV in the Wars of the Roses. His face faithfully portrays his family features; a finely formed nose, high delicate cheek bones and a finely pointed chin. Portrayed in his final sleep, he lies with a suggestion of a smile on his face, his lips pursed in serenity. He lies alone, having been twice bereaved.

Nicholas Fitzherbert's Tomb: Detail of his children.

The side panels of his tomb represent the eight sons and five daughters of his marriages. These figures, meticulously executed, portray their various vocations in life. We find priests, soldiers, maidens, nuns and twins, while on the end panel are to be found the figures of Alice and Isobel, his wives.

The tomb of Ralph with his wife Elizabeth lies across the chancel. It similarly bears witness to the turbulence of the Wars of the Roses, for around his neck is to be seen a boar pendant, indicating support for Richard III. His feet rest on a lion, but beneath one sole crouches the tiny figure of a bedesman in the form of a little monk holding the rosary. On the face of Ralph one finds the same family characteristics, though his features portray a man of care worn years. In the portrayal of his wife Elizabeth, we find a lady

of dainty and modest proportions, lying with her hands clasped in prayer and demonstrating her devotion to Our Lady by wearing a medallion showing the Virgin and Child. Her figure is clothed in a superbly executed flowing gown and head dress, a fine example of the dress of the period. As we gaze on the

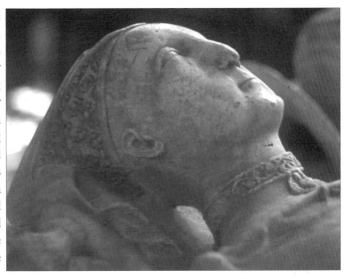

Elizabeth Fitzherbert: Beauty portrayed in stone.

serene beauty of Elizabeth, we can feel the warmth of her personality radiating from across the centuries. The side panels similarly portray the large family of eight daughters, seven sons and twins that she bore her husband.

Execution of the Tombs

The tombs were carved from white alabaster, a responsive medium which allows the artist to give the fullest expression. The stone came from either Fauld or Chellaston. Though the Fauld mines had for long produced excellent stone for the greatest contemporary artists, the writer contends that the transluscent creamy nature here is indicative of Chellaston. The stone has an almost living quality, being so transluscent that light appears to be drawn from within the figures. The artist certainly came from the Burton-on-Trent Alabaster School. Notable leaders of that period were Robert Bocher and Gilbert Twyste and it is possible that one of them was the sculptor.

The Decline of the House of Fitzherbert

The magnificence of the Norbury Tombs reflects an English feudal family at the zenith of their influence and power. The Wars of the Roses raged but they remained secure during the the reign of Edward IV. This dazzling monarch invariably rose to lead his troops with bravery and skill. When Nicholas Fitzherbert died in 1473 the ascendancy of the House of York seemed assured. It is suggested that both tombs are contemporary as they display many similarities. They were probably commissioned after Ralph's death in 1483 by his son, John Fitzherbert, and boldly display the loyalty of the Fitzherberts to

the Yorkist cause. Following the sudden death, some said from debauchery, of the Warrior King, the future of the Yorkist Cause still appeared secure in the person of Richard III. The House of Fitzherbert proudly displayed its loyalty. How mistaken are the plans of mortal men! Within two years, this confidence had fallen on the Field of Bosworth.

Sir Ralph was initially succeeded by his son John, who wrote books on agriculture. However on his early death, Sir Anthony succeeded as Lord of the Manor. He was a judge of renown, whose influence grew at Court in the wake of Cardinal Wolseley. With the fall of Wolseley his influence faded accordingly. He is recorded on a brass monument that lies in the centre of the chancel floor, with his second wife Maud and some of their family, though sadly portions are missing. The brass is very interesting because it is a palimpsest - a brass used previously on the reverse side. Part was used earlier as a memorial to Matilda de Verdun in 1316 at Croxden Abbey, while the other part came from nearby Calwich. These Abbeys were dissolved during the last year of his life in 1538, a development he would have deplored but dare not resist. The tide of events was now turning strongly against the Fitzherberts and their beliefs.

The Treacherous Fall of the Fitzherberts

In the church there is no successor to the memorial of Sir Anthony. His heir, Sir Thomas, remained a staunch adherent to the Catholic faith. He refused to accept the state religion and was imprisoned during the persecutions of Elizabeth I. While he was incarcerated, his brother John managed the estate, and he had an ambitious and corrupt son Thomas, who saw in the betrayal of the family and the Faith the means of securing an inheritance. Sir Thomas had married Anne Eyre of Padley in north Derbyshire, who brought her estate into the family. The Eyre family were also resolute in defending the faith of their fathers, using Padley both as a centre for performing Mass and as a hiding place for priests.

The treacherous young Thomas informed the authorities that Padley Manor was being used as a Catholic refuge. The house was raided on the 12th July 1588, when two priests were found in a hiding place and were arrested by the Earl of Shrewsbury. Fathers Nicholas Garlick and Robert Ludlum were later martyred with much cruelty on St Mary's Bridge in Derby. Thomas's father, John, was reprieved on payment of a ransom, but like his brother languished in prison for many years until ultimate release in death.

Sir Thomas had been imprisoned for 30 years for the Faith, dying in the Tower of London in 1591. The treacherous nephew Thomas had promised to one Topcliffe, a professional priest catcher and agent provocateur, £3,000, if all were sentenced to death. He later claimed that his father and uncle had both died of 'natural causes',and refused to pay. A bitter and protracted dispute arose, and Elizabeth I realized that these dreadful deeds had been carried out in her

name,and, as the final affront to the family, gave the Fitzherbert estates to Topcliffe. Though the estate was restored to the family after the death of the Queen, the family continued to suffer confiscations for their faith. The family had little further connection with Norbury, although the last possession was not sold until 1881. The family has continued with its branches at Tissington, Somersal Herbert and Swynnerton. The present head of the family is Lord Stafford of Swynnerton Hall.

Norbury Manor

Outside the Church, one is aware of a sense of peace that transcends the ages and puts the insignificant span of human life into its true perspective. Many features remain that the Fitzherberts knew; the spreading yew tree, which predates the church, and the old manor, which to them was home. For long derelict, the fine 14th century remains, including the great hall, undercroft and fine roof, were thoroughly restored in the 1970s. Today they are administered by the National Trust but, open to the public by appointment. Adjoining these medieval remains is a fine Charles II house in red brick with an attractive high-pitched roof that supports quaint dormer windows.

A later hall was built towards the end of the Victorian age by the Clowes family. It stood on an eminence and overlooked the Dove to the west. Like many other local mansions it was demolished in the 1950s though the family still retain the estate, which remains managed to a very high standard. The foot bridges over the road are the original points of access between sections of the Victorian gardens of the mansion.

Norbury: Attractive late Stuart manor.

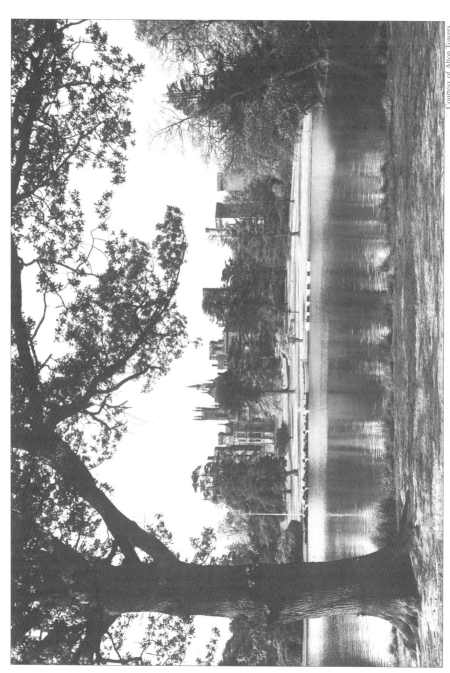

Alton Towers: Gothic perfection.

CHAPTER 7
ALONG THE RIVER CHURNET TO PUGIN LAND

As the secret valley of the Dove opens out into the wide Vale, a promontory of the lingering hills surges down to shield the approaching River Churnet. On this profile lies the Doveleys Estate, a multi-gabled Victorian mansion set in parkland, although now a hotel complex is planned. Through the later decades of the last century this estate was owned by Sir Percival Heywood.

Sir Thomas Percival Heywood

Sir Percival, who came from a banking family, was a landowner with many and varied interests. Fortunately his fertile brain was matched by ample financial resources to develop his varied interests. If he had been able to write his own obituary, it is likely that he would have placed the advancement of the Established Church as his priority. In 1873 he secured the establishment of Denstone College through the Woodard Foundation. The school has continued to provide an Anglican education since that time, especially to the sons of the clergy and others of more modest means, though girls are now admitted. In 1862, he underwrote the building of Denstone Church and further endowed the living of the parish. The Church of All Saints was designed by the famous G. Street and is considered a masterpiece of his work. It contains the vast, apsidal chancel that so typifies his concept of presenting the liturgy. Inside one may allow him credit for the simplicity that pervades his concept of Gothic simulation. The interior contains some fine stone work, especially by the adornment with Ashford Black Marble, a fine Derbyshire stone now unobtainable.

In the secular field, Sir Percival had other interests. He was dedicated to the advancement of the narrow gauge railway, which medium he saw as a desirable commercial and social enterprise. His concept was not to compete with the standard gauge system; but to supplement it in situations where a large scale operation would not be economical. He built a narrow gauge system on his Derbyshire estate at Duffield, which he developed as a promotional exercise.

If the development of railway engineering was considered an unusual occupation for a Victorian landowner, the promotion of campanology was bizarre. In those times change ringing on church bells, despite the high degree of mental discipline required, had become tainted with a stigma of disreputability. The discipline, before the reforms of the Oxford Movement reached the belfry, had become associated with beer swilling rustics or urban rakes. Despite his sophisticated background, Sir Percival was fascinated by the sound of church bells and engrossed by the composition of complex

permutations. His compositions are still well known amongst the current exponents of that art. The church tower at Duffield exhibits boards that record his compositions, particularly in the Stedman Method, which was originally discovered in 1680 by one Fabian Stedman whose family had their origins at Corve Dale in Shropshire.

The Churnet Gorge

To the west of the Weaver Hills the great curtain walls of the Pennines continue through Ipstones Edge and the Morridge, wild and dramatic ramparts of the Pennines. Below these dark frontiers lies a convulsion of new red sandstone foothills through which rushing streams have created craggy rock formations, heavily clothed with woodland. These are the rocks of the Triassic and Permian Ages which contain alternative bands of soft and hard rock with enclosed pebble beds. Through this land flows the fitful Churnet, its course delineating the outer territory of the Pennines.

The Churnet has incised a wild and furious gorge which runs for over 20 miles above Denstone. The finest days here are when the autumn sunlight lingers. Then due to the dry rocks and low fertility, the cascading woodland erupts into an indescribable galaxy of colour. Running into the main valley are a series of tributary valleys from the plateau above. The Churnet contrasts sharply both in mood and temperament with the Dove. Though the Churnet has seen the early rise of industry along her banks, and was for long polluted, none of this has detracted from her wild and romantic charms.

The Uttoxeter and Caldon Canal

The river has mainly avoided road travellers, but the canal and railway have successively penetrated its narrow confines. Throughout the late 18th century a period of canal speculation and intrigue persisted, as rival companies sought to extend their range and to frustrate their competitors. In the autumn of 1795 a canal was projected to link the Dee and Trent systems from Nantwich to the southward orientated Ashby de la Zouch Canal. The course was to have run through the Churnet Valley (connecting with the Cheadle coalfield) to Uttoxeter and thence through the Lower Dove Valley to Burton-on-Trent. To frustrate this initiative the Trent and Mersey Canal Company, headed by the famous Josiah Wedgwood, struck to eliminate competition from their heartland and proposed an extension of the Trent and Mersey Canal from Etruria through to Uttoxeter. At Etruria Junction, in the heart of the Potteries, the direction sign to Uttoxeter may still be seen.

The Uttoxeter Canal was authorized by Parliament in 1797 although for some obscure reason it was not commenced until 1807. Work was slow;

The Churnet Gorge: Land of wild scenery and rushing waters.

Oakamoor was reached in August 1808 and Alton by May 1809; finally the canal arrived at Uttoxeter to the acclaim of the townspeople in September 1811. The construction included the provision of 17 locks, a 40 yard tunnel at Alton and two river crossings. The boats used on the canal were of a maximum dimension of 72ft x 7ft.

Memories of the Uttoxeter Canal

The canal still functions from Etruria to the basin at Froghall, now a popular route for pleasure boats. At Froghall it was joined by a rail incline that connected with the Cauldon Quarries and the Whiston Copper Works. The canal provides a secluded and tranquil journey through the confines of the valley.

Beyond Froghall the canal has long been closed. Beneath the wooded slopes of Alton Towers can be seen dark, leaf-choked sulphurous pools, the long forgotten remains of the canal. Along this stretch can be found the ruins of an isolated inn which drew its life blood from the barge people; the remains stand beside a basin progressively invaded by saplings. Further along the course, below the former deer park of Alton Towers, can be seen a fine example of a humped backed bridge standing in glorious isolation. At Crumpwood, as the canal left the Gorge, it was necessary to cross the river. This was unusually achieved by obstructing the river's flow by a weir. The boats were then merely

towed across the deepened still water between the canal entrances on either side. The relics of the controlling locks and the weir remain, but the bridge over which the towing horses crossed has vanished. Below this point the railway has claimed the route to a point where the canal entered the Vale of Dove.

The Death of the Uttoxeter Canal

The principal cargoes on the canal consisted of copper, coal and limestone from the mines and workings of the valley. The canal would certainly have been used to transport the vast building requirements for the Earl of Shrewsbury's work at Alton Towers. The Canal was frequently surveyed for extension. In 1813 an extension was proposed to Ashbourne, while in 1839 the Dove Valley route was again proposed for the route to Burton-on-Trent.

The latter was on the limit of the canal age. The railways had arrived and peripheral canals such as this fell instant prey to the new force. When the North Staffordshire Railway Company proposed their route to Manchester, the axe fell and the canal owners eagerly sought the best terms available in a merger. In this, the Uttoxeter extension was specified for closure to provide a wayleave for the new railway through the narrow confines of the Churnet Valley. If the canal had survived into these days of pleasure navigation, it is certain that its contrasting course would prove unrivalled and it is easy to speculate on the appeal of the journey through the wild delights of the Churnet before entering the ultimate serenity of the Dove.

Of course, the same could be said of the succeeding railway, on which passengers were treated to the remarkable scenery. The Churnet Valley Line became duplicated as a route following the Railway Re-grouping of 1923, when the North Staffordshire Railway was merged within the London Midland and Scottish Railway. The line was to become popular with visitors to Alton Towers during the 1920s and 30s, though excursions were advertised by the North Staffordshire Railway as early as 1873. The visitors would arrive at the Earl of Shrewsbury's fine station which has now been fully restored.

After the Second World War the growth of motor transport resulted in further decline, until passenger traffic fell a victim to the Beeching Axe in the 1960s. The line continued to carry freight on one section from British Industrial Sand until the late 1980s. At the present time, a section of the route has been purchased by the Churnet Valley Railway Company, who propose to redevelop the track as a tourist attraction with steam locomotives.

Alton Castle

On the southern edge of the Churnet Gorge stands Alton Castle, a religious and historical expression of the Victorian age, built within the ruins of a castle

founded by the De Verdun family of Norman adventurers. They obtained the estate through marriage into the great De Ferrers family. Bertram De Verdun was a deeply religious man who founded Croxden Abbey in 1176. When Richard I joined the Third Crusade, Bertram rallied to his call, for which the King awarded him rights to build the castle. The great mission set out in 1189, taking up their battle stations in the Holy Land in 1191, where Bertram was to gain the ultimate accolade by being killed outside the very walls of Jerusalem!

However the most significant member of the family was the young heiress, Lady Ankaret, who married Sir John Talbot, whereupon Alton became part of the Talbot demesnes. There had been a male heir who could have inherited but he was killed at Crecy. Long preserved amongst the family treasures was a marriage casket which included a view of the Crucifixion showing John and Ankaret kneeling at the foot of the Cross. Behind the cross can be seen a view of Rouen where the casket was made in 1427. Surely this beautiful object was brought from France by John Talbot as a present for his young bride on their wedding day. It is believed that it is now in the British Museum. Ankaret was destined to spend most of her future life alone at Alton because Sir John was a brilliant general who had masterminded the highly successful campaign of the dashing Henry V in France. After the King's early death, Talbot succeeded in enabling the feeble minded Henry VI to be crowned as King of France in Paris. For these services Sir John was created the 1st Earl of Shrewsbury in 1442. However the tides of war had turned and the inspiration of Joan D'Arc resulted in a catastrophic series of defeats for the English. The Earl himself was killed on French soil in the Battle of Castillon in 1453.

The remains of the castle display evidence of defensive and strategic planning similar to that of Caen in Normandy. The gatehouse is a massive structure with a narrow entrance between two barbicans which covered every angle of fire. Also suggestive of Caen is a deep moat cut through solid rock to isolate the bailey from the remainder of the hillside. In recent times, during excavation for drainage works, tunnels have been discovered running from the castle to emerge on the valley sides. This has established the truth of centuries old legends that there were secret passages from the castle to the outside world. After the death of Lady Ankaret, Alton fell into a prolonged period of insignificance amongst the extensive domains of the Talbot family.

The 15th Earl of Shrewsbury
The hibernation of Alton continued until Charles, 15th Earl of Shrewsbury, visited his long forgotten property. Here he found the romantic scenery and isolation to match his dream of creating a palace that would give substance to his interpretation of the Talbot lineage and religion and to his own nostalgia for

the past. It is believed that the Earl first visited Alton in 1809 and started the great enterprise in 1811. It was to prove a vast undertaking which required a succession of architects, the first being James Wyatt. Great mansions were being built over the length of the kingdom but this was to be the greatest, whose complexity and eccentricities reflected the formidable wealth and zeal which sustained the Earl's ambitions. William Pitt writing in his "Topographical History of Staffordshire" in 1817, observes the early days at Alton; *"Near the north bank of the Churnet, opposite the Castle, stands Alveton, (a former name of Alton), the summer residence of the Earl of Shrewsbury. His lordship has made great improvements on his manor and given employment to masons, bricklayers, labourers, and different artists connected with architecture. He is somewhat fanciful, and has built and pulled down several ornamental temples in his grounds; he is now engaged in the erection of a tower on the summit."*

While the Earl was influenced by his sense of history, he was foremostly a Catholic and displayed his beliefs on every occasion. In the creation of Alton Towers he exhibited the zeal and conviction of early monasticism. He had been an early convert to the Gothic revival which had been promoted by Goethe following his treatise on Strasbourg Cathedral. The first name for his new mansion was Alton Abbey, which possibly conveys his thoughts and intentions. It must be remembered that at this time the Faith was still proscribed. In those days, with the nominal continuance of the Penal Laws, it was extremely disadvantageous to be a Catholic, even for the Premier Earl of England. While he would receive the outward respect of his fellow peers, many were the doors and hearts of the high born that would have been closed to him. This possibly affected his choice in marriage; Pitt carries on to detail his wife's origins; *"Lord Shrewsbury, who is a zealous Catholic, married a Miss Hoey, the daughter of a Dublin bookseller, who is also a votary of the Holy Mother Church, and a considerable number of Catholics are retained in the family mansion."* Countess Sarah was portrayed by Sir Thomas Lawrence as attractive, though with rather heavy features.

The Gardens of Alton Towers

Below the mansion lies a huge natural glen which the 15th Earl lavishly transformed into probably the finest created landscape in England. The Earl was a master interpreter of the beauty and elements of nature. Here were the natural gifts of nature arranged by the hand of man. At that time the collection and variety of species would have been remarkable, containing every colour and shade of green. Many would not have been seen in this land before, brought back by fearless plant hunters from remote and uncharted corners of the world.

Terraced pathways curve with the contours to create an atmosphere of

seclusion, while narrow flights of steps provide access to secret grottos and fanciful buildings which adorn the the sides of the valley. The largest are the conservatories grouped on a wide terrace, a vast creation in stone, iron and glass, with seven glistening domes reminiscent of the Arabian Nights. The most impressive is a finely proportioned pagoda, housing a great fountain which projects a huge jet above the enclosing trees. This pagoda was a replica of one in Canton; indeed the Chinese influence is strong throughout, which indicates the tastes of the Earl, who had his roots firmly in the 18th century. But the garden shows the influence of other lands too. Wide canals crossed by elegant bridges are witness to the Dutch influence, while the Mediterranean is represented by a pergola formed by a Romanesque arcade surmounted by elegant female statuary. To reflect the English taste, we find terraces with the clipped yews and urns so beloved of those times, vistas of massed bedding, the soft colours of the herbaceous borders and the elegance of the rose garden. It has been suggested that the typically English practice of massed colourful bedding was first displayed here. The rock garden was created on the steepest slopes of the grotto and with its many artificial streams is a magnificent presentation of mountain scenery in miniature. Many strands of the Talbot tapestry were incorporated in the presentation. A blind harpist from a family estate in Wales was provided with a home high above the valley, where he would intone the Celtic melodies of his native land.

While one may mourn the commercial fate of Alton Towers, it is the revenue from mass amusements that have enabled this unique garden to survive. Today, due entirely to the endeavours of the present owners, it is possible to view both the formal and informal in magnificent maturity. As these gardens were the creation of the 15th Earl, it is fitting that his bust stands above the grotto, erected by his successor. The inscription says much, *"He made the desert smile."* The gardens extend to infinity, merging into the enclosing woodlands, which contain miles of drives and sylvan paths, giving views to dark tors or an ominous rock face which in turn support clumps of the colourful open grown scots pine. This treescape, now in maturity, makes an impressive approach to the Towers and amplifies the wild beauty of the Churnet scenery. The main entrance from the mansion was planned to run south as far as Denstone, where the wide Tuscan colonnades and an arch can still be seen near the banks of the River Churnet.

The Alton Towers of the 16th Earl of Shrewsbury
Following the death of Earl Charles in 1827, the mission was pursued with even greater vigour by his heir and nephew John and the family wealth was mobilized to an unprecedented degree. As the castellated profusion of towers,

turrets and battlements grew, so did the ambitions and expectations of the Earl as he renamed the mansion "Alton Towers". Range upon range of buildings were built and successively replaced in his obsession with obtaining the ultimate in Gothic splendour and perfection. The climax had been reached at the time of his death in 1852, when the palace exceeded 460ft x 250ft.

The main entrance lay beneath a massive tower which housed a big bell. It was guarded by two giant dogs standing proudly upright on their haunches. These are the Talbots, the family emblem. The great entrance doors opened into the Armoury, which was 120ft long, and housed traditional armour and weapons and contained stained glass heraldic windows. The climax, a portcullis, gave entry to the ensuing Picture Gallery, a chamber 150ft in length which had a fine ceiling of oak and glass, supported by a series of arches and lit from a series of chandeliers. The size and grandeur of these vast entrance chambers may indicate the hand of Trubshawe. This hall in turn gave access to the Octagon, which in grandeur and size resembled a cathedral chapter house and commemorated those Talbots who had been ordained. The role of the Octagon was pivotal because it gave further access in two directions. Firstly, to the 150ft long Talbot Gallery which displayed the heraldry and lineage of the family, before the state rooms were entered at the far end; and secondly, to the Conservatory which was a fine construction in stone and glass, which proclaimed the apt text, *"The speech of flowers exceeds all flowers of speech"*. The purpose of these vast galleries was to enable the wealth and lineage of the great family to be opulently displayed. The full magnificence of this presentation was noted by Queen Victoria when she visited the Towers during a great progress with her mother shortly before her accession. On this occasion the grounds were open to the public for the first time. *"At 1pm we arrived at Alton Towers, the seat of Lord Shrewsbury. This is an extraordinary house. On arriving one goes into a sort of gallery filled with armour; guns; swords ... and then into a conservatory with birds. We lunched there and the luncheon was served on solid gold plate."*

At the end of the Conservatory stood two great doors within a tremendous arch. The glittering climax of the state rooms had only now been reached! Beyond those imposing doors lay the resplendence of the Drawing Room and thence, the pretentious Music Room, whose grandiose proportions exceeded the quality of any music. This chamber was lighted by a magnificent Gothic bay of three giant stained glass windows which rose from floor to roof and overlooked the courtyard garden. The writer feels that these great windows are an addition by Pugin because of the inspirational and aeshetic contrast with the heavy styles of the adjoining rooms. Through an arched doorway from the Music Room, the Library was entered - a vast room divided by two Gothic arches. This was at the

western end of the house, where the exterior profile reached a conclusive climax with the North West Tower. In that tower and integral with the Library, was an attractive alcove called Poets Corner. Through a delightful bay of three lancet windows, inspirational views could be obtained over the grounds and romantic valleys below the Weaver Hills.

Though the house itself is a massive construction in stone, much of the interior of the later rooms contains brick work. This would not have been visible because the walls carried rich coverings, evidence of which remain today. Now that these rooms have been opened to the public, it is possible from the remaining shell and earlier descriptions to appreciate their former extravagant glory. The main rooms in this north elevation of the house overlooked the lush lawns which gently slope down to the lake. These swards are studded with cedar of Lebanon, blue Atlas cedars and monkey puzzle trees, now growing in full maturity long after the departure of the noble family who caused their planting.

Today the bare shell of Alton Towers still hints at the magnificence of those days. Yet also along the long stone passages, can be felt something of a cold grim life that lay behind the state rooms. Surely in the depths of winter, with cold winds driving across the Staffordshire hills, some of this coldness would even have penetrated those tremendous rooms.

Augustus Welby Pugin at Alton (1837-1852)

A long succession of architects had already been employed at Alton Towers by 1837, when Pugin was appointed at the age of 25. Though the Earl was by then living in conditions of unprecedented splendour, he remained dissatisfied. The new architect was the rising exponent of the Gothic Revival; furthermore, he had converted to the Catholic church two years previously and considered the Gothic Revival to be an embodiment of the Catholic ideal. He regarded the projection of this architectural style as his religious mission. While his heart and brain burned with the zeal of the convert, he had never been a student of theology. However this omission did not prevent him from engaging in theological debate with priests! His knowledge and expression of Catholicism was confined to its buildings, its ceremonial and its liturgy. He was always an austere man; in work he drove himself without mercy, his only respite during a rigorous schedule being time for prayer and simple meals. In social life he was a favourite with women who could be enthralled by his captivating and brilliant conversation. When the resident priest at the Towers introduced Pugin, the Earl immediately realized that this was the man to complete his mission. From the time of that meeting until his death, Pugin was destined to work without a break on the Shrewsbury demesnes or their commissions. The Churnet valley was destined to become Pugin Land!

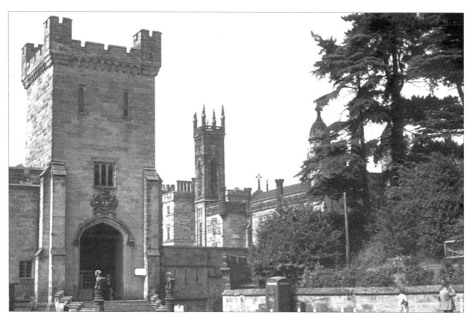

Alton Towers: Entrance to state apartments.

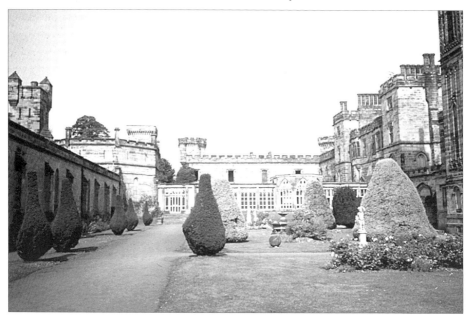

Between the Great Halls: Lady Shrewsbury's Garden.

The Banqueting Hall

While most of the construction had already been completed, Pugin worked on the re-appointing, embellishment and furnishing of the existing wings and halls. In this he was master, designing meticulously each item to an elaborate degree. However he felt compelled to make some major structural changes. The main object of his rebuilding was to give a climax, both to the glittering state apartments and to the profile of the house. The insertion of the Banqueting Hall was to provide the zenith of the whole complex. The chamber is dominated by the highly pitched roof which is crowned by the typically Pugin slender Lantern Turret carrying Talbots holding banners. The great gable of this creation remains the climax to the northern silhouette of the mansion, Gothic sublimity contrasting with the adjoining lugubrious facades of lesser men. The interior of the Banqueting Hall, beneath the highly pitched roof, is dominated by the vast north window. This, superbly Gothic, was filled with forty panels of heraldic glass, much of which remains, beautifully restored. There are two great fireplaces, with finely carved overmantels in white stone, where the family crest is again supported by Talbots. Around these fireplaces are to be seen finely executed Coalbrookdale tiles displaying other family emblems. It is remarkable that throughout what remains of the mansion, many of the original fire backs and grates have miraculously survived. In this palace of superlatives, no more are available to describe the masterpiece of this chamber; the whole effect is of fairy tale quality. Surely the soaring roofs of Alton and the huge mullioned windows must be considered a foretaste of Pugin's work at the Palace of Westminster.

The Chapel

The one part of the Towers indelibly associated with Pugin is the chapel. It is now accepted, as expounded by Pevsner (1974), that much of the structure was built before his arrival and does not display the confidence of Pugin.

This is academic, for the decoration and exquisite embellishment of the internal design are certainly from the hand of the master. The finely timbered roof and lavishly decorated bosses are all sublimely Gothic and accepted as a great creation of his design. The roof bosses carry kneeling angels reading the scriptures. Their gilded figures are larger than life and are most impressive resting on the ornate gilded bosses. The rich stained glass, the sacramental plate, the hangings were all minutely designed by him. The most ornate and detailed creation was the altar and gilded reredos which portrayed the Earl and Countess. At the time the chapel was the most magnificent ritualistic presentation within the English Catholic church. It was not intended for public worship but reserved for the family and their Catholic retainers. At the rear there still stands the two-decker Gallery which was a magnificent creation in decorated iron work. This

was built to accommodate the family, who would arrive for Mass directly from the state apartments.

The pews, beautifully made in elm wood, were recorded as surviving until 1950. The whole of this structure stood above an arcaded western transverse aisle which is analogous to Pugin's design in St Mary's at Uttoxeter. It is noticeable that he did not introduce windows; was this intentional to heighten the devotional effect of the interior? In the semi-darkness of the chapel the massed ranks of the votive candles would have made a tremendous spectacle before the glistening altar and the effigy of Our Lady. Further, the rich kaleidoscope of the colours from the roof would have been beautifully portrayed in this mysterious spiritual light. Following the failure of the Catholic line, the Chapel settled into decline until the great sale of the Tower's contents in 1924, when it was finally closed. The 41 inch high altar cross with its ruby mounts was sold for £2.10s, while the altar was sold for £1.5s. This masterpiece is now to be seen in the Catholic church at Bromsgrove.

After the near destruction of Alton Towers, the chapel was gutted to house a large model railway, claimed to have been the largest in existence. The ceiling and bosses were hidden beneath a false ceiling, while the windows were filled and the floor destroyed. In 1992 the owners became aware that severe damage was taking place to the roof from damp, dry rot and woodworm. The railway was closed and sold to allow a complete restoration. Happily this work has been carried out to such a magnificent standard that it would be applauded by the 16th Earl and by Pugin alike. This is a credit to the culturally aware owners. The damaged portions of the roof have been gloriously recreated using 1,300 books of gold leaf. The tremendous effect of red, blue and gold transports the viewer back to the mid 19th century, though the excellence, which in those days could only be appreciated by the few, is now available to the multitudes.

In the east window are to be seen the remains of the original richly coloured glass, though the majority has been destroyed. As the next step in the restoration of the Chapel, the owners held a competition for a design to replace the open windows with modern glass which would complement what is left of the original by Willement. He, in the Victorian age, was able to produce the deep, yet soft colours of medieval English glass. This glass is now irreplaceable. In the restored windows the designer has achieved an approximation of the original colour, but has not attempted to recreate the content of the original windows.

The Catholic Crusade

The partnership of Lord Shrewsbury and Pugin extended beyond Alton Towers. Across the Churnet Gorge lay the ruins of the ancient castle. Here in 1839, it was decided to build a complex that would provide a focal point for the Catholic

The Chapel, Alton Towers: Restoration of the Pugin roof.

revival that both men believed was at hand. Here in these uplands of North Staffordshire they envisaged a new Rome. The building precariously clinging to the edge of the gorge is obviously inspired by Pugin's visits to Germany. It boldly exemplifies the historic; but what was the intended purpose? An early controversy arose between the architect and his master. Having embarked on the grandiose project, their intentions were unclear. The Earl suggested a home for retired clergy; Pugin considered this unworthy of the undertaking.

The Castle eventually became a school, an institution that continued for over a century, after which it lay empty for some years. It has now been re-opened as a Catholic youth centre for the Archdiocese of Birmingham, while the adjoining countryside and woodland will provide additional facilities. The crypt of the medieval castle, having been hewn out of the solid rock, was for long used as kitchens. These are now being restored to include a chapel for the Adoration of the Blessed Sacrament.

Through the years, and particularly when it was closed, the Castle has become a rather austere building. From the gorge below the romantic "Rhineland" qualities are viewed to the full. However when viewed closely from the rear it has a gaunt and eerie appearance. This atmosphere is most pronounced in the long dark passages which lead through the vast gloomy interior. The centre of the castle is the chapel, now dark, neglected and sombre; but when cleaned and redecorated it will again proclaim the sponsor's original intentions. The chapel exemplifies the brilliant eccentricities of Pugin. The chancel is narrow and unusually high, but when viewed from the short and dark nave, it rises as a climax. However, the nave also has surprises; above the

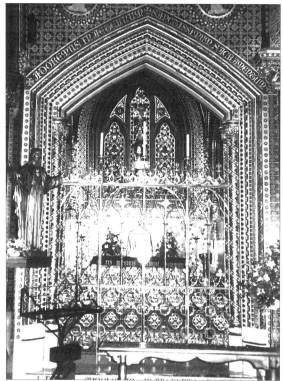

St Giles Church, Cheadle:
The Chapel of the Blessed Sacrament:
Integration of dogma and design.

arcades rises a wide Triforium, above which soars a wide lantern turret. This admits subdued light to the vortex of the chapel below. The rich glass of the chancel windows portray events from the history of the building, including the Earl and his architect inspecting building work and the arrival of the Sisters of Mercy who founded the School. This was placed there as as a memorial to those former pupils of the school who did not return from the Great War.

Undaunted by doubts, the partnership went on to build cloisters, a presbytery, a village church, a convent and a village school. In the village Catholic church we can again see clearly the hand of Pugin, especially with the magnificent gilded altar and reredos.

This was not to be the only project in hand. In the wooded and secret valley above the middle Churnet valley at Cotton, was built another church and complex. To this came John Henry Newman to found his Oratory Community. This great intellectual and theologian had shaken the

St Giles Church, Cheadle:
Heraldic guardians of the
House of Talbot.

Anglican Church by his conversion three years previously. The Earl and Pugin believed that he would provide the intellectual base their mission required. However Newman disliked continual interventions from laymen, however brilliant or high born they may be. He thereafter moved his community to Birmingham where, ironically, it became the powerhouse of Catholic revival. Cotton College later offered an advanced technical education for Catholic youths before becoming a Catholic public school. In the grounds stands the attractive church of St Wilfred with an enchanting slender spire by Pugin.

However, it is at Cheadle that the greatest memorial to the remarkable partnership can be seen. The Church of Saint Giles is without doubt Pugin's finest masterpiece. It reigns over the dreary streets and sombre uplands of this former coalmining area. A gift by the Earl of Shrewsbury, it was regarded by Pugin as his greatest achievement and fulfilment in life. For the first time he was able to interpret his religious and ritualistic vision to the ultimate. Here his abilities were totally unrestrained by money, as the flood of Shrewsbury's support became a torrent. At St Giles he was able to achieve the ultimate expression of ritualistic and architectual compatibility. The two men again spent hours in debate to achieve the desired effect. Of crucial importance was the integration of ritual and dogma with design.

While searching for inspiration, the design of interior adorment was held in abeyance until the right balance had been achieved. For example, Shrewsbury and Pugin debated on the provision of a pre-reformation styled rood screen until Pugin returned from a tour of the isolated medieval churches in Norfolk. This had provided the inspiration previously missing; in 1844, he wrote to Shrewsbury with child like enthusiasm, *"I am half frantic with delight. I have seen such churches with the painting and gilding near perfect! Such screens, exquisite painting. I shall have glorious authorities for Cheadle. I am delighted beyond measure to have seen them before we begin decoration at Cheadle."*

In the richly painted interior and grand embellishment there are numerous heraldic references to the House of Talbot. The body of the church is balanced by the massive Gothic tower that in turn sweeps into the graceful spire that exceeds 200 feet to dominate the bare uplands of North Staffordshire.

The End of the Catholic Line

Though Pugin had been working without a break on the estates and other commissions of his patron, he was also engaged in an exhausting programme of building to accommodate the growth of the Catholic population. However, his greatest commission became the decoration of the Houses of Parliament. This work was carried out to a standard of embellishment and grandeur that he had pioneered at Alton. By the end of February 1852 the House of Commons was finally opened, but his health had broken; his unquenchable genius had driven

him to mental breakdown. The obscene spectacle of this brilliant man living as an imbecile was mercifully ended in September, when he died without regaining lucidity. He had not reached his 40th birthday.

By a cruel irony, the Earl died while visiting Naples in the November of that same year. The great partnership was over; the frantic 40 years of building, which would have impressed even King Ludwig II of Bavaria, had ended. For long the unfinished buildings at the Castle remained open to the skies. Bertram, the 17th Earl of Shrewsbury, who was an invalid and unmarried, carried on some of the uncompleted work. He was himself to die in 1856 without an heir; the title was vacant and the estates impounded; the 16th Earl's Countess, Maria Theresa, died in her native France in that same year. The great days at Alton were over; the line had failed. The title and estate were claimed by a relative, the 3rd Earl Talbot of Ingestre Hall in Staffordshire. Lord Ingestre, his eldest son, set out to claim their right, but was to suffer the humiliation at being refused entry to the mansion. The Duke of Norfolk claimed that Alton had been given to his son by the 17th Earl (his cousin) to retain Catholic ownership. Further, there were two other claims; news came from Italy of a princess who claimed to be daughter of the 16th Earl; while from Ireland a rival kinsman presented a claim. The Earl Talbot resolved to take his claim to the Lords. The wheels of adjudication turned slowly, and it was 1860 before his claim was substantiated by the House of Lords.

On the 13th April 1861, the new 18th Earl ceremonially took possession of Alton Towers. After riding from Ingestre, the Earl was met near Uttoxeter by the Staffordshire Yeomanry Cavalry and a vast multitude of townspeople. A great procession then drew up, including many carriages containing the aristocracy of the area. The procession moved into Uttoxeter under triumphal arches, to the accompaniment of cheering crowds and the ringing of the church bells. At the Town Hall a loyal address was presented, in which relief was expressed that the title was now safely in the Protestant line. In celebration the poor of Uttoxeter consumed 600lbs of beef, 600 loaves and over 300 gallons of beer. The grand procession then set out ceremonially to claim the estate. In the vast halls of the Towers, 4,000 persons dined with the new Earl, while in the grounds a further 25,000 were fed at the Earl's expense. On this day it was estimated 40,000 were in the grounds for this lavish celebration.

The Decay and Rebirth of Alton Towers

The cost of securing his claim and the subsequent celebrations had been heavy. Further, after the initial euphoria of gaining a further earldom and the great estate, he found the cost and inconvenience of maintaining the vast cold mansion formidable. In his heart he preferred the homely comfort and convenience of Ingestre. In 1867 much of the Towers was emptied in a great

sale which lasted for 29 days, while other family heirlooms were moved to Ingestre. Again to raise income, the grounds were opened to the general public for the first time in 1860. Following Princess Victoria's visit, tickets became available for those visitors arriving in private carriages or accompanied by a clergyman. These precautions were applied to prevent vandalism! This became popular after the North Staffordshire Railway Company started to promote excursions. In 1890 it is reported that 30,000 attended one mass entertainment.

In 1880, the Shrewsbury estates comprised 18,954 acres in Staffordshire alone. The 19th Earl was the father of Theresa, Marchioness of Londonderry, who was the authoritarian and promiscuous hostess notorious in late Victorian high society. The 20th Earl was a pioneer of the motor car; he produced the Talbot Car and in fact, designed and drove the first car to travel over 100 miles an hour at Brooklands. The Earl was also by contrast an enthusiast of horse-drawn transport. He designed a stage coach called the Greyhound, which he operated from Alton, via Leek, to Buxton and returning in the same day. This service became popular, especially as the Earl frequently drove and collected the fares himself. It was probably the last stage coach service in the two counties. He also designed the rubber-wheeled Shrewsbury Hansom Cab, which for years dominated the streets of London. Examples of these carriages are now on view at the Staffordshire County Museum at Shugborough Hall. The later Earls preferred Ingestre and seldom lived at the Towers except during summer months. Sadly the 21st Earl sold Ingestre in unfortunate circumstances in 1960.

Courtesy of Alton Towers

The 'Greyhound': The last stagecoach in two counties.

The house and estate were maintained until the Great War. Changing attitudes and economic factors claimed many victims amongst the great houses of England at that time. Following the succession of the 21st Earl as a boy of 7, the family, weary of maintaining such a vast undertaking against the background of higher taxes, closed the house and finally left in 1924. In another large sale all the remaining contents and the whole estate were sold. The prices obtained were low due to the depressed state of post-war Britain. The house and grounds were purchased by a consortium led by the local Bagshaw family, whose aim was the retention of the Towers and gardens through entertainment and tourism. The masses came to walk through the starkly empty chambers, while the Banqueting Hall became a tea room, which was filled with the mass-produced furniture required to feed the visiting throng.

The Towers was occupied by troops during the 2nd World War when, as at many other mansions, terrible damage was caused by undisciplined occupants. Such behaviour was indefensible and difficult to explain. One is amazed at the lack of restraining discipline, many houses were left as though they had been looted by the enemy! On one particularly boisterous evening the conservatories were severely machine-gunned from the grounds above.

The property was released by the military in 1951 when Mr Bagshaw commenced the restoration of the gardens. Shortly before the grounds were re-opened to the public, the floors and roofs of the Towers were removed, leaving them a pathetic shell and a progressive ruin. That was at the time when the Towers first became an amusement park. In the following years the decaying interior was a tantalising mystery which lay beyond the barred doors and stark open windows. Later owners made efforts to maintain the open walls and ruins, which were first opened to the public by the entrepreneur Mr Broome. His activities at Alton Towers were greatly praised by Mrs Thatcher, who paid a special visit. At that time the Towers was also the venue for the televised programme in which the younger members of the royal family competed in games. A full scale restoration has now been carried out by the present owners, the Tussaud's Group. This is a tremendous achievement which allows the general public to enjoy something of the glittering interior of this tremendous place. Its success can be dramatically appreciated from the magnificent restored Banqueting Hall, in stark contrast to the still ruinous side rooms, viewed with their gaping windows and open fire places across a void of despairing decay.

The Upper Churnet Valley

Lying in the centre of the Upper Churnet valley is Oakamoor, a village whose history and aspect are marked by the industrial revolution. The close proximity of deposits of copper and the Cheadle coalfield gave rise to copper works at

Whiston, Froghall and Oakamoor and brass manufacture in Cheadle. Now the only survivor of this great industry is the works at Froghall, though they use imported copper. Similarly coal mining around Cheadle ceased in the 1960s. One industry which continues is the exploitation of glacial sand and gravel around Cheadle. These remarkable deposits appear as rounded and moulded caps above the lower levels from which coal was formerly worked.

Above the gorge the river pursues a course of twists and turns as it flows through Leek, the largest town in the Dove catchment. This is a firmly Pennine town, long associated with textiles and dyeing, where gaunt mills characteristic of the north dominate. Many of the mills, shops and public buildings carry quaint turrets and pinnacles, as do even the public conveniences, giving the town a unique character. These were the creation of a father and son partnership of Scottish architects in the town, Sugden and Son, during the last century. One can only wonder whether they gained inspiration from Pugin's work at Alton.

Above Leek, the course of the Churnet lies through bleak gritstone lands where small farmers win a living from a grudging terrain of short summers and dark rain-soaked days. The Churnet rises amongst the savage moors beyond the gritstone outcrops of the Roches. In the rocky recesses are found wallabies, descendants of escaped animals who have survived the severe blizzards and freezing winds on these wild moors for many years. Behind the Roches lie the dark mosses of the Staffordshire Moors where coal was formerly mined. These moors, beneath wide unchanging skylines, are the archetype of wild desolation and where this journey of the Dove has already begun.

Big Mill: One of many Leek buildings designed by Sugden & Son.

Water Crowsfoot: Like a bride's veil floating on the waters.

Uttoxeter Canal: Remains of a serene journey.

CHAPTER 8
THE VALE OF WEAVER: THE MEETING OF LANDS

As the soft valley of the Churnet converges with the Dove, the dividing promontory continues as far as Rocester. There the valleys join to form the Vale of Weaver. Rocester, which wears a workaday look, stands on the very end of the headland, with the two rivers flowing past at each end of the village street. As might be expected from such an easily defended location, Rocester has ancient origins. While the earliest proven settlement was in the Bronze Age, the village saw its greatest period during the Roman Occupation.

Roman Rocester
Following their conquest, the priority of the Romans was to facilitate the exploitation of their new province. There is little evidence of civilian colonization in this area, but the mineral wealth of copper and lead in the hills to the north was economically important. To facilitate the extraction of these metals, large gangs of conscripted men would have been required and these would certainly have been obtained from the Celtic tribes that continued to live in the hills. Specific to the exploitation of the minerals and to keep the British tribes in a state of subjection, a fort was established in the later part of the 1st century. Initially this was short lived, but during the 2nd century a more permanent presence was established, which later became an administrative town and marketing centre. While some civilian settlement took place, Rocester remained a military town on the frontiers of Rome, whose defenders would have shared the lot of all garrisons through history. From their secure position between the two rivers, the garrison looked north to the hills where lived people whose surly acquiescence to Roman rule could only be secured through the occasional use of force. The situation would have been similar to the presence of the British in 19th century India.

To link the garrison with the main fabric of Roman Britain, an east-west road was constructed which survives in the form of Long Lane. Today in rural seclusion, it arbitrarily pierces the innumerable tiny villages and matrix of lanes that date from the Anglo-Saxon settlement. A country lane throughout its length it forcefully dives like an arrow across the leafy and rolling country that lies below the hills. The best time to appreciate Long Lane is during the leafless days of winter, when the uncompromising straightness is clearly defined. The route connected with Rykneld Street at Chester Green, the major Roman town in Derbyshire. At Rocester the road crossed the Dove to enter the garrison near the ground of the now ambitious Rocester Football Club. As the road left

Rocester across the Churnet it led westwards across the hills to Chesterton in the Potteries. In addition to metals, this route would have been important for the transport of salt, a commodity vital to the Romans from Cheshire to the west.

The layout of the Roman fort and town followed the typical rectangular pattern with complementary entrances. A greater understanding of Roman Rocester has been derived from the excavations sponsored by JCB Ltd between 1985-1987. Many military buildings were unearthed and articles such as jewellery and personal effects found, which indicate a fairly high standard of living. Large numbers of amphorae have been discovered, the large jars used for the transit of wine and oil from sunny Mediterranean lands. An interesting visual display recording Roman Rocester and its excavation can now be seen in the church, while remains of the defending earthworks are still detectable.

Later and Industrial Days at Rocester

In 1140 a monastery was founded by one Richard Bacon for the Black Canons under the rules of St Augustine. This order, as at Calwich, was popular in the countryside. As all the brothers were ordained, members of the community would travel to say Mass in village churches. The community continued an uneventful existence until the Dissolution. In the churchyard is a 20ft high cross, believed to be 700 years old, ornamented with interlacing designs and dog tooth enrichment. The mounds in the field adjacent to the church are the only remains of this abbey.

Like other places along the Dove, the face of Rocester was indelibly marked by the arrival of the cotton industry. The great mill was built in 1782 by Sir Richard Arkright who claimed to have invented the spinning frame. The industry determined life in the village for generations; a life which was more akin to that of Lancashire than rural Staffordshire. In 1817 half the population of Rocester was employed in the mill, while in 1890 the payroll was 400.

By 1874, the owner of the Cotton Mill at Tutbury, Mr C.W. Lyon, had acquired the Rocester business from its previous owners; and following his marriage, he moved home to Rocester. In 1888 as trade slackened, he closed the Tutbury Mill to concentrate manufacture at Rocester where from that time onwards the mill was called "Tutbury Mill". The move would have increased the number of employees, as the removal of the business left many Tutbury families with no alternative but to move upstream to Rocester. With the removal of so many people, the strong family ties of Tutbury extended to Rocester; and so remained until recent times. From then onwards, many a holiday or excursion would involve a visit to other members of the family by train through the Dove Valley to Rocester. The writer as a boy, can remember old men in Tutbury recalling the great freeze of 1894 when it was possible to skate up river to

Rocester; visit relations and return by the same means.

The mill finally closed in 1990 but beside the river its regimented windows and arbitrary lines can still be seen, a monument to a now dead industry. The red brick, through the mellowing of years, has an attractiveness of its own. The village is clearly marked by its association with the cotton industry. Uninspiring drab red brick rows with simple backyards are fronted along the main street by more individualistic three-storey houses of local red brick. At the Churnet end of the village there is another mill which after a history of grinding corn converted to stone finishing in its final years. It is now fully restored as offices. Interspersed amongst the industrial dwellings are some attractive rural cottages and even a lovely black and white house which predates the arrival of cotton. The village has a small Catholic church which has the look of a Methodist chapel and carries the early dedication of 1837; it was probably opened for the spiritual needs of incoming workers at the mill.

The present century has ruined the face of Rocester. The 1960s mania for redevelopment resulted in a village centre recalling suburban Glasgow. As could have been expected the monstrous complex degenerated into a decaying resort of vandals and vermin before demolition. Now after only 30 years, the full stupidity of the planners is manifest. After demolition, redevelopment was delayed following the discovery of Roman remains.

Standing on the edge of the village is the huge J.C.B. factory which dominates the village in every way. This great enterprise was founded by Mr J.C.Bamford, who when he returned from War Service refused to re-join the Bamford family business in Uttoxeter and started to manufacture his own trailers in a hired shed in Uttoxeter. From this has developed the great factory of today, developed since 1950 on the site of a former cheese factory and earlier brickworks. The factory is set in large landscaped grounds where water plays a major role. With great sensitivity, the vast lines of this huge creation of the late 20th century are welded unobtrusively into the natural profiles of the topography. On the recent occasion of the 50th anniversary of the business a replica of the original workshop was opened by H.M. The Queen. On entry she found the now retired founder constructing a replica of that original trailer. The famous business is now headed by his son, Sir Anthony Bamford.

The Vale of Weaver

If one was forced to choose one stretch which exemplifies the character of the Dove surely it is here in the wide Vale of Weaver. This is a blissfully pastoral world, with the hills that have for so long protected the silver nymph providing a suitable backcloth. As though grouped around a table all the glories of the Dove's journey are here. The high profile of the Weavers superbly occupies the

head of the table and their dominance forces the surrounding scenery to pay homage to the river, while the the dark long line of the Needwood Forest rides out the skyline to the south. The river meanders across flat alluvial pastures and meadows and there is no finer time to appreciate its beauty than during early summer, when the lush new grass is attired in a riotous mantle of yellow buttercups, which coat one's shoes with their dusty sticky pollen and when sand-martins skim above the river from their nests in the alluvial banks. In the fullness of the year one can imbibe the smell of new mown hay; or hear the continual hum of flies that rise from some sheltered spot, a soft accompaniment to the continual bubbling of the larks, which seem suspended in the wide skies. As the summer progresses, the green-white blooms of meadowsweet rise from the ditches and water courses giving off an aromatic heady balm. The sky dictates the mood here. This is particularly true during winter, as exemplified by the glory of duck flying across the wide gulf of silver-grey skyscape that dominates the hard frozen fields.

The river is a wide, often shallow, silver highway, which swirls rapaciously around bends to enter pools, dark, reflective and contemplative beneath the casting shadow of the girding alders. Dour waters remain placid for a while, before breaking down over the next shoal into the crystal exuberance of youth. Through most of these reaches the river flows onwards, clear and chaste, through trailing masses of water crowsfoot. In the glory of high summer these peacock-tailed swarms erupt to carry a myriad of white flowers, which resemble a bride's veil floating lightly upon the waters, swaying gently as the currents permeate the virginal raiment.

By the river lies Abbotsholme School founded in the early years of the century by Cecil Reddie. This school inspired Kurt Hahn to found Gordonstoun. It was further developed between 1967 and 1981 by David Snell who was himself influenced by Hahn, though he placed greater emphasis on cultural values than on physical endeavour. It has been said that the Prince of Wales would have been happier at Abbotsholme. During his time, Snell maintained the traditional outdoor regime, feeling that it was important that pupils should be involved with animals. He also secured the admission of girls.

Eaton Woods and the Derbyshire Country

On the Derbyshire side of the river the Eaton Woods cling tenaciously to the steeply rising hillsides whose firm feminine wave-like mouldings are hidden by the woodland mantle. Behind Eaton Woods lies the "Country", that great sloping stage of pastoral Derbyshire which eases gently downwards from the hills to the Lower Dove Valley. The antiquity of Eaton Woods can be determined from the remains of earth banks that originally confined deer. The

woods were formerly of greater extent and were only saved after much havoc
had been inflicted. In his epic poem, Vales of Weaver, Thomas Gisborne
lamented their fate. He referred to their destruction together with a somewhat
sensual interpretation of the river's character in these words,

> *"Hence, Eaton, when thy woods dethrone'd*
> *Dryads and Fauns, a sylvan train,*
> *At eve shall mourn thy parting reign,*
> *In pale procession climb the steep,*
> *And o'er thy withering hour weep;*
> *Then shall thy blue eyed nymphs of Dove*
> *Glance at thy naked realms above,*
> *Lean on their silver oars and hear,*
> *The dulcet dirge with feeling ear."*

The Old Hall of Eaton, superseded by the farmhouse below the woods, was the
the residence during the Civil War of Sir Thomas Milward. On 24th May 1645
Charles I entered Uttoxeter with a force of 5,520 cavalry and in the evening was
entertained by Sir Thomas at Eaton. Francis Redfern, writing in 1865, says of
the Hall, *"The cellars only remain, and a bare tunnel communicates from a
distance"*.

Staffordshire; the Sandstone Hills and the Croxden Valley

On the opposite side of the river the rich green lands continue but with rising
profiles. It is a countryside of wide overgrown hedges with many damson trees.
These are acid lands and the sandstone rocks give a wilder, more colourful
character than the richer and softer lands beyond the Derbyshire bank.

In a gentle valley a little way from the Roman Road are the attractive ruins
of Croxden Abbey, a Cistercian house founded by the same Bertram de Verdun
who built Alton Castle. The Abbey was originally founded at Cotton in 1176 but
three years later the community moved to the richer lands of the Croxden valley.
The Order was founded in the late 11th century to counteract the growing
worldliness, luxury and pursuit of power that had permeated monasticism.
Croxden epitomises the new order, founded in the depths of the countryside,
where the monks could be sustained by their labours, removed from the
distractions of town life. The Abbey later became the greatest producer of wool
in Staffordshire. The monks originally came from the Mother House of Aunay
in France. The elegant church was consecrated to Our Lady in 1250. The days
of Croxden Abbey ended in 1538 when the 26th Abbot and twelve brethren
signed the Deed of Surrender.

The remains at Croxden still hint at long vanished magnificence. The
nave, now dissected by a road, would have led the eye to the high altar decked
with embroidered coverings and plate. Behind this are the remains of five

apsidal chapels, which would have been dark within, yet glowing from the light of a myriad votive candles as seen today in cathedrals in France. The red sandstone, which once echoed with plainsong chants, now resounds with the song of birds. The ruins are dominated by the full height of the west end with fine lancet windows. The remains of the south transept are also good. The presence of an aumbrey indicates that it once served as a chapel with a separate dedication. The entrance to the chapter house is magnificent and the cloisters set in neat lawns, are surely one of the most peaceful spots in both counties.

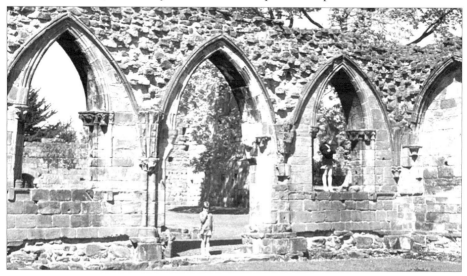

Croxden Abbey: A most peaceful place.

Above the rich valley of the Croxden Brook, the high ground carries dry oak scrub and open heathland as the hedgerows gradually give way to tumbling stone walls. At Hollington, astride the Long Lane, fine building stone has been quarried for centuries. In medieval times, many a cathedral or castle was built with this stone, as was Coventry Cathedral in recent times. The seams supply stone in both red and white. The lovely white stone was used to give a glistening, chaste interior to many a local country church. The village, with its quarries and derelict buildings, is reminiscent of Wales and the pastoral Vale of the Dove seems far away. Nearby in the village of Great Gate can be seen the ancient stocks and whipping post. The latter is a sandstone pillar 4ft in height with iron clamps on either side. Within these clamps the wrongdoer was fastened before being whipped as the onlookers hurled such abuse and missiles as thought appropriate. It was last used over 100 years ago for drunkeness, stealing, failure to pay fines and trading on Sunday. Also surviving is the village pound where stray cattle were secured. The acid oakwoods that clothe these

hills were formerly cut for charcoal burning; much of the charcoal produced was used in the cleansing of molten copper in the Churnet works.

The Dove Fishery

The *Compleat Angler* made the pure calcareous waters of the Dove famous for their fishing. While that treatise concentrated on the Dales, it is probable that the reaches below the Dales now provide the finest fishing. The upland waters support native brown trout while below Hartington the river is occasionally stocked with rainbow trout. This practice could have a detrimental effect on the native stock and should be reviewed in order to maintain the genetic integrity and diversity of the indigenous stock. Grayling, another delightful quarry for the fly fisherman, is common throughout the river. The weir at Rocester, built to power the mill, presents a barrier to the movement of coarse fish.

The salmon was formerly a familiar resident of the Dove. From its home in the North Atlantic it ascends rivers to breed in the head waters, like the shallow reaches above Rocester. Before spawning, the fish are in fine condition with attractive pink flesh and were a famed quarry for the game angler of yesterday. When the Consultation Report of the Dove Catchment Management Action Plan was released in January 1995, emphasis was placed upon the re-introduction of salmon. Some months ago as the guest of its owner, the author visited a local estate endowed with rich trout and grayling fisheries. If the long term objective of the original plan to restore salmon is to be successful, the estate would be restored to its former reputation as a salmon fishery. With his roots deep in the countryside and traditions of the area, the owner did not welcome the initiative because he could foresee the waters becoming prey to the depredations of unscrupulous poachers; not the local rustic of legend but ruthless criminals. Also concern has been expressed for the viability of the existing trout fisheries. However on Monday 5th October 1998, 75,000 young fish were introduced into the river above Rocester. It is accepted that this will initially result in only small numbers of salmon in the River Dove.

Although the valleys converge at Rocester, the Churnet appears reluctant to unite with the Dove and the confluence occurs covertly one mile downstream as the tributary sneaks in from its murky alder-lined course. The result is an immediate reduction in the quality of the fishery due to the poor Churnet water, the largest single contributory cause for which is Leek Sewage Works, though great improvements have recently been made, while copper works continue as a lesser cause for concern. The water quality has greatly improved in recent years; traditionally the Churnet discharged a heavy mask upon the surface of the Dove and the stocks of trout and grayling were decimated. Even before the growth of industry on the upper Churnet it had an inferior fishery, possibly due

to the inherent acid of the rocks, though poor water quality could remain due to seepage from disused coal and copper mines. In spite of these problems, the upper Churnet has now become a suitable habitat for brown trout.

Crakemarsh

Crakemarsh Hall previously stood in the rich alluvial fields of the Vale. Though of older origins, the majority of the house dated from about 1820, with Victorian additions. Originally it was a fine looking mansion, with creeper covered wings and a fine south facade viewed across the wide pastures. It is said to have been haunted by evil spirits. The house appears to have been entirely re-built around a magnificent staircase dating from the reign of Charles II. The staircase, which occupied the whole of the entrance hall, had open panels carved with acanthus foliage and was lavishly decorated with fruit and flowers. It has been suggested by Pevsner that the work is reminiscent of Pierce's great work in Sudbury Hall. It is certainly similar, especially in its ornamentation, but a similar contemporary staircase is to be found at Thrumpton Hall, Nottinghamshire, the seat of Hon Mrs G.Seymour. This fine staircase, also from the reign of Charles II, was executed by Webb. Listed Building Consent was given around 1980 for the staircase and panelling to be removed for storage on the Bamford Estate at Wootton, where it remains to this day.

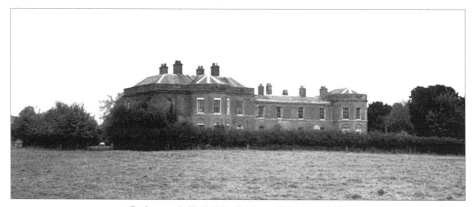

Crakemarsh Hall: Finally demolished in 1998.

Crakemarsh was originally the seat of a branch of the great Cavendish family. Like so many other houses it was severely damaged during the war when it was used by American troops and it later fell into irretrievable disrepair. In the early 1970s the house was bought by JCB Ltd to provide residential accommodation for the nearby factory. Later, the Hall was chosen by Sir Anthony Bamford as his family home. The house would have been completely renovated, presumably to the same standard that had been carried out by his father at Wootton Lodge which would also have achieved a long held family

ambition. How cruel was the turn of fate! His dear wife and her young companions were killed in a horrific car accident. Later serious dry rot was discovered in the house which led to it being abandoned. The final condemnation came when a fire rendered it unsafe. The last ruins were demolished in 1998. The newly aligned B5030 has robbed Crakemarsh of its original pastoral seclusion; the wreck is now complete. Crakemarsh originally had its own church which was lost after falling into disrepair. It is recorded that one Mary Blood was the last person to be baptised there. She had the distinction of dying at the age of 106, a remarkable age for the mid nineteenth century.

The Uttoxeter Canal; the Final Length

The Uttoxeter Canal originally entered the Vale from the Churnet Valley where the JCB factory now stands. Below the gaping shell of the mansion at Woodseat the original course can be seen as it widens out to form a lake. The route led to Combridge where wharfs and warehouses were situated. Here the course of the canal and railway became identical. Further south, well preserved remains of the canal exist as earthworks to be seen from the redundant road that leads to Spath. At that point the course led westwards to follow the 300ft contour to enter Uttoxeter. The River Tean was crossed by a 35ft aqueduct, remains of which can still be seen south of Stramshall. The canal ended in a terminal basin opposite the present Elkes Biscuit factory. This is still called the Wharf; the associated warehouse was until recently used as a factory for the manufacture of women's underwear. One can easily imagine what a magnificent journey this would present through those idyllic pastures below the line of the Weavers.

The River Tean

As the Dove flows to towards the end of the Vale she is joined by the River Tean. This fast flowing stream formerly powered a cotton mill near Uttoxeter which has long been abandoned. It borders the great fertile pastures of North Staffordshire which roll westwards to Cheshire. This remains one of the greatest concentrations of grassland still to be found in England. It is in such country that the roots of Uttoxeter lie and from which it has always drawn its life blood.

In the green and pleasant lower stretches of the Tean valley lies the village of Checkley. The village has a church dating from Norman times, which presents a fine spectacle from the rising hillsides. In the churchyard there are three saxon crosses commemorating a nearby battle against the invading Danes. They are said to have similarities with those at Ilam. Also in the parish is Upper Tean, a workaday village whose past has been dominated by spinning mills. The River Tean rises in the grey uplands above Cheadle and the upper reaches are able to support brown trout, though further downstream. it becomes more polluted, though the Dove Management Plan has already secured improvement.

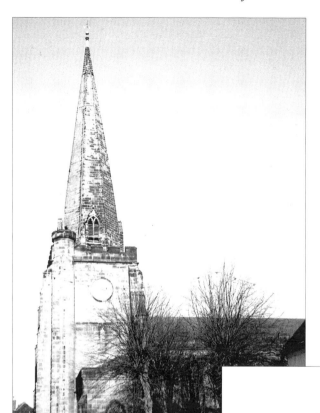

Uttoxeter Steeple:
Scene of a bizarre romance.

The Conduit and Kiosk: Monument to
Dr Johnson's penance.

CHAPTER 9
UTTOXETER: HEAD OF THE VALE

Seen from the Vale of Weaver, Uttoxeter sinks insignificantly into the landscape, with only the wide church tower and spire visible. With a population exceeding 10,000, it is the largest town in the Dove Valley. It belongs uncompromisingly to the country and is the commercial and focal point for a wide area, enjoying the loyalty of the country people from as far as the outskirts of larger and more sophisticated towns.

The wealth of Uttoxeter is founded upon its market, held mainly on Wednesdays. The open market still pulsates with a life and atmosphere that defies change. In the illustrated guide to the North Staffordshire Railway published in 1908 is found the following description, which could have been written today, *"It is well attended by the country people from the surrounding district and buyers from the adjacent towns, and it is a most interesting sight to see the market practically conducted on the same lines as 100 years ago."*

The market exemplifies the richness and depth of local country life. Among the tightly packed stalls can still be seen the occasional trader or cottager offering home-produced goods for sale, a practice known as "selling on the stones". The market traditionally specialized in butter, which was sold in unglazed cylindrical pots from the nearby Pottery towns. The traditional scene owes its continuity to the livestock market which exudes life and atmosphere. Around the pens, farmers engage in barter and intercourse that is as old as farming itself. Though the atmosphere is essentially friendly, the yards are peopled with two classes of people, farmers and others. Not all come to the market for business alone. It was a tradition for many to spend much of this weekly event in the inns of the town. Even before the extension in drinking hours, it was possible to drink virtually all day in Uttoxeter on market days. In the days of horse drawn transport, many a loyal horse dutifully brought its oblivious master safely home!

In addition to the regular weekly markets, Uttoxeter had a number of special fairs. In mid September a special fair was held to accommodate the damson harvest from the numerous trees which lined the fields of the Needwood Forest. Hiring and Wakes Fairs were also held and these were great social events in the diaries of the country people.

In the streets of Uttoxeter one can discern the changing pattern of architecture in a typical English country town, from early timber framed buildings to the elegant town houses of the Georgian and Regency periods which line the thoroughfares. Though houses of exceptional architectural merit

are rare, the old world charm of Uttoxeter is always appealing. In recent years ancient timbers have been revealed beneath a typical red brick facade and it is clear that much of medieval Uttoxeter still awaits discovery. Town houses and the more humble agricultural dwellings are constructed with a distinctive gingerbread coloured brick which was obviously manufactured locally. As in many English towns the wide space of the market place is dominated by the church steeple. This great pile is typically early 14th century and is all that remains of the medieval church. The tower houses a magnificent peal of eight bells, six of which were cast in 1729 by the famous bellfounder Abraham Rudhall in Gloucester. The bells are inscribed with delightful salutations to both town and country. The tenor bell carries the solemn message, dated 1729, "I to the church the living call and to the grave do summon all". The octave of bells is used by a carillon which play well-known national melodies at regular hours of the day. These chimes installed in 1874 were restored in honour of those who did not return from the Second World War.

In common with other country towns, many events of minor importance have happened which enliven the pages of local history. In 1814 the church spire was so damaged by lightning as to require rebuilding. When this work had been completed and the gilt cross and weather vane replaced, an event occurred which demonstrated the vitality that has always typified Uttoxeter girls. Mary Allport, who was a maid at the Red Lion Hotel below, climbed to the top of the spire. There she fondly kissed one of the young masons around the Weather Cock. Not to be outdone, her friend, Sarah Adams, also climbed the terrifying network of ladders to receive her own reward in an embrace.from another young tradesman. These feats were accompanied by cheers of approval from the crowds assembled below. It is probable that these daring exploits were the fulfilment of amorous relationships which had started when the young masons enjoyed a drink after work in the company of the girls. This suspicion is strengthened by the fact that both couples were later married. The Red Lion Hotel, which stood on the corner of the Market Place, was to continue as a major Uttoxeter hostelry until the demise of Parkers Brewery. The cellars of this former inn are said to be haunted by the ghost of a policeman who committed suicide when a later barmaid refused his attentions.

Early Uttoxeter

The name and pronunciation of the town has changed through the centuries. The town also gives its name to one in Canada. All the various forms indicate Roman foundation, though mysteriously little evidence of a settlement has been discovered. In 1927 coins, pottery and an inscribed stone were unearthed in the north east of the town. Unfortunately the finder was not anxious to seek

attention and no further attempt was made to investigate. The site would have been suitable for a Roman settlement, being both well drained and overlooking the Dove Valley. Further searches have failed to produce evidence. It is possible that the Romans used Uttoxeter as an outpost of their garrison at Rocester.

The first recorded history came with the Norman Conquest when Uttoxeter became part of the De Ferrer's domains, a vast holding that had Tutbury Castle as its administrative centre. In a unique form of land settlement and commercial exploitation, Robert de Ferrers established satellite towns to supplement Tutbury. One of them was Uttoxeter charged with the smelting of iron which was for the supply of implements, tools and weapons to the whole Honour of Tutbury. At that same time, the market was established. Uttoxeter continued as an appendage of Tutbury throughout the tenure of the De Ferrers and their successors, the House of Lancaster.

Loyalty to the Stuart Cause
At the start of the Civil War Tutbury Castle was garrisoned for the King, and so remained until further opposition was futile. During these years, Uttoxeter was repeatedly levied for cash, provisions and men to maintain the Tutbury garrison. Charles I stayed in the town on three occasions. On the first, shortly after the start of the war, he was greeted by the ringing of the bells and the acclaim of the townspeople. However on the last occasion, as they sensed the hopelessness of his cause, an ominous silence prevailed. On that visit sentries had to be positioned on the church tower. After the fall of Charles, the victors were unable to find sufficient volunteers to raze Tutbury Castle and men from Uttoxeter had to be conscripted into this disagreeable work.

In an attempt to reverse the result of the war, a Scottish army led by the Duke of Hamilton invaded England in support of the Stuart Cause. After initial success, they suffered defeat at Preston. The Scottish Army carried on in the expectation of English support. Not for the last time the English royalists were reluctant to rise to the Cause. The last remnants, having reached Uttoxeter, surrendered, thus saving the destruction of the town. Many of these dispirited troops, in the absence of an alternative were imprisoned in the church. The frustrated prisoners desecrated the church, presumably because of their natural antipathy to an alien land and also because their guards were reluctant to protect the Church which had supported the King.

Following the collapse of the Stuart cause, Tutbury declined into insignificance, as Uttoxeter thereafter grew progressively. Loyalty to the House of Stuart was to continue as a latent force for many years. When the Jacobite Army passed through Ashbourne en route to Derby, much uncertainty prevailed. Many were the secret Jacobites who were hoping for the success of the Stuarts,

but who kept their options open. On the other hand wealthy and establishment figures were concerned at the prospect of a Jacobite victory and repaired with their valuables to the wooded valleys of the Needwood Forest. During the passage of the Jacobite army isolated parties of Highlanders were engaged in acts of pillage in the surrounding areas, particularly at Foston, Scropton and Sudbury. While the Prince held court at Derby, the Duke of Cumberland entered Uttoxeter to cover enemy movements and collect intelligence. He stayed two nights at the White Hart Hotel before leaving to shadow the Scottish withdrawal. For many years afterwards a group of Uttoxeter Jacobites continued to meet annually ironically in the White Hart. This attitude was typical of the stay at home supporters who had been contemptuously described by the Scots as "Drinking Jacobites". The ceremonial cup which was used for their toasts still existed into Victorian times, as did their secret plans. How exciting it would be if these relics could now be discovered.

The Holy Wells of Uttoxeter
For many years Uttoxeter continued to preserve its holy wells. One of these was Pennycroft Well which was situated in the north east of the town. Francis Redfern writing in 1865 records that it had lately been turned into a drinking place for cattle, though in previous times it had been decorated with flowers. According to legend the well's waters possessed curative powers because of their sulphur content. Another well was to be found on the side of the road as it entered the Needwood Forest. This, called Maiden's Well, was also claimed to have curative properties during the last century. It was also alleged to be the haunt of ghosts, particularly that of a girl whose beauty and charms surpassed description, yet who for ever remained unapproachable. This well, whose source is a natural spring, was excavated in 1873. A sandstone column possibly bearing Ogham script was found. Such Ogham inscriptions are of Celtic origin and indicate great antiquity.

The Decline of Uttoxeter
Uttoxeter, like most rural towns, formerly supported a number of local industries. One of the most renowned was the manufacture of long case clocks. The names of those now forgotten craftsmen are to be found on the faces of family clocks in the farms and cottages of the neighbourhood and increasingly in specialist shops.

The town formerly supported its own brewery, Bunting's. As if in rehearsal for the wholesale brewery mergers of today, the proud undertaking was taken over by Parkers of Burslem and closed in 1928. Parkers replaced the town's distinctive brew with their own, which became affectionately known as

"Parker's Purge". The Burslem brewery was itself acquired by Ind Coope and Allsop in the early 1950s, and from then on the story has become only too familiar. The last remains of this brewery have recently been demolished.

Like everywhere across the land, many of the staple and family businesses which so characterized the town have gone. The great Bamford Works, which for over a century was established as a major world designer and manufacturer of agricultural machinery has closed. This famous undertaking was a pioneer in farm mechanization and made the name of this little Staffordshire town famous across the world. It remained family managed throughout its existence.

Other well known businesses such as the friendly Yellow Bus Service, whose routes linked the surrounding villages with Uttoxeter, have become parts of a larger combine. The town's old newspaper, known affectionately as "The Stunner", has fairly recently been taken over by a larger group, with the result that its old world format and style have become lost. One industry still thriving is the Elkes Biscuit Factory. This has grown from the family firm that proudly produced the cake for the wedding of HM The Queen.

The station at Uttoxeter was formerly a junction on the North Staffordshire Railway, with branch lines to the Churnet Valley line, Buxton and Ashbourne; while the Great Northern Line, led to Stafford. This latter line, originally promoted by the Earl of Shrewsbury became known as the "Clog and Knocker Line". It was to become an early closure when competition grew from road transport. The regular goods service ceased in 1951 though a train was run in 1957 by enthusiasts. The once grand station, with its elegant Booking Hall, decayed into a derelict shell before final demolition and the provision of halt status on the remaining through line.

While these developments are typical of many other towns, what is unusual at Uttoxeter is the loss of local government control. This started in 1974 when Uttoxeter, as part of the reorganization of local government was forced into a merger with the Tutbury and Burton-on-Trent authorities. The merged authority, dominated in population terms by Burton-on-Trent, has seen a decline in the representation of the rural interest. Further, the local offices and services on which the country people rely are progressively closed. Even the vital cattle market is now threatened.

One local institution which is prospering is the racecourse, which has an attractive setting below the rising slopes of Needwood Forest. The course was opened in May 1907 with the active support of the local gentry and the Meynell Hunt. Following closure during the Second World War, the racecourse seemed to face demise until the Uttoxeter Urban District Council re-opened it and improved the amenities. The course was threatened again after it was inherited by East Staffordshire in 1974, but the future now seems secure following its

Uttoxeter: A medieval corner.

Uttoxeter in the 1920s: The Red Lion.

acquisition by Mr S.W.Clarke who has enabled this beautiful rural course to become a leading centre in the world of the Turf. A native of Needwood Forest, Mr Clarke has risen from modest origins to head several major national companies, and his proudest moment was as the owner of the Grand National winner in 1997.

Mary Howitt

Uttoxeter was for many years the home of Mary Howitt, a forgotten Victorian writer, who came here in 1798 as a little girl with her family. Her parents were of Moorland stock and, like many in North Staffordshire, were Quakers. In her writing, she had an innate ability to enter the mind of a child and to project the essential wonder and enquiry which awakens the beauty of creation. Her writing for the young now seems dated, but it remains a key by which little minds can be opened. She was the first to translate Hans Christian Andersen into English. Possibly her best known work today is the long poem, "The Spider and the Fly", in the often forgotten stanzas of which are to be found many moral meanings. Mary was to marry William Howitt, also a Quaker. During their long marriage they were both prolific writers and travellers. Through her adult life she became disillusioned with her Quaker background and was progressively drawn to the Catholic faith. She had long been in contact with the Faith, the Pugin church at Uttoxeter having been opened in 1839. She was finally received into the Church shortly before her death in 1888, by which time her only reading had become the Catechism.

Although she was to spend much of her later life away from Uttoxeter, she retained her love for this little country town. As a child and adolescent in Uttoxeter, she heard the legends and folk tales of the area from the poor people and from her sensitive interpretation of those we can rediscover a vivid folk history of the town. She had an intimate knowledge of the dark forest, its associations, legends, mythologies and characters.

The Legend of the Ghostly Abbess

One legend is that of a mythical abbess who when approaching the town with another nun, became lost in some marshy area within the Needwood Forest. They had become fearful until they heard the curfew bell at Uttoxeter and were guided to safely. However the abbess fell mysteriously ill and died three days later, leaving a bell full of coins for the continuance of the ringing of the curfew. Tradition records that the abbess was buried in the church. Some legends say that she and her companions had originated from Hanbury after it had been sacked by the Vikings. Again we are grateful to Mary Howitt for recording the legend in *Chronicle of Wood Leighton*, (a book which was in reality an account

of her beloved home town). During the demolition of the old church nave in 1828, a long forgotten alabaster tomb was found. This was so heavily coated by the dust of ages as to resemble a mummified corpse. The townspeople were quickly reawakened to the legend and believed that the long lost abbess had now been found. Sadly their euphoria was soon extinguished when the tomb was cleaned and the dress indicated that the figure was of a young noblewoman. Later research revealed the figure to be of one Elizabeth Hussey who died in 1523. The tomb still reveals the beautiful feminine lines of a petite young figure. Sadly the once lovely face and body is defaced, possibly by the Scottish prisoners whose Presbyterian sensitivities may have been offended. Following the tombs discovery after centuries of being hidden, the feet of the lady were arbitrarily sawn off to enable the monument to fit under the stairs which were being constructed to the gallery. These feet were superbly replaced in 1889 as a gift from the Kinnersley family, who had lived at nearby Loxley Hall for many generations, and to one of whom she may have been betrothed.

Dr Samuel Johnson

Uttoxeter's most famous literary association Dr Johnson is however not with one of its own sons. The father of that great wordsmith Dr Johnson was a Lichfield bookseller who came weekly to Uttoxeter market. One morning he was unwell and unable to travel, so he asked his son to attend on his behalf. In the typical way of youth the young Samuel stubbornly refused, although he had previously attended with his father. This incident was to trouble him for much of his life until, when staying with friends in his native city, he suddenly decided to make a journey of penitence. He later recorded his own version of that penance, *"Once I was disobedient; I refused to attend my father to Uttoxeter Market. Pride was the source of that refusal, and remembrance of it was painful. A few years ago I decided to atone for this fault; I went to Uttoxeter in very bad weather and stood for a considerable time bare headed in the rain on the spot where my father's stall used to stand. In contrition I stood, and I hope the penance was expiatory"*.How many of us carry similar burdens of remorse for sins against our parents! Later an attractive domed commemorative building was erected which depicts of Dr Johnson's penance, showing his head bare to the rain. Each year in September on the anniversary of the event, a ceremony is held when a notable speaker from the academic world delivers an address on the life of Johnson and the English language.

Uttoxeter Highwood; to the Needwood Forest

Above the town to the south the escarpment of the Needwood Forest rises sharply. This area, called Highwood, was originally the Uttoxeter Ward of the Needwood Forest, the first division of the forest to be cleared. It was here that

the Uttoxeter Gibbet was situated. After falling into disuse it was last used following the Restoration of Charles II for the suppression of local Commonwealth supporters. On the eminence of Highwood stands a well moulded Bronze Age tumulus called Toot Hill. From here the views are magnificent, with the heavy profile of the church steeple rising out of the vast basin. The barrow was excavated in 1860 by Francis Redfern, the chronicler of the town. He discovered calcined remains in an earthenware pot and records that on its summit he found charcoal and other remains of great fires. These he concludes were evidence that the summit was the scene of Beltane Fires. This was a Celtic festival of druidical rites held at the beginning of May. The meaning of Toot is a lookout; it is highly likely that those former inhabitants who roamed dense Needwood used the hill as a viewpoint over the wide valley. It is unfortunate that so much excavation took place by enthusiastic amateurs in the 19th century.

From Toot Hill there is an exceptional view over much of the course of the Dove. In addition to the Vale, one can see the opening of the wide Lower Valley. This is truly a superb spot and who could better describe Uttoxeter at the head of the Vale than Mary Howitt in *Chronicles of Wood Leighton,*

"The situation of (Uttoxeter), as seen from this height, unites everything of which I can form an idea in the most beautiful pastoral landscapes. About a mile below us, at the foot of those rural enclosures that we passed on our ascent, and of which now only here and there a green slip can be seen through their abundant tress, against whose fresh vernal foliage rises the white smoke ... (Uttoxeter) is seen, with its clustered buildings and lofty spire, just where a fine valley opens into one still finer, and indeed, into one of the most luxuriant and celebrated vales of England, and down which river. I have mentioned before, flows from the wild regions of the Peak. It is just, too, where this noble and prolific valley changes its course, and leaves a flat of the most abounding meadows in the immediate neighbourhood of the town. Thus to the right, we command a view along this extensive vale in all its beauty, ... as far as the lofty ruins of Tutbury Castle; and before us, beyond the town, over another region of wood, from the midst of which are dimly seen villages and the grey halls (Alton?), to the blue and shadowy softness of wild hills, at 20 miles distance, which form the north of the county, and run into the still wilder hills of the Peak....seemingly proud to survey the scene; its thousands of cattle; its river winding though it's green expanse; and all around it a vast extent of undulating country".

Courtesy of Duchy of Lancaster
The Fallen Father of the Forest: The Swilcar Oak showing Mr McBean.

WILD CATTLE IN CHARTLEY PARK

The Wild White Cattle of Chartley: Relic of Wild Needwood.

CHAPTER 10
NEEDWOOD FOREST: THE DARK LAND OF LANCASTER

When viewed from Uttoxeter Highwood, the escarpment of the Needwood Forest rises in sharp profile. Facing north, the dense woodland presents a dark presiding line, which undulates and swirls like an ocean towards Tutbury. For centuries these were the ramparts of the dense forest that lay beyond. The Forest originally stretched nearly from Tutbury Castle to Bagots Park, a distance of 10 miles; while to the south it reached the Trent Valley some 9 miles away. The dark northern edge still presents the foreboding outward face of the old forest. This escarpment, known as Forest Banks, is the watershed; beyond it the streams flow south to join the River Trent.

Geologically the spectacular formation consists of horizontal outcropping bands of sandstones, marls, shales, limestone and rich seams of gypsum. Hidden below are beds of sulphur and salt whose location remain a mystery, though their presence is attested by the emerging springs. The plateau is generally covered by marl and clay, but many of the higher levels carry a sandy glacial till and in the past speculators vainly sunk a shaft in an attempt to exploit this material.

Early History of Needwood

There is evidence of human occupation during prehistoric times. A Neolithic axe and a Bronze Age palstave have both been found on Forest Banks. For centuries the Forest was home to Celtic people. A Promontory Fort existed above Marchington; the well defined earthworks can be clearly seen when found within the woodland. This was a lookout or defensive position above the valley. In 1848 a Torque of pure gold was unearthed by a badger. This lovely adornment, consisting of twisted wires and weighing $15^1/2$ ozs. was obviously intended to be worn by a Celtic dignitary and can now be seen in the British Museum. The Celtic tribes who roamed this dark land were largely unaffected by the Anglo-Saxon settlements. Their remoteness resulted in the retention of a language similar to Welsh into the years following the Norman Conquest. Even after the language fell into disuse the Celtic influence persisted and the area was noted for its minstrels and poets through medieval times.

Following the Norman Conquest, Needwood became part of the Honour of Tutbury; the combination of estates, rights and manors which belonged to the House of De Ferrers. Henceforth the primeval forest became an early exercise in conservational management, when the incomes from timber and game became an integral part of the Honour finances. Newborough was established

within the Forest as a satellite town to Tutbury for the bleaching of cloth, a parallel venture to the foundation of Uttoxeter. With the fall from power of the De Ferrers, the Forest became part of the possessions of John Gaunt and the House of Lancaster.

The Legend of Robin Hood

In common with other midland forests we find several references to this legendary figure. No real historical figure can be discerned through the mists of legend and it is probable that there were several bands of fugitives living within the great Greenwood during those times.

Local tradition contends that Robin Hood was born at Loxley near Uttoxeter. Other legends associate him with Chartley Castle. The strongest evidence associating him with these localities is a ballad in the Roxburgh Collection at the British Museum. The ballad is worthy of study because of its many references to specific locations and its rich portrayal of medieval England. It describes Robin as being attracted to the great Tutbury Fair by his skill at archery. Details are given of his journey, his meeting with a girl called Clorinda at Doveridge and a battle fought on the Forest. This battle is described as being, *"Fought near Tutbury Town, when the bagpipes baited the bull"*, a reference to the bull running at the Tutbury Fair. By repute the location of the fight was the old inn on the summit of Marchington Cliff. This inn, called the Robin Hood, has long been closed and the old building demolished. The ballad continues to a happy ending with his marriage to his beloved Clorinda (not Marion) at Tutbury, *"The parson of Doveridge was sent for in haste. He brought his Mass Book, and bid them take hands, to join them in marriage full faste"*.

Modern scholars are now treating these stories with more credulity and it is possible that Robin was a Staffordshire man. It is further suggested that the Robin and his companions were members of the Ferrers family who were forced from their estates after their rebellion of 1264. Another association with Robin Hood is to be found in the Abbots Bromley Horn Dance. In the isolation of the old market village this unique event has continued for centuries. Some contend that it is was initially a fertility right, while others suggest the event had its origin in forest rights. The complicated steps and unique ritual, has six Horn Dancers simulating deer, and a portrayal of Robin Hood and Maid Marion!

The Royal Hunting Forest

After the accession to the throne of the House of Lancaster in 1399, Needwood became a Royal Forest and the enforcement of Forest Law was pursued with vigour. Tenants whose land adjoined the Forest were particularly aggrieved by marauding deer. These hapless peasants became the victim of fines and

punishment because their lands had originally been gained from the Forest. After unrest in 1446 the Duchy Court at Tutbury Castle ruled that the limits of Forest Law were to be defined and enclosed by hedges, banks and pales, which remained until disafforestation. Some examples of these demarcations survive at Hanbury Woodend.

In addition to the exploitation of the natural wealth of the Forest, the area became a famous hunting ground, particularly for the Kings. On one visit Henry VII became separated from his companions. On emerging from the thickets he enquired directions at a cottage. Though the King did not identify himself, he was invited into the poor man's house for hospitality and proudly shown the newly born boy triplets. The King, to the surprise of his humble host, promised to pay for their education. The poor man was even more surprised when he learned that he had entertained his King, and that the King actually kept his promise. One of these sons was later to become Master of the Rolls.

Needwood later became popular with the Stuarts. Mary, Queen of Scots, was a prisoner at Tutbury under the liberal care of the Earl of Shrewsbury. She enjoyed hunting, and from childhood was a fearless rider who loved the chase. The watchful Shrewsbury obviously felt that the isolation precluded any attempt to secure her escape. Later her son, James I, did not allow this association to dampen his enthusiasm for Needwood, particularly the eminence between the Lin and Mare Brooks; which became known as Kings Standing. His son, Charles I also came here for sport. Following the Civil War, Cromwell ordered a valuation with a view to clearance to offset the debts of his Army. In short, the assets of the vanquished were to be sequestrated to pay for his victory.

The Fall of Needwood
Following the Restoration, the Forest was saved, but for the next 150 years it remained under threat as Georgian royalty had little interest in hunting. In his "History and Antiquities of Staffordshire" of 1798, Rev Stebbing Shaw in a lengthy evaluation of the Forest in comparison with its agricultural value concluded that the continuance of the prevailing situation was indefensible. William Pitt in his "Topographical History of Staffordshire", agreed with these conclusions, though with the skill of a politician he also recognized the contrary argument, *"I cannot help observing however that, much as I agree with him upon the great public utility of enclosure, yet to the eye of an admirer of picturesque scenery in all its wild and natural beauty, such a plan would doubtless be an insufferable innovation".*

The days of wild Needwood were indeed running out. Sir Oswald Mosley described the opening of the 19th century as having an "enclosing mania". An Act of Parliament in 1802 was made for the enclosure of Needwood and the

division of its lands. It was 1811 before the final allocation was made to balance the claims of tithe holders, the claimants of traditional rights, with those of the Duchy of Lancaster. This division ensured that the Duchy remained the dominant influence. Today the Lancaster estate, which dates from that allocation, covers some 7,500 acres of which 1,300 acres are woodland. After division the sylvan mantle was progressively removed as the new owners exploited their lands. Sir Oswald Mosley sadly recorded, *"A scene of melancholy devastation rapidly ensued; the trees which had hitherto clothed it in all the rich luxuriance of unrestrained nature, were felled in every quarter.....The coverts and underwood were quickly cleared away, and a dreary waste appeared on every side..... relieved only by a few picturesque groups and charcoal burners and woodmen."*

Francis Munday, the Bard of Needwood, in mournful verse recorded this heartbreaking scene in his *Fall of Needwood*.

> *"How changed! those oaks that towered so high,*
> *Dismember'd, stript, extended lie,*
> *On the stain'd turf their wrecks are piled*
> *Where a thousand summers bask'd and smil'd,*
> *In smouldering heaps their limbs consume,*
> *The dark smoke marks their casual tomb".*

Following the allocation of lands, a large central block of forest still survived into the middle of the 19th century. This area was later acquired by newly enriched industrialists to establish a series of estates on which magnificent mansions were built, which greatly contributed to the character of the area and also created much employment. By the close of the century almost the whole of Needwood was covered by estates. Unfortunately by the middle of this century, nearly all of these had been broken up with the result that the parks, where for many years the spirit of old Needwood lived on, have been converted into farm land, while the woodlands have generally degenerated.

Management of the Needwood Forest

At the time of clearance the Forest covered 9,400 acres with a circumference of 23 miles. Overall control was vested in the High Steward of the Honour of Tutbury who was responsible to the Chancellor of the Duchy of Lancaster. The responsibility for forestry was vested in the office of Axe Bearer who resided at New Lodge, Hanbury. For detailed administration, the Forest was divided into 5 wards, Tutbury, Marchington, Yoxall, Barton and Uttoxeter. In each of these wards there was a Lodge where local officials were situated. Offenders against Forest Law were tried before the High Steward in the Woodmote Court held at

Byrkley Lodge: The lost mansion of the Bass family.

Byrkley Lodge in Tutbury Ward. (In the 19th century on this site a magnificent mansion was built by the Bass brewing family. It was demolished in 1954.) The management of this vast forest and its game required numerous officials. During the reign of Henry V a document called the Coucher defined 23 such officers under the Crown.

The prime income from the Forest was building timber. Major timbers were called "Houseboote" and smaller timbers "Hayboote". The latter were required for the construction of timber framed buildings and came from the branches of the wider crowned trees. Material for the manufacture of ropes was produced by stripping the bast layer from lime trees. Alder was in demand for the provision of scaffolding and vast supplies of firewood were always required. From the 15th century the burning of charcoal was suspended when it was realized that the forest cover was being seriously depleted. At enclosure, in addition to an estimated 3,000 deer, cattle and horses roamed the Forest. These, the property of the Freeholders from the surrounding villages, were rounded up and branded with their village mark. Another valuable harvest was Pannage which was obtained by the grazing of pigs, particularly during the autumn. The falling acorns were a valuable food source for the pig and the regeneration of oak benefited from the acorns being buried by the foraging animals. Henry de Ferrers gave such rights to Tutbury Priory, a right which was greatly valued.

The Foresters; a Bygone People

The robust people living on the edges of the Forest wrested a living from the great Greenwood. For long they retained Celtic features, which the writer still noted amongst the traditional families during the 1950s. To these inhabitants the herds of deer provided a rich resource. It was well known that forest deer tastes better than from parkland animals. In deerstalking many achieved fame and notoriety in local legend.

A common guise was to appear to be leading a cow through the woods at twilight near some grazing deer, before a carefully concealed gun was produced. The carcase would then be hidden in undergrowth before later removal under cover of darkness. Mosley has left us a vivid pen portrait of one such notorious individual called Wilmore, who supported his family from the fruits of the Forest.;

"He had two small cows depastured in the summer, for which he provided some hay from the land around his cottage; his fuel he obtained from the neighbouring woods; and his food was in a great measure supplied by his successful attacks upon deer and game. His strength and activity was more than a match for any keeper; and his company so agreeable, that the under keepers themselves found it irresistible whenever they chanced to meet him in an ale house, as he engaged them in drinking. When he saw a convenient opportunity, he would steal away, to kill a buck or doe in the recesses of the Forest. A screw-barrelled gun was always his companion upon these occasions, the greater part of which was concealed within the lining of his coat; a dog was also taken with him, the diminutive size of which was supposed to render it harmless, but this little creature had been well trained by its master. Thus attended, he used to ascend a tree on the edge of a small plain (an open area), with which the Forest abounded; and by a well known signal, his dog would ramble about until it met the deer; the instant it had attracted their attention, this cunning animal would away, apparently in great alarm, and the finest bucks, together with the herd, soon joined the chase. When it had thus amused them for a short while, it would skulk off to the tree in which it knew its master to be fixed, and would take its stand just below it, whilst the deer stood at a short distance from it. This was the moment that Wilmore seized upon; his aim was certain".

This formidable man eventually died one September evening after killing a deer within view of the keepers at Byrkley. After a fight he escaped, only to be waylaid as he tried the cross the swollen waters of the Lin Brook. There another ferocious fight ensued in which he sustained severe injuries. He again escaped through the familiar thickets, heading towards a quaking bog where he

hoped to avoid his pursuers. In the gathering darkness and as a result of his injuries he fell into the mire to rise no more; he had drowned. Remains of this bog existed until the 1960s, situated near Rangemore. Many of these professional poachers had a secret chamber built into their cottages. Ash Bank, the home of one Malabar, became known as Venison Hall, on account of the number of carcasses which could be concealed there.

We are told that Wilmore was a great favourite in the ale houses which were a feature on the edge of the Forest. We have already encountered the Robin Hood Inn. Below Woodedge was to be found the Cat and Fiddle, which was not only renowned for poachers, but also for women of dubious morals. Another haunt was the Royal Oak near Tomlinsons Corner. Most of these humble taverns have long vanished, though some have survived as enlarged establishments, such as the still old world Crown Inn at Hanbury Woodend.

Following deforestation the new land owners found they were having to share the game of their newly acquired land. Although the estate owners regarded the game as their legal right, the Foresters felt their rights were being taken away. These were bitter men, for with the loss of their traditional rights, they had become landless peasants. To suppress poaching the gentry established an authoritative body aimed at suppressing the activities of the former inhabitants by appointing keepers and paying rewards for informants. The situation had become even more bitter than in the days of the Game Laws.

On clearance much of the northern area was divided into very small holdings. These were allocated to the Freeholders, their size proportionate to the value of the individual's Forest Rights. Working these smallholdings enabled their individuality to survive into recent times. Sadly modern farming methods and large scale farm amalgamations have led to their demise and the Needwood plateau has now become an open arable landscape with fewer trees.

Beneath the edge of the Forest the escarpment breaks down into a profusion of little hills with damson lined pastures. In spring this presents a beautiful sight as the little hills carry a raiment of blossoms. In the folds of the hills are little hamlets of cottages and small farms which were the homes of the pre-clearance Foresters. Built of soft red brick they are an attractive sight when seen in the falling light, with their friendly smoke rising and curling beneath the enveloping woodland. In the past everything possible was harvested from the woods, the cottages usually having a bread oven fired by oak brash and using wind blown sticks for kindling; bracket fungi for sharpening razors, oak bark for tanning and even a humble holly bush for sweeping the chimney. In recent years these traditional cottages have increasingly been bought by outsiders and modernised. Sadly character has been lost and in the future, Needwood will be indistinguishable from other areas as all signs of its past glory disappear

The Forest

Before clearance Needwood would have presented a menacing mass of intractable forest, especially at the close of a winter afternoon. The tracks from the peripheral communities entered at a series of gates in the well defined perimeter. Within the Forest the way often became lost in the trackless waste, a hazard to both man and horse seeking journeys end in the gathering gloom. The former access points are now usually occupied by a collection of cottages bearing the names of the original gates. Since clearance, travelling over the Forest has become very different. To give access to the newly won lands, a series of wide straight roads were laid out radiating from central points. The bounds of the Forest as established by the Duchy Court still remain recognizable as typical English lanes suddenly become straight for miles ahead.

Thankfully, some large blocks of forest were retained. These were mainly on the steep slopes of Forest Banks which precluded the plough. They were retained as part of the Duchy of Lancaster estate and today bear witness to successive forestry practice. Needwood had always been predominantly an oak forest, being the natural climax forest on these rich but heavy soils, and the earliest plantings were still dominated by oak. Prior to the First World War, a radical new Head Forester was appointed to replace the traditional office of Axe Bearer; a Mr Mc.Bean who was to remain a formidable personality at Needwood for some 40 years. He was the first to introduce conifers on a large scale. This altered the character of Needwood, as the dark plantations contrasted with the adjoining open crowns of the oaks. However, the European Larch which particularly thrived on the sandy outcrops, gave the Forest new beauty with the delicate new flush of soft foliage in spring.

During the Second World War large areas of these plantations were prematurely felled as part of the War effort. This was a major operation in which large gangs of men were deployed and even light railways laid through the woods. However afterwards there were further changes in sylvicultural tastes and oak was again included in the planting prescriptions. It is sad to reflect that in the last thirty years many giant oaks which dated from the old forest have been felled. However there are still some majestic specimens surviving, a delightful sight to the conservationist and timber merchant alike. It is to be hoped that some giant oaks will remain forever, for when they have vanished, the old Forest of Needwood will finally have been lost. The Duchy of Lancaster woodlands continue to be managed commercially with a comprehensive planting programme based on sound forestry practice.

Without doubt the greatest Needwood oak in recorded time was the Swilcar Oak which stood at a place called Swilcar Lawn above Forest Banks. This was known as the Father of the Forest. In 1832 Mosley described this 600

year old giant as having a girth of 21ft. In Victorian times this survivor of the primeval forest became a favourite spot for fashionable picnic parties. At that time, it would have been struggling to survive as fungal infection spread through the trunk, progressively causing branches to be shed. The writer can remember the tree as a decaying wreck which was finally destroyed by lightning in 1944, when it vainly carried sheets of lead to protect the broken limbs.

The Wild Forest

In its pristine glory Needwood was a sanctuary for wildlife now extinct. The wild boar is known to have existed until comparatively late times, exterminated possibly because it competed for profitable Pannage, as well as providing thrilling hunting. The wolf would have been exterminated because of its depredations of domestic animals. Until the time of enclosure many creatures survived which required large tracts of forest. Though both red and roe deer were present, it is the fallow deer which are now principally encountered. Since the 1960s the cervine race has been supplemented by the diminutive Chinese muntjac deer. These solitary creatures which hide in the bushes and brambles have spread by escapes from collections. The badger continues to be found in the Forest usually on the steep banks of some secreted dingle. It is remarkable that this harmless creature should have survived despite the onslaught by successive gamekeepers. In 1863 Mosley doubted whether it could do so in the face of such persecution. Gamekeepers also continue their depredation of foxes on an increased scale. A few generations ago the killing of a fox on Needwood, except by hounds, was treated as a crime more heinous than treason.

In historical times one species of animal associated with Needwood was the White Cattle. These animals roamed the Forest until the De Ferrers transferred them to Chartley Park during the reign of Henry III (1216-1272). It is thought that these fierce denizens of the forest glades gave the Forest its name, Needwood being derived from Neat, the ancient name for cow. Chartley Park was originally a portion of the Forest when it stretched much further to the west. The great park remained a wild tract of open woods until earlier this century. The cattle were white, or rather a cream colour, with sharp horns tipped with black. Their ears and muzzle were also black. The animals were similar to the herds which can still be seen at Chillingham in Northumberland and Dinefwr in Carmarthenshire. The herd would occasionally produce a black calf; in past generations this was regarded as a harbinger of ill omen to the Ferrers family. Sir Oswald Mosley in "Natural History of Tutbury" records this description, *"The Chartley cattle are wild; when alarmed they run off to some distance, and then suddenly turning about, they look at the object of their terror, and assume a menacing attitude by shaking their heads and tramping the soil*

with their feet; they repeat these flights and halts several times, but each time their flight shorter and their menaces bolder. In a winter, however, they are much tamer, and willing to receive support from the hand of man. The cows hide their calves in some thick covert, but visit them at intervals for the purpose of suckling."

When the De Ferrers were deprived of the bulk of their estates following a rebellion, they were able to retain Chartley until earlier this century, when the great estate and its wild park were sold. The herd was obtained by that collector of parkland animals, the 11th Duke of Bedford. Though an eccentric recluse, the Duke secured the survival of many endangered species in his park at Woburn Abbey. Recently, the current owners of Chartley have restored some of these animals to the park.

Bagots Park

Not all of Needwood came under the control of the Duchy of Lancaster. A large extension to the west was given at the time of the Conquest to the Bagot family. Like the Duchy lands their area too clung to the escarpment and for centuries the two great estates met at Buttermilk Hill. This is a spectacular narrow road which cascades steeply down the escarpment edge. It is claimed that the road was so uneven that milk turned into butter during transit.

The Needwood Forest terminates in Bagots Park, a great expanse of open forest, which was a wild area of bracken-covered wilderness studded with ancient wide-crowned oaks. The Park was in fact a primeval area of the forest which survived for centuries as a vast hunting park of more than 1,000 acres. The open park was surrounded by areas of woodland, especially the great Bagots Wood which exceeded 900 acres. The whole vast expanse was enclosed from an early date by a fosse with mound which carried a cleaved oak fence. Many lengths of this remain to this day. The soils of Bagots Park are not particularly fertile but have slowly produced some of the greatest oaks of England. These were the object of many a visit during the last century. The Beggars Oak had branches spreading 48ft from the bole; it was said that the tree was large enough to shade a troop of cavalry. It is recorded that in 1812, £200 was offered for the timber in this tree. None of the trees was more spectacular than the Walking Stick, an immense tree that had grown as a perfect cylindrical bole to over 70ft without a branch. It sadly fell in the 1980s.

The Bagot Family

The earlier lineage of the Bagot family lived at a moated manor, appropriately called Bagots Bromley, before a marriage with an heiress to the adjoining Blithfield estate in the 14th century. Since that time the fine medieval Blithfield

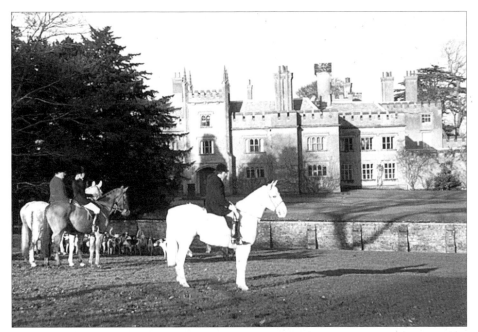

Home of the Bagots: The fine medieval Blithfield Hall.

Hall has been their home. As this house overlooks the River Blythe, it is outside the catchment of the Dove; however as the estates of this great family belong to the Forest, its place in history deserves further attention. The family continually rose to the call of their sovereigns during the wars against France, being found on the fields of Crecy, Poitiers and Agincourt. One Richard Bagot was charged with the detention of Mary, Queen of Scots in conditions of great surveillance at Tutbury and later at Chartley Castle. His grandson, Sir Hervey, raised a regiment from his estates to the cause of Charles I. This regiment, commanded by his son, saw action during the siege of Lichfield and supported the royal cause on the disastrous Field of Naseby, where Bagot was killed. The fall of Charles I was a disaster for the family and it was only with the Restoration that the Bagots avoided total ruin. In later times Sir Charles was a successful diplomat, who was involved in the international settlement following the fall of Napoleon; later in Canada as Governor General, he was responsible for the definition of the border with the U.S.A. In 1880 the Bagot estates comprised of 10,841 acres in Staffordshire.

The Bagot Goats
For centuries, through the leafy glades of Bagots Park roamed the famous Bagot Goats. Similar goats were used on Crusade by Richard I, when milk and meat

Courtesy of Lady Bagot

Bagots Park: The Beggars Oak and Bagot's goats 1826.

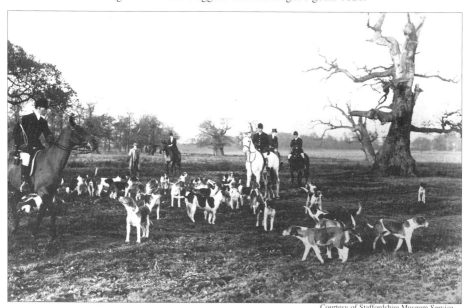

Courtesy of Staffordshire Museum Service

The Wilderness of Ancient Oaks: The Meynell Hunt Meet, Bagots Park 1925.

Beggars Oak in the 1920s:
With the well-known
Uttoxeter photographer
G. McCann.

Courtesy of Staffordshire Museum Service

The Bagot Goat:
Symbol of a dynasty.

on the hoof were vital to armies on the move, and these goats are identical to those found in the Rhone Valley through which the Crusade marched. Richard II enjoyed hunting on the demesnes of his courtier, William Bagot, who was a major influence on the King, and after one particularly enjoyable hunting trip, the King presented the goats to Bagot.

Did Bagot gain satisfaction from entertaining the King on the very edge of the demesne of John of Gaunt, against whom he consistently conspired? The tradition of the goats became inseparable from the family. Local legend proclaimed that if the Goats died out, the Bagot family would depart. The herd normally exceeded a hundred and were overseen by a goatherd appointed by Lord Bagot. The last incumbent was an old lady, Miss Jackson, who until the 1960s remained diligent in caring for her charges, even in heavy snow. The goats were obliged to share the wide demesne with fallow deer, which at times broke out to replenish the depleted stocks of the Needwood Forest.

The End of the Bagot Domain
The wild glories of Bagots Park survived unviolated until 1933, when the pressures of the 20th century penetrated this primeval land. The direct Bagot line had been extinguished with the death on the Somme of the nephew and heir to the 4th Lord Bagot. In the event Lord Bagot was succeeded by an elderly kinsman, who was forced to sell 7,000 acres and the finest timber to alleviate death duties. Included within the sale was all the worthwhile timber within the woodland, together with over 600 superb park grown trees, possibly the finest parcel of timber ever to come under the hammer. It is interesting to note that the Walking Stick was specifically excluded from that sale on the orders of Lord Bagot. At the auction in Rugeley the sale realized £26,240, which was a sum of modest proportions when compared with the £1,000 which had been offered to the previous Lord for 10 trees. His Lordship's reply to the offer was typical, *"The Bagots are not timber merchants"*. There had been a long association between the family and their oaks which had been recognized by Stebbing Shaw in 1786, when he described the Park, *"An additional property of £100,000 value at least, to the noble and worthy owner; whose taste for preserving such picturesque beauties of nature and valuable relics of his ancestors rarely suffers them to fall beneath the woodman's ravaging blows"*

For years following the sale gangs of skilled men worked on the felling in the Park. Many of these came from the village of Wheaton Aston near Stafford, where tree felling remains a strong tradition. Most of these men would cycle from their native village on Mondays, to spend the working week here.

Before the Second World War the 5th Lord Bagot sold most of the remaining estate, including the Hall, to the South Staffordshire Water Works

Co. as the site for a reservoir. However, his Lordship was allowed to live there for the remainder of his life. During the War a kinsman serving with the Royal Australian Air Force found the lonely old 5th Baron, living in conditions of melancholy decay. He wrote home enthusiastically describing his visit to the ancestral home. Sadly, this young officer, who had descended from the Irish Ascendancy branch of the family, was killed on active service. *"An old servant came and took me in, up the back stairs to the one sitting room used by Lord Bagot. He lives in three rooms out of 82 and is a lonely, but charming old man. He took me all over the house, which must be one of the most complete museums in existence."*

The influence of this sad peer over his depleted estate was minimal; the Bagots Wood was sequestrated for ammunition storage, while the Park was used for war time arable production. To achieve these aims, many more wooded areas were cleared. In 1946 the 5th Lord was succeeded by another elderly cousin who had lived much of his life in India. Arriving from Australia to arrange for the final closure of the house, he and Nancy, his young wife, fell in love with Blithfield. They decided to buy back the Hall and grounds, and the unenviable conditions did not deter them from devoting the rest of their lives to revive the sinking family fortunes. The writer is privileged to remember this last resident Lord Bagot as an amiable and approachable elderly gentleman. Without his enthusiasm it is certain that Blithfield would have been demolished and much of beauty destroyed. Since his death in 1961, Nancy, Lady Bagot has striven to maintain as much of the Bagot tradition as possible.

Sadly it was found impossible to maintain Bagots Park and it was finally sold by the 7th Lord. The present 9th Lord Bagot lives in Wales. Subsequent ownership has resulted in the conversion of the former wild paradise into a sterile barrenness, above which the omnipresent skies must surely shed tears of grief. The surrounding woodlands were acquired by the Forestry Commission who have replaced the degenerate woodlands with dark compartments of pine. These are clearly seen from the Dove Valley, though the management plans allow for a return of oak as the final climax.

With the Park cleared and cultivated, the only remaining habitat for the goats were the woodlands where their continual browsing was unacceptable. Initially some goats were transferred to Blithfield when Lady Bagot opened the house to the public in 1956. When the Hall was closed to the public in 1978 the remaining animals were transferred to the care of the Rare Breeds Survival Trust. The fateful legend had sadly been proved correct; for with no goats in their demesne, the domain of the Bagots had passed away! On the final sale of the Park a branch of the family living at Levens Hall, Cumbria, bought a number of goats to maintain the family tradition there.

Francis Noel Munday; the Bard of Needwood

Following the fate which befell the major part of Needwood, its spirit lives on in the brooding line of the Forest Banks which continue to pulsate with life, song and a distinctive magic; the sound of a myriad of rills rushing though the deep valleys to join the Dove below; the euphoria of the first signs of spring emerging from winter's heaviness and the moist soils decked with masses of primroses and dogs mercury. Needwood's floral climax is on the drier soils of the slopes or flats, when the bluebells break into bloom, their individuality lost in a fragrant, misty veil of beauty that stretches to infinity.

The peculiar beauty, mystique and spirit of the Forest was recognized by Francis Munday, who came from a Derbyshire family who were squires of the Markeaton estate. Markeaton Hall was demolished during the 1960s, but the grounds remain as a municipal park in the suburbia of Derby. In the closing years of the 18th century Francis Munday rented Ealand Lodge, in a wide valley surrounded by the forest. Here he was inspired by the wild countryside. Through his now forgotten stanzas, we can return to wild Needwood. The diction and metre of his long poems are typical of the 18th century, but his lines portray a deep understanding of the beauty and spirit of his surroundings. He interprets the magic and illusions of wild nature through sensualistic and secretive analogy, likening the forest to a voluptuous yet evasive wood nymph who delights the passions. Imagine the vision of a green-robed nymph, with loose hair (a contemporary illusion to wantonness), bare breasts and legs displayed in tight-fitting and high-heeled leggings!* (i.e. Buskined) Yet this was not written to describe an erotic encounter, but to explain the fantasy of the wild and unobtainable in a pristine dawn,

> *"Needwood! if e'er my early voice*
> *Hath taught thy echoes to rejoice;*
> *If e'er my hounds in opening cry*
> *Have fill'd thy banks with ecstasy;*
> *If e'er arrayed in cheerful green*
> *Our train hath deck'd thy wint'ry scene;*
> *Ere yet thy wood wild walks,*
> *My tributary verse receive;*
> *With thy own wreath my brows adorn*
> *And to the praises tune my horn!*
> *What green rob'd nymph, all loose her hair*
> *With buskin'd leg,* and bosom bare,*
> *Steps lightly down the turfy glades,*
> *And beckons tow'rd yon opening shades?*
> *No harlot form dissembling guile,*
> *With wanton air and painted smile,*

Lures to enchanted halls and bowers,
Where fetive vice consumes his hours.
Her mild and modest looks dispense
The simple charm of innocence:
And a sweet wildness in her eye
Sparkles with young sincerity.
Lead on, fair guide, ere wakes the dawn"

The escarpment of Forest Banks marks the southern boundary of the land of the Dove. At eventide, darkness gradually creeps amongst the remaining thickets and dells, the raucous cascading calls of the warning blackbird fall silent and the gathering stillness is broken by the melancholy call of the tawny owl. At these times the forest returns to the world of beauty and pathos and we sense again the great wild wood of former days. From these ramparts of Needwood can be seen the full expanse of the Lower Valley with views across the pastoral stage of Derbyshire to the ever present backdrop of the Weaver Hills.

And pierce the fable veil of night,
Green bends the waving shade above,
And glistening dew drops gem the grove:
Next shine the shelving lawns around,*
Bright threads of silver net the ground;
The billowing mist recedes beneath,
Slow as it rolls away, unfold
The vales fresh glories green and gold;
Dove laughs, and shakes her tresses bright
And trails afar a line of light."

The last two lines of Munday's description of dawn over the Dove Valley. perfectly characterize the Dove as she skirts Needwood. Now we must continue the journey downstream.

*These "lawns" were areas caused by the continual grazing of deer.

HRH: Forever jaunty and self-assurred.

Courtesy of David Smith

Lillie Langtry:
Always a distraction.

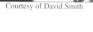

Courtesy of David Smith

CHAPTER 11
THE ARISTOCRATIC COUNTRY OF THE DOVE

When Mary Howitt surveyed the Lower Valley, she described two *"wood embosomed mansions of noble lords"*. The first was Doveridge where in recent years new houses have infilled most of the the yew and holly plantations of the old hall grounds. Here for centuries the Cavendish family were dominant. In Vales of Weaver, Gisborne describes the church as *"Peering through the tufted trees"*. The groves integrated the church into the grounds of the the the great house.

The Illegitimate Cavendish Family

Bess of Hardwick was an indomitable woman who made a career of marrying rich older men. For her third husband she married William Cavendish of Suffolk. While she was familiar with life at Court, her heart remained in her native Derbyshire and at the Dissolution she "persuaded" her new husband to acquire the former Tutbury Priory lands that included Doveridge. It was a shrewd investment as many of these lands were to remain in the family until this century. With Cavendish she produced 8 children of whom the eldest son, Henry, was given Doveridge. Though married he lived as a wild rake, being known as the "Common Bull of Derbyshire and Staffordshire". He had no children by his wife but sired many bastards of whom the eldest, another Henry, remained at Doveridge to found an independent branch of the Cavendish family in 1611. More than a century later, a similar liaison appear to have again settled the Doveridge succession, when one William was fathered out of wedlock. It is possible that his father was the 3rd Duke of Devonshire, head of the Cavendish clan! Throughout their tenure the family were never able to escape this taint of illegitimacy.

The 3rd Duke was a quiet aristocrat, noted as a hard drinking and hunting countryman. Following service in Walpole's cabinet, he was appointed Lord Lieutenant of Ireland in 1737. He was noted for his great sense of loyalty, which was probably the reason why he chose Henry, the son of the illegitimate William, to accompany him to Ireland. Henry held several senior appointments in Ireland and was given the title of baronet. In 1766, richly endowed from the spoils of Ireland, he decided to build a great mansion at Doveridge. He chose Stevens as his architect, probably after having seen his submissions in Dublin. Stevens was a brilliant exponent of the Palladian facade but died at an early age before the house was completed. The work was carried on by Pickford of Derby and finally Gardener of Uttoxeter. It was the latter who designed the stable block in the distinctive red brick of that town. The Hall was described by Firth

in 1911 as, *"A rather ponderous brick mansion built on a base of stone"*. If the
design was somewhat heavy, the situation was magnificent. From the wide
terraces the whole valley was projected as though it was a private demesne. In
the subsequent layout of the park, the main road was diverted away from the
Hall and centre of the village, a great benefit to later generations. The family
were ennobled in 1792 when Sarah, the Irish wife of the 2nd baronet, was given
the Irish Barony of Waterpark. The family remained part of the Ascendancy in
that troubled land for many years. The 1st Baron, who succeeded to his
mother's title, also married in Ireland.

The Doveridge of High Society
From the time of its building, the Hall was to be be one of the most glittering
and socially graced mansions in both counties. At weekends, particularly during
the hunting season as the sinking wintry sun was reflected on the long Georgian
windows, the lavish rooms echoed with the conversations and banal intrigues of
the powerful, titled and gifted. The author remembers a conversation with the
late Derbyshire writer, Miss Rosemary Meynell on the subject of the Waterpark
family during the 19th century. That renowned lady, brought up within the
Derbyshire landed families, recalled the widely held belief that Derbyshire was
never the same after the Waterparks departure.

 In winter the main pastime was field sports. The shooting at Doveridge
was somewhat restricted due to the modest area of coverts, but the hunting with
the Meynell was of national repute. To pursue the excellent fishing and the
shooting of water fowl on the Dove, an elegant suspension bridge was built.
This now serves the footpath to Dove Bridge. During the lazy days of summer
the routine was more relaxed, with cricket and lawn games, or merely
sauntering on the terraces.

 On Sunday mornings attendance at church was virtually compulsory,
Evensong being associated with the servants. Only someone with the
personality of the notorious Lillie Langtry was able to decline. Once she
declined to attend, saying that her reputation would cause "such a stare".
Traditional Anglican Matins was the norm, the Oxford Movement having not
reached these grand circles. It was desired that the church music would be of the
highest quality. The village church choir was trained by a professional musician,
Mr Drewry. Though an accomplished organist himself, he frequently ceded his
console to Sir Arthur Sullivan or more frequently John Stainer when guests at
the Hall. In fact it was the latter, who designed the organ. On these occasions
the congregation would remain in their pews after the service to hear further
thunderous works. As Doveridge declined Mr Drewry left to became the
choirmaster at Tutbury Priory Church.

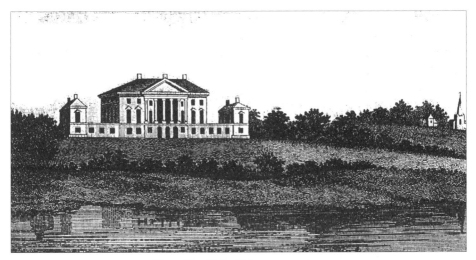

Doveridge Hall: 18th century print.

Decline at Doveridge

Such a lifestyle could only be maintained by those with a large mansion and unlimited finance. In 1863 the 3rd Lord Waterpark left the Hall to live in East Lodge, a smaller Georgian house on the estate. Was the formidable cost of maintaining Doveridge Hall the cause, and was his death shortly afterwards predisposed by this indignity? His wife, Elizabeth had been Lady in Waiting to Queen Victoria and received a letter of condolence from The Queen on the death of a beloved maid. The 4th Lord was a fine hunting man, who was Master of the Meynell for 10 years. However another hint of financial pressures is the fact that despite his popularity, he refused to subsidise the Hunt; always presenting detailed accounts for settlement. He died in 1912 in the twilight days of the great families. One member of the family drowned on the Titanic, having persuaded his wife to step into the last lifeboat for the sake of their infant sons. The 5th Lord Waterpark died in 1932, ending the long association of the family with Doveridge.

The Edwardian Intrigues

After 1863, the Hall was let by Lord Waterpark on a series of tenancies until the first Lord Hindlip arrived. He represented the newly enriched industrialist class (heading the Allsopp brewing family).

Lord Hindlip restored the social reputation of the house. As the country house circuit flourished, Doveridge Hall shone like a star with incandescent light. The late 19th century social set could indulge their every whim and followed the example of the jauntily self-confident Prince of Wales. He enjoyed

drink and good food but his overriding passion was women, whom he liked to be dignified yet lively and young; however he hated the whiff of scandal. He enjoyed life to the full and though he grew older and fat, his personality and charm never waned.

If the men of the Edwardian set appeared to be stereotyped figures with similar backgrounds, the women were the opposite. Though often poorly educated they were highly trained in the arts of deportment and conversation. In movement they strutted like well trained horses in dressage. The climax of their day approached when they retired with their maids to dress for dinner. They descended in their magnificent dresses and extravagant jewellery, to entrance their awaiting audience in the soft radiance of the chandeliers.

Amongst these women were a group known as the Professional Beauties, who practised the highest degrees of femininity, vivaciousness and notoriety. These outstandingly good looking women allowed their photographs to be on general sale. The attendance of any of them was sufficient to raise the expectations of a gathering. Jennie, Lady Churchill (mother of Winston) had lovely hair which crowned her outstanding looks. The Countess of Shrewsbury was a local beauty who had previously been chatelaine of Markeaton Hall (the Mundys being related to the Waterparks). The ultimate mistress of social skills and allurement however was Daisy, Countess of Warwick. She was a vivacity and delight in motion, who loved hunting and rode fearlessly. Into this high born throng strode Lillie Langtry. She had neither their upbringing, social graces, or highly bred looks. If birth had not given her rank, it had given her powers of persuasion and enticement, which she used with devastating effect. She became a regular visitor at Doveridge, frequently joined by the Prince of Wales.

While these ladies observed the social graces within the house, rivalry was rife; given the opportunity, they would probably have scratched each other's eyes out. In 1880, the Meynell Hunt Ball, a wild event always renowned as "open season for bucks", became known as the Beauties Ball, as Lillie Langtry, Lady Churchill and the Countess of Shrewsbury all competed for attention. The following year the Prince and Lillie Langtry again attended the Ball, both staying at Doveridge. The following morning, she surprisingly arrived for the Meynell meet at Etwall in her carriage immaculately groomed and dressed. As usual she caused a distraction amongst the men followers. Later on the same day HRH fell. He rose and said in jocular tones that he would be taking some of Derbyshire away on his tunic.

Here in the late 1880s their affair developed under the discreet eyes of Lord Hindlip. The Prince loved Doveridge, the area, its hunting and the social scene. He would also regularly stay here for the period of Derby Races. In 1897 Hindlip died but his son was also a great entertainer and sportsman. The

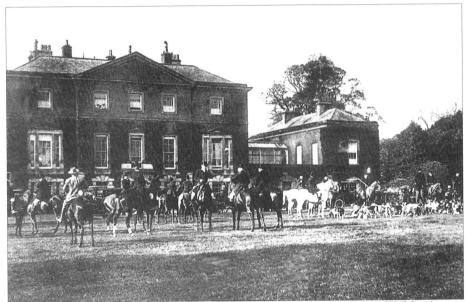

Courtesy of Mr G. Sowerby

The Meynell Meet, Doveridge 1910: "What better thing in this workaday world".

Doveridge Hall Meet became a major spectacle. One report describes one such satisfactory morning, *"A hearty welcome and open house hospitality was extended; what better things in this workaday world!"*.

The Demise of Doveridge Hall

Following the departure of the 2nd Lord Hindlip, the house became home to the Brace family who originated from the Walsall leather industry. The family were also well known in hunting circles. Following the death of Frank Addison Brace in 1912, this tradition was maintained by Miss Dorothy Brace. She was destined to be one of the last exponents of the traditional side saddle, remaining a vigorous rider until her tragic death in 1957. Following the First World War, the maintenance of the household became a formidable task. The Brace family moved to the smaller Coton Hall near Hanbury, leaving the fading mansion empty. In 1938, the memories of the great house were extinguished with its demolition, leaving a huge gap on the skyline. In 1944 Miss Brace moved to The Elms at Tutbury (demolished in 1964). At the sale of the Doveridge estate, much of the land was bought by Sir William Feilden who farmed for many years. His first wife died tragically and her ghost is still said to haunt the surrounding lanes. The second Lady Feilden was a well known character, particularly when following the Hunt in her old Morris Minor car.

George Vernon of Sudbury

As Mary Howitt recorded, three miles further along the valley from Doveridge lies the Sudbury estate which came into Vernon possession through marriage to the heiress of the Montgomery family of Cubley. This branch of the famous Peakland family, who arrived with William the Conqueror, had previously lived in modest affluence at nearby Marchington.

When George Vernon inherited the estate in 1659, he started the building of his great house at the age of 24 years, and continued to deploy his entire resources for his remaining 43 years. He was a sensitive man who for periods worked tirelessly; yet when suffering from melancholia allowed his ambitions to fade. He is portrayed as an elegant man though heavily reflective.

The Building of Sudbury Hall

Sudbury is unique in Derbyshire as being the creation of one man. Throughout the work George Vernon kept detailed records, it being assumed that he acted as the architect himself. Throughout the house there are features which conflict with the Carolean mode and spirit. Why do these incongruities exist? The probable answer is that George Vernon expressed his own influences and interpretations. While the mighty windows which brood over the surrounding landscape are suggestive of Hardwick, the great pile is dominated by the towering cupola. This Carolean feature is surmounted by a great golden ball visible from afar. The orientation of the south front is superb, giving views over the valley to the Needwood Forest on the horizon. The plans also involved re-building the village, including the building of the coaching house, the Vernon Arms which today maintains the best traditions of an English inn. Only the church, in the shadow of the Hall, remains of the medieval village.

The first work at Sudbury was carried out with local builders and materials. The huge numbers of bricks required were made at the estate brickworks, while the oak timbers would have been grown locally. Both enormous frontages are relieved by projecting stone frontispieces, which give the house the E shape typical of the Elizabethan era. These and the cupola were built by William Wilson who was also engaged on the rebuilding of Lichfield Cathedral following the Civil War. In this first surge of work, the exterior shell was completed within a few years. On the decoration of the interior however George Vernon spent the remainder of his life. Initially the craftsmen were local, such as the Derby plasterer, Samuel Mansfield, who created the first of the tremendous ceilings which are so representative of Sudbury.

When residing in London, Vernon was able to enlist the finest exponents of decoration for the renewed activity at Sudbury following his second marriage. These men had made their reputations following the Great Fire of

London. Though built during the reign of Charles 11, there is a huge Long Gallery typical of an earlier era. This vast chamber is south facing to maximize winter warmth. From London came the great plasterers, Bradbury and Pettifer to create the immense climax of this chamber. Another craftsmen of this time was Edward Pierce, who created the artistic heart of the whole house, the Grand Staircase. This has wonderful carvings of Restoration oak leaves and acorns with other motifs repeated below an exhilarating acanthus balustrade. The work is executed in pine, probably the heart wood of trees slowly grown in the forests of Scotland. For many years the staircase was stained dark brown and treated with beeswax and turpentine. This gave a dark Victorian appearance which was in contrast to the original concept. Following research by the National Trust the original white colour scheme has been restored despite some controversy. As the eye is involuntarily drawn upwards, the ultimate unity with Pettifer's plasterwork becomes manifest. In the Drawing Room can be seen a magnificent overmantel by Grinling Gibbons in lime wood; the effect is of overwhelming reality in which the components from nature can be recognized with ease.

The craftsmen required to achieve the third and final great embellishment of the house were obtained following visits by an older George Vernon to Chatsworth during that great rebuilding. From there came Laguerre, a great exponent of large scale portrayal, who provided the crowning glory of the Grand Staircase and other chambers with his magnificent ceilings and murals depicting both the sensual and dramatic.

The Influences on George Vernon

So essential is George Vernon to the integrity of the house that his personality and intentions transcend the centuries. Had not his family been regarded as a minor branch of the great Vernons? Surely here he was striving to re-establish the position of his family amongst the great families of Derbyshire? George Vernon established a family tradition of profitable dynasticism in marriage. His first wife, Margaret Onley was married at 19 years. She was an impressively built woman with a superb carriage. It is likely that her vitality, support and wealth were a significant influence on his early ambitious plans. She was destined to die early. She must have been an exceptional young woman, because her epitaph in the church records that she successively obeyed her father and her husband. Work resumed following George's second marriage to Dorothy Shirley who came from a long established Derbyshire family. While she is portrayed as rather featureless with heavy eyes, he gained much confidence from her and her Shirley family. This marriage also ended tragically after four years. At the age of 46, George married a distant relative Catherine, who was 18 years old. Being young, vibrant and rich, she provided that vital

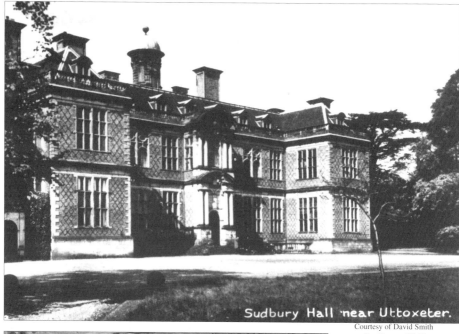

Courtesy of David Smith

Sudbury Hall:
The Carolean house of
incongruity.

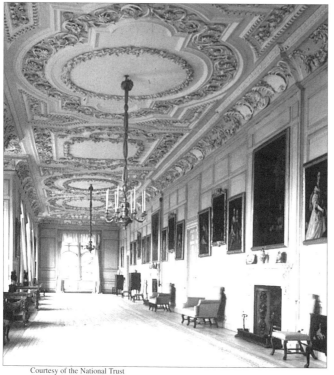

The Long Gallery
Sudbury Hall: Ceiling
climax.

Courtesy of the National Trust

encouragement and the enthusiasm of youth for the final lavish decoration. She is portrayed as demure though attractive. Though destined to become a young widow, she produced the long sought male heir.

George Vernon was much influenced by the Shirley family. Had not his father-in-law been confined in the Tower until his death for the royal cause? His brother-in-law, Robert (1st Earl Ferrers), was a vibrant and colourful man, who furthered the Shirley family fortunes and rebuilt the family seat of Staunton Harold. This example could have influenced Vernon in his attempts to reinforce his own position. It is obvious

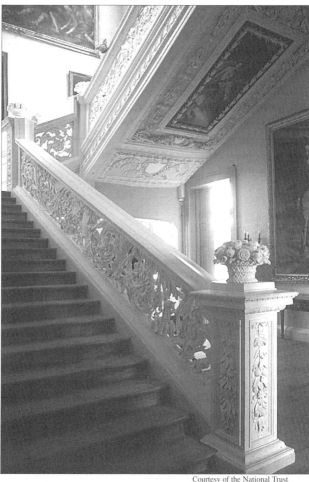

Courtesy of the National Trust

The Grand Staircase: Artistic centre of the great house.

that he was greatly influenced by the Elizabethan style; is this a display of his love for a past age, or is it a sign of his innate conservatism? During the Civil War the loyalties of the Vernon family were divided. However at Sudbury, George safely proclaimed loyalty to the restored monarchy. In the Long Gallery amongst the essentially family portraits are to be seen three of Charles II's mistresses. Their origins remain an enigma!

The Vernon Succession

George Vernon was destined to found a dynasty that was dedicated to the development of Sudbury estate; from this they rarely deviated. This was in contrast to the Cavendish family of Doveridge, who for long continued with

their Irish interests without developing their Derbyshire base. Though the Vernons were wealthy, the ambience of Sudbury remained security as opposed to grandeur. Henry, son of George and Catherine married Ann Piggot, the heiress to great estates on the Welsh border. This enabled their son, who was created the first Lord Vernon, to relay the grounds in the mode of Capability Brown to merge into a deerpark of 600 acres. The main feature in this landscape is the deercote which was built in the form of a fortified manor. Considerable building was also carried out on the estate to provide well designed and ample farms and cottages. The Rectory was also well endowed. This building has now been demolished, though a fine crinkle-crankle wall remains, the intention of which was to provide maximum protection for fruit trees.

The 2nd and 3rd Lords were half brothers who lived the comfortable lives of Georgian gentry. Their main priority remained agriculture and the self sufficiency of the estate. Great works brought an ample supply of water to both Hall and village. With the aid of a pump this was sufficient to power a lift which rose from the basement to the highest floor. During this time the lease of Tutbury Castle was obtained from the Duchy of Lancaster. To integrate this visually into the landscape a mock keep was added to the castle to enable it to be seen from the house. The confidence of this expansion can be appreciated from a contemporary painting which demonstrates the Hall dominating the whole Lower Valley from Doveridge to Tutbury Castle.

The 4th Lord was an agricultural pioneer who remained devoted to his estates He was much influenced by his friend William Coke from nearby Longford. To demonstrate his commitment to agriculture he drained the Sudbury lake to grow maize and bind the works of Cobbett in the paper made from the crop. He greatly enriched the family by marrying Frances, the heiress to the Poynton estates in Cheshire. This was a good acquisition because those estates were rich in coal. (The last colliery in fact closed within living memory).

The 5th Lord spent much of his life in Europe. However it was during his time that the North Staffordshire Railway projected their line through the valley. to which he finally acquiesced on condition that a station was built on the Sudbury estate. This amenity allowed plentiful supplies of coal to arrive from the Vernon mines; as a result a gas works was built to supply the house and village. This Lord was also responsible for the re-establishment of the lake. His long absences resulted in the Hall being leased to Queen Adelaide following the death of her husband, William IV. She was a quiet retiring lady who stayed for three years. Here she wrote the simple instructions for her funeral which typified her innate humility.

During the life of the 6th Lord it became obvious that the Jacobean mansion lacked the facilities to accommodate the growing requirements of the

high Victorian social scene, Following several abandoned projects, the house was eventually extended by George Davey in 1876. Following the early death of the 7th Lord. it was decided to lease the Hall to the brewing family of Gretton. The 8th Lord succeeded to the title at the age of 10 years, but died young after being wounded in action at Gallipoli. His brother returned to Sudbury as Lord Vernon in 1922. He strove to maintain a house which had become rather dour, though Lady Vernon made great efforts to renew an atmosphere of life and warmth. Lord Vernon's problems were immense, particularly through increasing taxation and the unavailability of staff. He introduced agriculture to the park which later became arable during the Second World War. That war brought fundamental changes, an American military hospital was built in the park. His Lordship accepted the demands of the War, but was grieved by the subsequent depredations of the Vernon inheritance. After the War, there was no return to the previous genteel order. The American presence was followed by a camp for displaced persons from eastern Europe. This site was later requisitioned for a prison which remains today. Despite these problems and heavy taxation, the reduced household continued quietly until the death of his Lordship in 1963.

In 1967 Sudbury Hall and the immediate grounds were transferred to the Treasury in part payment of death duties and subsequently acquired by the National Trust. A major restoration was carried out, which resulted in the return to a light colourful regime; a sublime ambience in which the magnificent plaster work can now be appreciated with much of the original integrity of the rooms restored. Not all appreciated this refurbishment, but the general public are now able to see possibly the finest Carolean house in pristine condition. The Victorian East Wing has been converted into a Museum of Childhood and staff quarters. The 10th Lord Vernon now lives in a newly built residence on his estate.

The Tremendous Country of the Meynell

The Dove Valley is a land that has for centuries been dominated by great estates, Doveridge and Sudbury being the high points of a story to be repeated throughout the final course of the Dove. As in the country to the north, memories abound of the families and manor houses of the old squirearchy who had their roots securely in the land and traditions of Derbyshire. In Victorian times a further wave of houses arrived, as the newly enriched industrialists aspired to a country house or a hunting lodge, particularly on the Needwood Forest. Nearby Foston Hall was an impressive mansion of that time; it now serves as a womens prison. At the turn of the century, the combined staff of the estates would have made service the major local employment The numbers of

workers were accentuated by the estates being self contained and self sufficient. In the tenure of these families, those extravagant days were the aristocracy at its zenith. The grand life could never be maintained; the Great War eliminated it at a stroke as the tide had fatefully turned.

Here, in this rich land below the hills, the Meynell Hunt's fame became established. By the turn of the 18th century the rustic's sport of hunting of foxes was taken up by the gentry. In 1793 the 2nd Lord Vernon, known as the Hunting Baron, founded his own pack. At the same time Hugo Meynell who is acknowledged as the "Father of Foxhunting", kept his own hounds at his seat of Hoar Cross. Following the death of Lord Vernon, the latter pack became dominant in the area. It is interesting to note that in those times the area was principally arable with reynard being scarce. It became essential therefore to protect the fox, a fact that the anti-hunting brigade should remember. Within a generation the animal became numerous particularly following the planting of fox coverts, which were rigorously protected. By the latter days of the 19th century, fields (mounted followers) of over 200 were commonplace, though at that time few women rode. The meets at mansions were magnificent events preceded by a lavish breakfast. A report of a Lawn Meet in 1866 at Egginton Hall describes those splendid days; *"The morning was as favourable for hunting as the most fastidious sportsman could desire. When the time of leaving arrived, a sight presented itself such as is rarely witnessed; a field of 300 with an assemblage of ladies to give a parting greeting which comprised all the youth and and beauty of this part of the country".*

In 1871 a later Hugo Meynell secured the ultimate accolade for a Master, death on the hunting field! The Meynell Hunt then became formally constituted and supported by subscription, as kennels were established at Sudbury. This hastened the process of plutocracy replacing squireocracy towards the end of that century; even special trains were run to some of the meets. One of the features of the Meynell country was the migration of foxes from the hill country down to the coverts of the lowlands. One such famous fox four times led the chase over 20 miles into the snow covered hills of his peakland sanctuary and darkness. At that time, two flamboyant figures were Rev G.Buckston of Sutton on the Hill and Rev F.Spilsbury of Willington. This pair were known as the "creeping and flying parsons."

Following Irish independence, Sir Harold Nutting left his native land to become Master, bringing his own staff from Ireland. With his fortune from Irish railways and breweries, he enthusiastically revived the Meynell following the Great War. As the 20th century progressed, the Hunt became continually restricted. However under the mastership of Sir Peter Farquhar, with his wild self confidence, more kills were recorded in the 1930s than in the heydays of

the 1880s. The decline of the hunt has been accentuated by the break up of estates and the growth of arable farming. In the early days, hunting was disrupted by the railways, but today the roads have created worse problems. Also changing attitudes have resulted in less sympathy for the Hunt. Despite these problems, the now Meynell and South Staffordshire Hunt remains one of the most fashionable in the land. The Prince of Wales, like his predecessor, is a regular follower. What cannot be denied is that the sport has indelibly marked the area, the most outward and visible sign being the numerous running fox weather vanes above former stables and the large houses that were built as second homes for the Season.

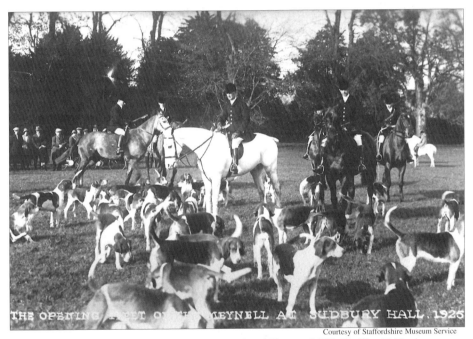

Courtesy of Staffordshire Museum Service

Opening Meet of the Meynell 1925: Host, Lord Vernon; MFH, Sir Harold Nutting.

The Great Doveridge Yew: Walking through a millennium of growth.

Marchington Church: Georgian elegance.

CHAPTER 12
THE LOWER VALLEY: THE FINAL WAY

For long protected by high ground, the Fair Nymph now flows beneath the falling Eaton escarpment for her final journey. At the end of the ridge rises the spire of Doveridge Church, a sentinel to the wide pastoral Lower Valley.

The Dove Bridge
Before this change the clear waters divide beneath this fine old bridge, now an ancient monument. The present bridge originates from the 14th century with slightly pointed arches in the Gothic style, three with characteristic hood moulds. It is a very good example of a medieval bridge with structural work from many periods including widening in 1915. The centre arches are of a later period, probably rebuilt after damage during war or disaster; many armies have crossed here. In April 1987 a hoard of silver coins from the reigns of Edward I and II was found nearby; were they hidden at the time of the Lancaster rebellion like those at Tutbury? The last time the bridge was defended was during the Jacobite Rebellion of 1745, though fear of invasion in 1940 prompted plans for its defence; pill boxes were erected and concrete cylinders were positioned to block the road. Near the bridge on the old road stands a toll house, indicating that it was formerly a turnpike. Now the new A50 trunk road linking the M1 with the M6 has been constructed to pass the same way.

In the days of religious bigotry at the close of the 18th century, a local boy, Michael Sadler, was seized by fanatics and held over the side of the bridge by his collar. He was ordered to curse the Methodists; *"I never will"*, replied the boy, though he was not a Methodist. His father, the Vicar, preached a doctrine of tolerance which had aroused the hatred of local bigots. In his teens Michael became a preacher and frequently received abuse or worse when expounding his beliefs. He later entered Parliament and became a defender of factory children.

Doveridge - Gateway to the Valley
Doveridge is a village with timber and brick cottages either side of the winding village street, formerly the main road. The perpetual peace of the Dove Valley is best appreciated from the churchyard. The heavy, algae stained sandstone headstones, bent and bowed with age, epitomize man's perpetual protest at the transitory nature of life. The stones gather around a medieval cross mounted on five steps. This was returned to its present position, and the crucifixion added, as a memorial to those who never returned from the Great War.

The church is a typical English amalgam of Norman, Early English and Perpendicular, welded together and wedded to the landscape by time and

weather. The church is unusual because the broad 13th century chancel is continuous with the nave. The overall feeling is of light, space and simplicity enhanced by the expanse of the vast Perpendicular east window. Even the side aisles are wide, flanking a central aisle. In common with many village churches, pre-reformation relics remain, in particular an unusual double piscina where the Priest could wash his fingers separately from the sacred vessels. There is an ancient bell which rings in the peal of five. It carries a pre-reformation text which in translation declares, "Rose of the World I sound, Mary my Name Around". This refers to the practice, unique to medieval England, of addressing the Blessed Virgin as Mystic Rose. This reference can also be found in the hymn, "Crown him with many crowns", where Our Lord is referred to as "Fruit of the Mystic Rose". Here lies a mystery because the bell carries the late date of 1633. Was the donor of this bell a secret Catholic supporter?

In early Norman days Doveridge was given to the Priory of Tutbury by Bertha, wife of Henry De Ferrers. From that time until the Dissolution the monks retained control, although there was a resident priest. One such priest, Robert Kniveton, is recorded as having founded a chantry in 1392 in honour of Our Lady. His family must have been wealthy because another priest of the same name promoted the building of the chancel at Norbury. Here again is mystery because it was usual for the founder to provide in the dedication for his own repose. Also, there is no evidence of a separate altar which was essential to such a chantry. This Robert is thought to be the priest portrayed on an incised alabaster slab. He appears with his head resting on a pillow held by angels; his eyes appear strangely lifelike with a pronounced stare.

The church is remarkable for the memorial tablets, not only as a record of the period but for the richness of epitaphic prose. One records Rev William of the FitzHerbert family of Tissington, who died in 1785 after being the vicar for 39 years. The 18th century diction declares, *"He delivered the momentous doctrines of Christianity with a peculiar propriety and affectionate energy"*. Another tablet dated 1859 records a member of the Cavendish family who was vicar for 20 years. It was then common for a younger brother of the squire to be ordained and serve his native parish. This explains the former palatial vicarages to be seen here and in some estate villages such as Rolleston and Blithfield.

The Great Doveridge Yew

Centuries before the first church was built, the great yew had germinated, it being estimated to be over 1,600 years old. The trunk, which exposes its crumbling interior, is only a segment of the former circumference. It is also likely that the tree has lost much of its original height but has continued to grow by branch layering. What remains is still of giant proportions with a crown

circumference of 260 ft. The crown of the tree is remarkably healthy with little sign of dieback, indicating a healthy root system.

The name yew indicates antiquity, deriving from the Welsh name, Ywen; moreover the yew is the longest living European tree. It forms a mysterious link with the distant past when groves of yew were the scene of satanic and idolatrous rites. Some authorities believe that early churches were specifically positioned on the site of these pagan groves. In England, the yew has always been associated with the churchyard. Its poisonous properties preclude it from grazed areas, and during the middle ages the wood was in demand for the supply of bows. These are facts; yet surely the yew's survival is due to the world of fear and legend which entered the traditional minds of countrymen. As a symbol of immortality in bygone years yew branches were carried at funerals and laid in the grave. Sprigs were placed within the folds of the shroud before the coffin was closed. A local legend says that Robin Hood was betrothed to Maid Marian below the branches of the tree, though in ballad her name was Clorinda.

A Valley for All Seasons

Mary Howitt described, *"where this noble and prolific valley changes its course, and leaves a flat of the most abounding meadows"*. The broad highway of the river progresses through the wide alluvial valley for 10 miles to Tutbury. Formerly it was flanked by boundless pastures, though now many have been converted to intensive arable farming. The landscape is dominated by the ash tree, that most feminine of trees, which always appears youthful even in the darkest days of winter. In recent years the ash has been subject to crown dieback. The cause of this sad spectacle remains a mystery, though it is probably attributable to a lowering of the water table and applications of nitrates.

The valley reacts to each season with a different face, yet throughout it is the beauty of the river that provides its climax. In the gathering light of spring, the clear waters break down into reflections of gold and silver, light breezes kiss the surface and the river replies with a ripple and a smile. The wide verdance has a special attraction in summer when the freely growing hawthorn trees erupt with unrestrained blossom which clings like frozen snow. The gnarled and gaunt trunks are smooth from the rubbing of the cattle, as they find shelter gently swaying their tails. The year finds fulfilment in high summer, the new mown hay intoxicates the air with an ecstatic perfume, and a peaceful languor pervades all living things in the July heat.

Autumn evokes a sad response, as though the wide valley awaits the year's fall with trepidation. In past times, in anticipation of the shortening days, great flocks of peewits massed and rose like swirling smoke. Some can still be seen but recent decades have seen a large reduction in their numbers due to changes

in farming practice. The setting sun sinks through the enveloping mist to draw glowing tresses across the western sky like lingering memories. To the south, the brooding skyline of Needwood becomes increasingly shadowy and ominous. This kaleidoscope of gold and red lingers until darkness is finally complete and only the song of the silver highway remains to beguile the senses.

As winter brings a dark presence to the valley, the isolated farms become lost in a grey gloom. Often these are silent days, yet in times of hard weather the rich fields and hedgerows provide a feeding area for great colourful flocks of arctic thrushes, whose roaming hordes, in Welsh legend, are thought to be the harbinger of the severest weather. Another winter spectacle, again less common now, are the massing flocks of skylarks.

Marchington

The Needwood Forest and the river are kept apart by a land of little hills and small fields surrounded with overgrown hedges and damson trees. Here lies the village of Marchington. Prior to the Second World War it was composed of partially timbered and red brick cottages along winding lanes, a village that epitomized both the splendour of Needwood and the serenity of the Valley. The writer had the privilege of knowing a splendid old countryman, who was invalided back to his native village from the sufferings of the Mesopotamia campaign during the Great War. He recalled alighting at the little Marchington station (now closed), to inhale the fresh air and survey the fresh green countryside before confidently declaring, *"I feel better already"*. During the Second World War Marchington was engulfed by a large American base; later in peace this became a British Army Ordnance Depot and now serves as an industrial estate. A prison is now also planned.

In more recent times the village has been further assailed by ribbons of "executive housing". However all is far from lost, as much of the spirit of the old village survives especially in the tranquillity of the beautifully tended churchyard, where the large sandstone headstones mark the last repose of those nurtured in this peaceful land. The church built of red brick, is a fine example of Georgian elegance though achieved with simplicity. The tower is crowned by an octagon capped by a copper dome. From this small and unusual tower can be heard some of the valley's finest sounds; the deep toned, clear voices of the bells which entwine to produce a unified pulsating cascade.

Above the village stands the fine Stuart manor house of Hound Hill which was the original home of the Vernons of Sudbury. It was here on Saint Brice's Day in AD 1002 that Danish settlers in the valley were massacred as the peace of Saxon England again became threatened. A local legend, presented as a play on words, describes some advice to a long forgotten army advancing this way,

> *"Don't let us lie like hounds upon a hill,*
> *But march into town."*

Lost in tranquillity, but allied to Marchington is the hamlet of Woodlands which has been traditionally treated with antipathy by its dominant partner. In medieval times glass was made below the Forest on primitive hearths using local timber. The industry later became centred in Tutbury.

The Dove in Angry and Nurturing Moods

Late winter brings a most dramatic spectacle. The Dove and her tributaries have a vast catchment high in the hills. This collects an overwhelming torrent which surges and discharges over these wide acres. This flooding can be caused either by the sudden melting of snow or by heavy rain. The main feature is the ferocity with which the gentle stream turns into an uncontrollable and volatile coloured force. The effect of the vast catchment was noted by the Bard of Needwood, Francis Munday,

> *"Down yon mid dale the British Nile,*
> *Fair Dove, comes winding many a mile,*
> *And from her copious urn distills,*
> *The flatness of a thousand hills."*

Most of the old established villages are situated far away from this peril, but the large Victorian village of Hatton, has constantly been threatened. Some of the most severe flooding in recent years occurred in 1946 and again following the great snows of 1947. At that time Tutbury and Hatton were divided by a surging torrent that washed away the bridge of the gypsum railway. Serious flooding also took place during the early 1960s. A sudden storm in the dark moors can cause much distress. On August Bank Holiday 1957 terrific flooding followed a furious thunderstorm, the fury of which washed away a road bridge and devastated the army camp at Foston. At these times that the silver stream turns into a dark and terrifying force carrying away crops and beasts without trace. Severe flooding is now much reduced following extensive defensive works carried out during the past 20 years to restrain these violent changes of mood. However the Dove still retains the strength to deliver a sudden blow. During the winter of 1992, following 4+ ins. of overnight rain in the moorlands, residents at Hatton awoke to find water entering their houses; within a few hours this had reached the depth of several feet.

While the river's inundations were fearsome, before the use of fertilizer they brought prosperity and fame. On her course through the hills the river collects lime in suspension and smaller amounts of trace elements which stimulate an exceptional growth of grass. The farmers of yesterday appreciated that flooding promoted a flush of grass. This underwrote the traditional dairy farming saying, *"In April; Dove's flood is worth a King's good"*. The growth of

grass was so prodigious that it was said, *"If a stick be laid down overnight in spring, it will not be found for grass the following morning"*. So rich was the growth of grass, that nearby land was described, *"Nearly as good as Dove land"*. In 1817 William Pitt in his "Topographical History of Staffordshire" described the perplexity for the valley farmer, *"The plain on the Staffordshire bank of the Dove comprises several thousand acres of luxuriant pasturage for black cattle, sheep and a few horses. A very small proportion of this extensive space is fenced in for hay, in consequence of the uncertainty and suddenness of the inundations of the Dove,....a rapid and resistless flood, which soon overflows the banks of the river and covers the level fields to a great extent; in so much that it requires much vigilance in the proprietors of flocks and herds to preserve them from drowning"*.

Reminders of the Past
The pasturages stand on river alluvium which covers light soils and river gravel. Within these beds are found peat beds which date from various periods over several thousand years. In the peats are occasionally found preserved hazel nuts, acorns and alder cones from the great forests that existed before the overwhelming impact of mankind. Occasionally from a depth of several feet are unearthed tree trunks of the former valley forest. The oak, known as Bog Oak is particularly fine, being as black as ebony and capable of being attractively worked. Tutbury Church contains a fine lectern which was carved from one such trunk found during the search for a young boy drowned in the floods of 1936. The memorial was provided in his memory by the grieving parents. It is certain that many remains of this lost world await discovery.

Hanbury on the Hill
At the western end of the Needwood escarpment the naked hillsides cascade down to the valley floor with green and rounded swards analogous to chalk downland. On the horizon, like a homing beacon, stands the tower of Hanbury Church. Hanbury must surely be one of England's most finely positioned villages. From its high seat one can survey the Land of the Dove like a hawk searching for prey, with the ecstasy of a prophet surveying Canaan's land, a crucible containing the distillate of freedom and beauty. *"For ye shall go out with joy, ... the mountains and the hills shall break forth before you into singing, and all the trees of the field shall clap their hands."* Isaiah 55. Below lies the wide valley and, far beyond, the heaving line of the Weavers and Pennine Hills; while to the east can be seen the open plains of eastern England. Since the 1930s the church has had a companion in the form of the water tower.

A church was built following the Norman Conquest but the present structure contains many restorations, dominated by the great Victorian

rebuilding from 1842 which had become a necessity because the old church was unsafe. Unusually for that period the restoration did not produce a sterile result. The Victorians recognized the church's historical importance because the lovely statue of Saint Werburgh as a young nun was added to the tower wall. A further major restoration was required following the Fauld Explosion.

The most famous effigy in the church is that of Sir John Hanbury. It is claimed to date from 1303 and if this is correct it would be the oldest such tomb in Staffordshire. It is a fine portrayal in alabaster of a crossed legged knight in chain mail. Yet here lies another mystery, for there is no record of such a knight at that time; also the quality of the workmanship is suggestive of the Burton School of a later date. One of the greatest treasures in St Werburgh's Church is the beautiful 14th century glass seen in the south aisle; their lifelike figures are almost tangible in their medieval simplicity. The window and glass were restored in memory of those killed in the Fauld Explosion.

Throughout the centuries following the Conquest, the dominating influence in the parish was the Needwood Forest. Because of this there was no local squire to provide unity and leadership. The Forest was administered until recent times from a Georgian mansion called New Lodge and it was here that George III was incarcerated during periods of his tragic madness. The monuments within the church are a gallery of the families who have held patronage under the Crown. The Agards and the Egertons, though both enjoyed similar wealth and position, had widely differing loyalties. In the north aisle is Sir John Egerton, dressed as a cavalier. While in the chancel are two austere Puritan women of the Agard family. It was Sir John's specific instruction that he should be located away from their severe protestant gaze.

The size of the church bears witness to the former wealth and importance of the parish. In Pope Nicholas's Taxation of 1291, Hanbury was one of the richest benefices in the Diocese and continued to be so for many centuries. Until the close of the 19th century the parish was of immense proportions, including the villages of Marchington, Newborough and much of the Needwood Forest. The village itself is of hamlet proportions containing some attractive period houses and cottages with few modern intrusions. The parish of Hanbury is a composite containing sturdy farms and hamlets of traditional warm brick which follow the original boundary of the Needwood Forest.

Saint Werburgh of Hanbury

Fame and history came to Hanbury through the ministry of Werburgh, a princess of the Saxon kingdom of Mercia. She was the grand-daughter of King Penda who had established Mercia's power. He was succeeded by Wulthere who, although a pagan, married a Christian princess. These were the parents of

Princess Werburgh. Following the death of her father, his much younger brother Aethelred became King. As in some large families of today, the younger children were brought up with the next generation. Their upbringing virtually as brother and sister was the basis of the special relationship between Princess Werburgh and the new King. They were both Christians; King Aethelred was dedicated to the conversion of his kingdom and gave Werburgh responsibility for this. For the whole of her adult life she remained devoted to this vocation.

After training as a nun she founded monasteries at Repton, Weedon, Trentham, Crowland and Hanbury. The nunnery at Hanbury was founded in AD 680 when she was a young woman and was to remain her favourite, chosen as her last resting place. Hanbury in those distant times lay in remote country despite the closeness of the Mercian capital at Repton. While the conquest and consolidation of the Saxons had been complete, the depths of the Needwood Forest and other remote areas of Staffordshire were enclaves of the Britons.

Werburgh eventually died at her monastery at Trentham in 699. So devoted to her was that community that they sought to retain her body for veneration. Legend records how her final wishes were eventually fulfilled. While in adoration of her sacred remains, the misguided community were overtaken by a supernatural sleep and the people from Hanbury approached secretly and crept away with her body. In AD 708, when her body was transferred to a splendid new shrine here, it was found to be preserved from decay. During the next two centuries Hanbury became a place of pilgrimage. The shrine on the hill was visited by kings, princes and bishops, to pray for her intercessions and to demonstrate Mercian nationality. Hanbury became rich as many miracles are reputed to have occurred through her intercession, especially for healthy pregnancies. A special legend concerns a wild goose which despite Werburgh's orders was killed when grazing on the monastic lands. On finding the dead bird she restored it to life. Since that time she remains associated with the goose, which became both her emblem and that of the shrine.

The rich and secure Saxon world was destined to end abruptly. Through the river system from the east coast advanced a tide of Danish invasion and the Saxon Christian world retreated into a ghostly twilight. In 875, the monastery was pillaged and sacked; only ashes, mutilated corpses and memories remained on the sacred hill. The only remains today are the Saxon carved stones in the Church porch, which reflect Celtic influence. A well which had associations with the period of pilgrimage was only destroyed in recent times.

Werburgh's remains had been removed before the monastery was sacked. Though the beleaguered kingdom was reduced to chaos, inspiration and leadership came from Princess Ethelfleda, wife of the Regent. As the effective ruler she decided to raise morale by the invocation of Werburgh. Once more a

simple band set out, carrying the sacred remains towards the western sanctuary of Chester. It was said that wherever the cortege rested for the night a church was raised in her honour, the nearest being Kingsley in the Churnet Valley. Known as the Lady of Mercia, Ethelfleda was a fearless and formidable leader, who through the inspiration and intercessions of Saint Werburgh led her troops to victory from the redoubt of Chester.

At Chester a further shrine was built which has survived through the centuries. After the Norman Conquest the shrine wash housed within a great abbey which later became the Cathedral. This later period of adoration, which sustained the abbey, ended at the Reformation, though the cathedral itself remains as a splendid memorial to Saint Werburgh.

The Mining of Gypsum

While Hanbury remains outwardly agricultural, the principal employment through centuries has been the mining of gypsum. The mineral has principally been mined from Fauld, a hamlet which lies below the eastern end of the Needwood Escarpment, called the Stonepit Hills. Gypsum arises from the drying out of vast inland lakes between 150 and 180 million years ago and is usually found in 8-10 ft thick seams or isolated large balls within the rock hard Keuper Marl. These deposits are part of the great Tutbury Seam which can be traced along the Trent Valley as far as Nottinghamshire, though much has dissolved through geological time. The mine also contains the anhydrite which has harder properties which renders it suitable for use externally; locally it is called "hard arse". The gypsum seams contain the beautiful translucent white stone, alabaster, often permeated by intrusions of marl which produce the typical feathering effect, and traces of aluminium which give a yellow colouration. These colours impart to the stone a "living" quality. The solid nature and colour stability of the stone make it ideal for monumental work, particularly as it is easily worked and permits armour and clothing to be portrayed accurately. The proximity of the Fauld stone was crucial to the development of the famous Burton School of memorial sculpture which achieved unsurpassed artistic creativity during the 15th and 16th centuries.

Gypsum is said to have been worked by the Romans, but it was the Normans who left the first evidence of its use in building and ornamentation. The second arch of the west front of Tutbury Priory Church (early 12th century) is of alabaster, being the earliest known use in building. The Fauld alabaster was much admired by John of Gaunt. Six loads were sent for the magnificent tomb which he ordered to be raised in grief for his first wife, Blanche. This was a masterpiece by Henry Yevele, who became the greatest mason and architect of his time and built the nave of Westminster Abbey. He had been brought up in

the Lancaster Court at Tutbury and learned his craft through the medium of alabaster. In the same year of 1369, Fauld alabaster was used for the tomb of John of Gaunt's mother, Queen Philippa in Westminster Abbey. Later John of Gaunt used the stone to build a great white tower at Tutbury Castle for Constance, his second bride. The glistening white spectacle, built to appeal to her Spanish taste, became a legend in medieval England. Finally further blocks were sent for his own great tomb in the old St Pauls Cathedral; this like Blanche's tomb was destroyed in the Great Fire of 1666. The demand for alabaster fell away during the Renaissance, although Fauld stone was exported for the building of the Ottoman Emperor's palace in 1526. The decline was reversed during the 17th. and 18th century when

Tutbury Priory Church: Modern alabaster carving.

architects began to use it in the embellishment of mansions. In Sudbury Hall there is a fine chimney piece worked by William Wilson in 1670; while elegant door cases were provided in the great building of Chatsworth, In both cases the architects used stone from Fauld. The chancel of Dunstall Church in the Needwood Forest is clad in alabaster, being built for the Arkwright spinning family. At the turn of this century alabaster was a popular medium for the internal decoration of houses for the "nouveau riche" particularly in the USA.

During the 18th century the main production was of gypsum for the manufacture of plaster which was carried out on site by calcining gypsum over a wood fire, before breaking with wooden flails. This provided the material for the plaster floors which are still a feature of old houses in the area. Traditionally demand was satisfied by working outcrops and quarrying, but by the 1880s local companies had commenced deep mining by adits. These supplied the rising demand that followed the introduction of the railways. These mines were

A Vanished Industry: Fauld Alabaster blocks, in the Scropton sidings, awaiting transport to the USA.

The Gypsum Quarry at Fauld: Early 19th century workings.

The Fauld Gypsum Railway: the attractive little train with the tall smoke stack.

Courtesy of David Smith

served by narrow gauge railways which combined to cross the river and link with the main-line sidings at Scropton. The attractive little train with its tall smoke stack continued to puff across the fields until the end of the Second World War, when the cost of transferring loads on to standard gauge wagons resulted in closure. The large traditional blocks of glistening alabaster were formerly a feature on the flat trucks loaded at Scropton. The Needwood Mine at Draycott-in-the-Clay was a parallel undertaking which had its own mill and tramway. Eventually the independent mining companies became part of British Gypsum Ltd when the Fauld mine became the biggest such complex in Europe. In 1955 large scale milling commenced though the Tutbury Mill continued to produce specialist plasters until 1968. The extraction of the great blocks of alabaster declined though it remained constant through the 1970s. Highly mechanized mining still continues deep below the Needwood Forest to make cement, though the extraction of alabaster has now ceased.

The large scale mining of recent years has created a vast honeycomb of chambers supported by great pillars of unworked stone. These silent chambers, penetrated by bats for roosting during hibernation, have a still, eerie effect

The Fauld Explosion
In 1937 as war clouds gathered over Europe, the attention of the RAF was drawn to the abandoned gypsum mines. It was decided that they were suitable for a vast underground bomb storage unit, partly because the remoteness of the site and partly because the depth of the workings would preclude damage from enemy bombing. The huge civil works required for this establishment were carried out by workers recruited from across England, many of whom had not worked for many years. By 1938, 21 M.U. was operational as a storage unit but after the start of the War it also undertook the maintenance of returned bombs. Bombs arrived and were dispatched for their grim business along another railway built to Scropton. The whole establishment was supposed to be secret, but residents in the nearby villages were well aware of the nature of the great underground undertaking. The Unit became known as "The Dump" and soon became the subject of foreboding rumour.

As the tides of war turned the massive Allied bombing raids over Germany made increased demands upon the Unit. Initially this was satisfied by a big extension to the underground storage which required the penetration of further chambers. Aware of the potential danger of explosions, the authorities decided to protect the original galleries and those of the working gypsum mines by retaining great ramparts of unworked stone. By 1944 pressures again reached a crisis with intolerable demands on the personnel and following peace with Italy, Italian prisoners of war were deployed in the mine.

The dawn of the 27th November 1944 was typically grey and misty, but by late morning the sun had broken through to produce a hazy but sunny autumn day. At 11.10am a small explosion was heard followed by a horrendous searing blast heard as far away as Northampton, Coventry and even London. In those minutes the lives of many and the surrounding countryside were to change beyond recognition. This had been the world's biggest non-nuclear explosion. The tremendous impact ripped through Stonepit Hill like a volcano to climb in a vertical column thousands of feet into the sky. All who lived through this terrifying event can remember precisely what they were doing at the time. The writer, as a child can vividly recall the great mushroom-like cloud climbing high into the sky. The explosion blew into the sky thousands of tons of gypsum, but much more of the enveloping Keuper Marl, which was dispersed in a fine tilth. This gave the dreadful spectacle its fearsome red colour. To the majority this was the most menacing feature of the explosion. All of the material had to return to earth, falling like red snow to cover everything with a choking layer of dust. More sinister were the great rocks of gypsum which fell in a devastating bombardment to cause even more damage than the explosives. The total terror of the event was compounded when a large reservoir used for the surface works of the gypsum mine was blown out of existence, an avalanche of mud engulfing the works and burying the hapless workers without hope. Further water from this reservoir poured into the underground workings causing further terror to the gypsum miners who were already fighting against darkness and gas. It was a tragedy that some miners perished on the threshold of safety at the bottom of the safety shaft. At Upper Castle Hays Farm the farmer and his wife were swept to their deaths when engulfed in that fearsome torrent in their car. All the workers, animals and buildings of the farm were obliterated without trace.

As in all disasters there were reports of incredible bravery and devotion to duty. Many were the reports too of people suffering only minor wounds while nearby colleagues suffered horrifically. As the first timid efforts were made to ascertain the extent of the damage, it was found that a great crater had been blown through the hill. This measured quarter of a mile across to a depth of 100ft. It remains today as the biggest tangible reminder, though erosion has reduced its earlier impact. The village of Hanbury was ravaged by the falling debris; in fact the Cock Inn was devastated, though in the best traditions of English determination, it opened in the evening as usual. Mercifully the village school was saved, and at the time of the great stone bombardment, the children were found by the Vicar valiantly being led in singing, "There'll always be an England". Later that day the school was used as a mortuary; particularly tragic were devoted village families tending their own dead. The evening of that terrible day saw the area around Hanbury looking like the battlefield of the

Courtesy of the Burton Daily Mail
The Fauld Explosion: A spectre of the Western Front.

Somme. Some 70 people were dead, 19 of whom were never found; ironically only a minority of those killed were working in the bomb storage unit.

During the intervening years many theories have been presented as to the cause, invariably based on rumour. Conjecture centred on sabotage, particularly by the Italian prisoners. However in 1974, the secret details were released of the official enquiry held at the time. It was revealed that immediately before the event men were seen using brass chisels to chip out the nose and tail plugs of the bombs to remove the exploders. This was extremely dangerous! It was obvious that due to pressures of work safety regulations were not being observed, an example of familiarity breeding contempt. It is assumed that one bomb exploded which in turn set off a chain reaction. Despite the holocaust it was found that the explosion could have been ten times worse if the retained gypsum ramparts had not contained much of its impact.

The tragedy remains an emotive issue in Hanbury, where the bereaved continue to suffer their pain in silence. In 1990 a monument in granite was unveiled recording the names of those who died. It is appropriate to mention that this includes the names of those hapless Italian prisoners who were initially vilified. It is further fitting that the granite came as a gift from their native land.

The great crater and depressions surrounding it have precluded farming ever since. Here in negation of the tragedy, nature now reigns unfettered. New woodlands have emerged, bird song reverberates, the deep ponds caused by the falling gypsum contain amphibians under threat, including the great crested

newt. On the grassy banks cowslips and orchids grow in profusion, and the great crater is a microclimate supporting specialized plants and insects.

The Royal Stud and the Ghostly Girl of Fauld

From earliest times until the First World War an essential element in every fighting army was the horse. In medieval times the Houses of Ferrers and Lancaster had their own armies to maintain their positions of influence. To support these armies the breeding of war horses was undertaken on the Tutbury lands. Needwood was unique in containing a large number of parks to enhance the wealth of the Forest, areas of fertile grazing for large numbers of domestic animals and also for the growing of timber. The war horse stud was situated principally in Castle Hays Park but also at Hanbury Park; both these parks lay between the forest and the castle. After John of Gaunt established his court at Tutbury, this stud became important in the affairs of England. In 1380 it was recorded that many horses from Castle Hays were used for John of Gaunt's invasion of Scotland. When his son became Henry IV in 1399, the stud gained greater stature by becoming the Royal Stud. Its importance increased until its zenith during the reign of Henry VIII, when the main activity was the breeding and supply of horses for the numerous wars against Scotland and France. The superintendent of the Royal Stud at that time would have enjoyed an extremely influential and lucrative office under the Crown. In addition to the rich and sheltered grazing, substantial stables were built. During the reign of his daughter Mary I, it was recorded that, *"The park of Castle Hays has been disparked and the herbage therof kept for the King's race of great horses, the compass thereof was 4 miles, or more. That Hanbury park had been disparked and the herbage reserved for the King's stud of mares"*.

Following the defeat of Charles I, the stud was disbanded by the Commonwealth in 1650. The tradition of these mighty horses remained and in the 18th and 19th centuries renewed breeding was undertaken by a new generation of squires to develop the enormous Shire Horse associated with the Dove Valley. It must be remembered that the war horse had to be extremely strong and hardy to carry a knight in full armour through a whole day.

In 1989, during a break from work in the gypsum mine, a miner became aware of a presence. As he turned he saw a richly dressed girl about the age of 12 years. In amazement he enquired about her origins, to which she replied, *"My father is breeding war horses for the King."* The miner further asked, *"What are you doing in the pit, and why have you come to me?"*. To this she answered, *"I am here to look after you!"* There were other workers in the gallery at the time, but they remained unaware of the ghostly visitor. During the whole incident this gentleman experienced no fear, but felt a prevailing sense of

tranquillity. A few weeks later, some 200-300 yards from that location, the girl again appeared and repeated, *"I am still looking after you."* The witness had already realized from her clothes and speech that she was a visitor from a bygone age. Despite searching through the recesses of the mine he never saw her again. The girl was dressed in a ruby coloured silk dress and long stockings with yellow suede shoes; her long blond hair was held in a white linen caul. This clearly was no peasant girl.

This story may appear suspect. In fact the miner felt so emotional and embarrassed that he did not even confide in his wife for a long time. It was only with reluctance, during a conversation on the supernatural, that he felt able to recall these strange events. The writer believes his story unequivocally! Firstly, because he has known this gentleman for many years and knows him to be of unquestionable honesty and stability. Further the history of the Royal Stud is not widely known. In fact this gentleman was not aware of its former existence in the area. From a study of authoritative works of dress in medieval England, it has been established that the date of the clothes was the late 15th century. This dating concurs with the period of the stud's greatest activity and importance. The final reason for believing in the story's authenticity was the location of the apparition within the mine. When the miner asked the mine surveyor what point on the surface lay above the location of his underground meeting, he was told that it was Capertition Wood. This place is situated within the original Castle Hays Park and adjacent to the medieval timber-framed Lower Castle Hays Farm which might have been her family home. It is interesting to note that these locations adjoin the headwaters of Belmot or Alder Brook, which becomes the last tributary of the Dove from Staffordshire.

The Country of Lanes and Villages
The country that unfolds below Hanbury Hill is a pastoral land of supreme Englishness. It is a vast sloping apron stage projecting from the hills to the Lower Valley. Through this land flow the final undulations of the hills like the soft ripples of the turning tide. Also running through the area are a succession of fast flowing brooks which run happily to the Dove. In the past these brooks have been harnessed to power watermills for local use, though the Sutton Brook, which assumes river proportions, has driven more powerful mills at Longford, Sutton and Hilton. The first of these was built by the famous millwright, Arkwright. These clear brooks are full of small but delicious brown trout. Each of them has its own wide, well watered valley of lush pastures which provide the richest farmland in Derbyshire. Essentially a land of fresh green, in high summer the pastures are interspersed by the gold of ripening corn. The pastoral wealth resulted in an early excess of milk. In 1870 the first cheese

factory in England was opened at Longford. Later a larger venture was opened at Sudbury by Lord Vernon, to be followed by several more.

Weaving aimlessly through the country is a seemingly intractable maze of lanes, often sunken and flanked with trees which meet overhead. Without road signs, as was the case in the War years, the traveller would find it almost impossible to locate the multitudinous villages which lie hidden by time. They are built of warm red brick, though in those nearer the hills brick cottages are interspersed with limestone houses whose gardens sometimes strangely contain a yew tree. Since they were settled by the Anglo-Saxons, these villages have drawn their life blood from the rich soil on which they stand. Only within living memory have they lost their total isolation. Many, though of hamlet proportions, have their own churches, essentially rural with distinctive low towers. Often the churches were cared for by the ancient families who dominated village life for centuries. A few contrasting examples may illustrate the individuality and interest of the villages, a rich heritage which awaits further exploration.

Nestling in its own idyllic valley, Cubley has a church with a fine Perpendicular tower, added to the Norman nave by the great family of Montgomery, for four centuries rulers of vast estates from the manor. They have long died out, though the earthworks of their fortified house can be seen from the church. After their departure the village entered a long slumber; surviving from those days is a lovely 14th century window depicting St Catherine and two medieval bells proclaiming the intercessions of Ss Andrew and Barbara.

On the upper reaches of the Sutton Brook lies the village of Longford. The church which stands beside the hall, again shows evidence of a noble family in residence, with a fine 14th century tower and chancel added to a Norman nave. The hall was a fine Tudor mansion with a Stuart additions. Unfortunately it was much consumed by fire in 1942, possibly from a stray incendiary bomb, though sabotage was also suspected. Much of the house has now been beautifully rebuilt. Following the Conquest the village was the home of the De Longford family. Starting with Sir Nicholas who died in 1357, generations of the family are recorded in the recently restored alabaster tombs which display exquisite and accurate portrayal of armour and dress, most likely from the Burton School. Another Sir Nicholas, who died in 1610, is seen with his third wife. He was the last of the line, for in spite of his marriages, all of his children pre-deceased him. He was succeeded by a sister who married into the Coke family as they became the new owners of Longford. The estate buildings are in a grand and confident style. The majority were built by the most famous of the Coke squires who became the 1st. Earl of Leicester. He was the pioneer of agricultural revolution based on soil improvement and crop rotation. The principal residence of the family was Holkham Hall in Norfolk, though they remained at Longford until

1920. The 1st Earl died and is buried here. The family were also heavily involved in the development of the shire horse.

Nearby Rodsley is a hamlet which never had a church and like many a small community has now lost both its chapel and inn. It was the birthplace of Ralph Sherwin who left this remote spot for Eton and Oxford. From there he answered his vocation by entering the exile seminary at Douai in northern France. Following his ordination in 1580 he went secretly to London to minister to the faithful during the despotic reign of the first Elizabeth. In reality he was awaiting the call of his native diocese to serve as a missionary priest. This mission was not to be. He was arrested and dreadfully tortured before suffering martyrdom at Tyburn for the faith. It is a fitting conclusion that he was canonized among the English Martyrs by Pope Paul V1 in 1970.

On the eastern extremity of the Dove catchment, nearing the outer suburbs of Derby lies Radbourne, for centuries the seat of the Pole family. In December 1745 a highly secret meeting was held here between the local Catholic and Jacobite gentry and Prince Charles Edward Stuart, who came in disguise and great secrecy from Derby. The Jacobite Army had been disappointed that they had seen no great rally to his call in the area. The meeting was a failure as the local leaders could only promise their moral support. The Prince returned to the city where the decision was to return to Scotland, which he fought to the end. The fine Georgian brick mansion stands proudly on a hill in the park. It is thought to have been built for German Pole shortly after that fateful meeting.

Possibly the finest example of the peace nurtured by the departed aristocracy is to be found at Somersal Herbert which lies lost in a hollow near Marston Brook. For over 700 years this was a home of the great Derbyshire Fitzherbert family. Here again the family suffered persecution for remaining Catholic. The hall is certainly one of the finest Elizabethan half-timbered manors in the land. Legend says that during the Civil War a confrontation occurred between opposing forces based at Tutbury and Barton Blount. In this skirmish many were killed, with the corpses rolling down the hill. The house is said to be haunted by a mysterious White Lady. The direct line of the family died out during the last century, to be replaced by a scion related to the nearby Vernons of Sudbury. The last Fitzherberts of Somersal died earlier this century.

In this countrside are many examples of villages which failed; usually the only visible signs of a lost village are a series of mounds in the fields. The cause of failure were sometimes changes in agricultural practice, but more frequently plagues, such as the Black Death, which decimated the villagers. The maps of today record their former existence, such as Hungry Bentley, Osleston or Barton Blount. The only remains of the latter is the hall which became garrisoned by the Parliamentary Army during the siege of Tutbury. In medieval times it was

home to the Blount family. One of these, Sir Walter Blount married a lady in waiting to the Spanish wife of John of Gaunt; he was later killed at the battle of Shrewsbury. The grounds contain the lovely little church which was beautifully restored by a previous owner. Barton Blount is said to be visited by a terrifying apparition, the Barton Bitch. This is a wild dog which terrorizes the night uttering horrific cries while wearing a lighted lantern around its neck.

Church Broughton, like many of these villages has fine Norman work in the church. This village is a good example of the changes which are taking place in the rural depths of Derbyshire. Until the 1960s it presented a face of bucolic continuity. This ambience was replaced by the large scale building of new houses for the executive classes, a new generation of villagers who owe no allegiance to the soil or rural traditions. During the Second World War an airfield was constructed on the flat lands above the river. At the end of the War this site was used for the trials of the first Rolls Royce jet engine. Like many former military sites the decaying bleakness of years is being replaced by the erection of an industrial estate. Sadly some very obtrusive storage buildings dominate the visual aspect of the Lower Valley.

We return to the river at Scropton, a village which has for long been dominated by the railway: it had its own station until 1872. There are some nice period buildings and quiet lanes; and despite some signs of change it retains some of that relaxed nonchalance found in the Trentside villages through Derbyshire and Nottinghamshire.

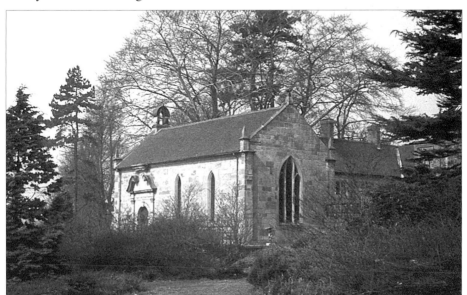

Barton Blount: The church of the lost village.

Tutbury Weir: The salmon leap.

The Tutbury Treasure: A silver penny of Edward I.

CHAPTER 13
TUTBURY: THE MEDIEVAL FORTRESS TOWN

The Lower Dove; a Fine Fishery

Throughout its length the Dove remains a superb fishing river. While the upper reaches are noted for game fish, the river becomes progressively a coarse fishery. Though the succession of deep pools and intervening swift currents would be ideal for trout and grayling, the spawn and young fish of these species fall prey to predatory coarse fish. While it would be impossible for these reaches to become a game fishery, trout are commonly taken during coarse fishing; fly fishing is now rare. In 1863 Sir Oswald Mosley in *The Natural History of Tutbury* wrote, *"Our Dove presents a perfect specimen of a grayling river"*. This species unlike the trout is not now stocked.

The river conditions combine with the superb water quality to make this an exceptional fishery with a wide range of coarse fish. For many years the river has been rich in minnow, bleak, gudgeon, dace, perch, bream and to a lesser extent carp. It also contains many pike which are regularly taken at 30 lbs. These are however modest when compared to the famous denizen of 50 years ago in the depths below Tutbury Mill. This monster was regularly seen taking duck and other large prey and defied all attempts to catch it.

The diversity and quantity of the fish stock is constantly changing as the fishery goes from strength to strength. In recent years, the most common fish has become the chub, the first sightings of which 20 years ago were treated with some disbelief. A further recent arrival has been barbel and the waters have now become noteworthy for this fine fighting fish. In recent years the population of eels has also increased following a prolonged decline. These are usually taken by night fishing, though the current population is not now sufficient to support the former practice of exploiting the ascending shoals with lines in the spring.

Salmon formerly travelled their migratory course to the Dove's headwaters, after a hazardous journey through the Trent. Many of the migrants were caught at weirs, though specially prepared salmon leaps were constructed on the Dove at Dove Cliff and Tutbury. Ultimately the industrialization of the nineteenth century led to the pollution of the once silver Trent. By the 1880s the end neared as indiscriminate destruction of salmon was recorded by Mosley:

"In the month of December 1853, many salmon were observed in the river at Tutbury Bridge, and some of the inhabitants of that town were tempted to load their guns and shoot them, by which they obtained several, weighing 12-14 lbs. each; while others were speared at the weir, about half mile higher up. It is necessary to add that the whole of them were out of season; and useless!"

"The greatest number that I remember being caught at Dove Cliff in one year was 42, the average weight of which was 14 lbs..... Within the last 8 years, not more than 14 have been caught in the whole period"

Parliament appeared sufficiently concerned by 1860 as to appoint a Royal Commission, with a view to "Increasing so valuable an article for the benefit of the public". In their deliberations, the Commission visited the upper Trent and Dove and inspected the weirs at Dove Cliff and Tutbury. At the latter they reported having seen salmon leaping in succession. In their report they recorded the belief that with care and protection, a valuable fishery might be returned to the river! This was not to be the case; the last specimen was reported at Tutbury in 1939.

The re-introduction of salmon remains an emotive, if desirable aim. Opposition from land owners has already been noted. On these lower stretches there is also opposition from coarse fishermen who fear that there would be a large increase in the cost and availability of their sport. It is also recognized that much has to be done to restore access at weirs, especially at Clay Mills.

The Dove has produced a succession of outstanding anglers. Possibly one of the most famous was the late Roger Woolley of Tutbury, who spent his working life as a barber. Having been nurtured along the river bank, he made a detailed study of fishing flies to became a leading authority. His greatest contribution to the sport was, *The Fly-Fisher's Flies*, a masterly work, published in 1938, which details the entomological and Linnaean nomenclature of some 200 species. This was an amazing achievement for a man without academic training. Mr Woolley founded a business which utilized the hair from his daytime patrons in the manufacture of flies. This brought him fame, with clients coming from far away. This great tradition continues with the present generation of fishermen, who know the secrets of the holes and gravel shoals.

The riches of the river were fully exploited in medieval times. Large amounts of fish were required to maintain the garrison of Tutbury Castle. This even included quantities of the diminutive minnow, probably intended for the lower ranks. During the reign of Henry V, a high value continued to be placed on the fisheries, boats and nets at Tutbury. It is probable that many fish were caught with traps of osier positioned on the river bed.

Earliest Tutbury

The descending line of the Needwood Escarpment abruptly rises for one final crescendo: the great eminence on which stands Tutbury Castle. The precipitous mass casts a shadow over the valley in all but the sunniest days of summer. The hill is an ominous sight especially in the dark days of winter, crowned as it is by the open halls and ruined towers of one of England's great natural fortresses,

So many have been its glorious and sorrowing days that the very hill seems to be impregnated with the passage of history. This is the historic centre of the Land of the Dove; its story, a rich saga from the history of England.

The origins of the castle are lost in an impenetrable mist. It is certain that before recorded time, man sought protection on the hill. The Iron Age people were divided into tribal states which were unable to achieve unity and lived in a constant state of warfare. Hence the need for large hill forts consisting of concentric earth works within which lived the tribe and their cattle. At Tutbury, apart from the castle earthworks, the old town is enclosed within concentric earthworks. Some writers have suggested that these are the outer defences of the castle or the remains of medieval town walls. These defences have long been one of the great mysteries of Tutbury. Excavations carried out in 1974 by W. Morland established them to be of Celtic origin. The writer contends that they are evidence that Tutbury was the capital of some past Celtic kingdom, of which the present castle site was the nucleus. This hypothesis is based on the following:

1) No documentary evidence has been produced of medieval defences.
2) Iron Age pottery has been found over the area.
3) The outer earthworks do not align with those of the Norman motte and bailey earthworks.
4) The writer has indentified the entrance to this fortress which still retains the inturned embankments which enabled a penetrating enemy to be bombarded from above. This gateway was approached along a sunken way from the south, which could have had ceremonial significance.
5) The great size of the enclosure, exceeding half a mile in diameter, would indicate a place of great magnitude.

The writer considers it likely that the Dove was the disputed boundary between two Celtic kingdoms. This would explain the additional defences on the northern side and also the fort on the Needwood Forest. The extent of these works indicates the period of about 500 BC, when territorial capitals became permanently inhabited. Most of these earthworks have been destroyed during development over the last 40 years. This is a reproach to the neglect by local authorities and the nonchalance of the public.

It is certain that the Romans kept a watching brief over the native people from the hill, while their coins have been found by metal detectors over a wider area. It is also certain that Tutbury was used as a fortress by the rulers of the Saxon Kingdom of Mercia. At Tutbury Church there is a Saxon tympanum representing a boar hunt. Despite the ravages of time, one can still trace the hounds attacking the rising mass of the beast.

The Tenure of the De Ferrers

With the arrival of the Norman conquerors, the Saxon world receded into a ghostly twilight as the golden age of Tutbury dawned. In recognition of his loyalty and valour, King William bestowed upon his friend Henry de Ferrers a domain of over 200 manors in adjoining counties from which supplies and manpower could be drawn. To control this turbulent territory, Henry De Ferrers selected Tutbury as his principal seat. Because he was one of the most powerful men in the new order, Tutbury gained population and wealth to become one of the principal towns and fortresses of Norman England. Throughout his domains, known as the Honour of Tutbury, there was hardly a village or church which did not flourish under his enlightened rule.

Henry de Ferrers founded a dynasty of noblemen of supreme and eventually unbridled power. His son Robert was a fearless fighter who was renowned for his defeat of the Scots in 1138. Impressive would have been the sight of him riding out at the head of his army drawn from the Tutbury lands. The castle of that period consisted of the vast motte and bailey earthworks with wooden pallisades. The only stone building which dates from the Ferrers period is the chapel of Saint Peter which was re-discovered by Duchy of Lancaster excavations in 1955. This chapel is richly Norman in design.

The later Ferrers became influenced by ambitions other than the absolute loyalty to the King, which had characterised their founder. William, grandson of Robert joined the revolt against Henry II which led to the pillage of Tutbury by a Welsh army led by Prince Rhys of Deheubarth, an ally of the King. On the accession of Richard I, Ferrers joined him on his overriding passion, the 3rd Crusade. The Ferrers' reputation was enhanced when he was killed in the Holy Land at the Siege of Acre in 1190. His son, another William, must have learnt a lesson, for although possibly the most powerful baron in the land, he consistently supported and entertained the embattled King John.

The last Ferrers of Tutbury was another Robert, who inherited the domains at an early age. The family's name shone from this remote hill in Staffordshire with a brilliance which was only outshone by the King himself. Looking out over the valley to the rising hills of the Peak, Robert de Ferrers would have been master of all he surveyed. On reaching maturity he staunchly supported the young Henry III. From Tutbury, they rode off together to campaign in Wales, with Queen Eleanor staying behind. A legend says that the sensitive King made a secret return from Chester to visit his beloved French wife in Tutbury Castle. Later the great comradeship ended when Ferrers joined the Barons' Rebellion and later seized the royal heir, Prince Edward. A victory against the king at Chester briefly put Ferrers in the ascendant. However, with the viciousness that he would later inflict on Wales and Scotland as Edward 1, the former prisoner

attacked Tutbury with the full ferocity of medieval vengeance and the Priory was severely damaged. Robert de Ferrers was later captured, but begged for mercy and promised future loyalty. King Henry pardoned him according to the prevalent code of chivalry, upon the presentation of a gold cup studded with precious stones. Humility was however not one of his characteristics. Soon the fires of revolt were re-kindled as he again rode out in rebellion. Later he was forced to live as a fugitive until being betrayed by a girl whose lover had been killed in one of his crazed schemes. At this further betrayal, the meek King's wrath was merciless and Tutbury again became a smouldering ruin. The wreck was complete. The Ferrers were expelled forever; how are the mighty fallen!

The Rise of the House of Lancaster

Henry III gave the Honour of Tutbury to his son, Edmund, Earl of Lancaster and from that time it has remained in the possession of the House of Lancaster. Subsequently it became the property of Thomas the 2nd Earl, who realized the potential to rebuild the castle, where he held court in full medieval splendour. Today the main gatehouse, built in red stone, is the only reminder of his castle.

Tutbury again exerted much influence upon the affairs of England. From an early date, Thomas had been conspiring against his cousin, Edward II. Along with other barons he was incensed by the influence upon the Throne of Edward's perverted favourites. He decided that the King should be overthrown, perhaps to be replaced by himself. In pursuance of this policy he stood back when the pathetic King invaded Scotland, leading to humiliation on the Field of Bannockburn. King Robert the Bruce, of Scotland, was naturally very pleased at this forbearance and concluded a secret alliance, with the promise of complicity in the future plans of Lancaster.

The Lancaster Rebellion

In the days following Bannockburn, England entered a period of unprecedented strife. Even Queen Isabella, by repute promiscuous and estranged from her wretched husband, became supportive of the rebels led by Thomas of Lancaster. Though Lancaster was aggressive by nature and skilful in plotting, he was irresolute in action. His banner was to prove the ruin of his townspeople. The civil war flowed across England until 1322, when the King seeing his reign progressively undermined, decided to expunge the troublesome Earl and his principal fortress.

Heading an army of mainly Welsh mercenaries, he advanced from the south to the River Trent. The river was in flood and Burton, the only crossing was controlled by Lancaster. Thomas of Lancaster was confident that he was secure with the 30,000 troops he held at Tutbury. However, with excellent intelligence, Edward's main army forded the Trent at Walton, while to distract

attention a detachment fought the Battle of Burton Bridge. This skilful manoeuvre resulted in the King marching unfettered upon Tutbury. Outflanked, the Earl at Tutbury was seized by irresolution at the advance of the King. With only a half hour separating the two armies, and without news from his Scottish allies, he decided on retreat. When Edward's army arrived mayhem broke out, as pillage, rape and systematic destruction were visited upon the prostrate town. Their defenders had fled in panic!

The Tutbury Hoard of Coins

On the arrival of the King, Tutbury abounded with rumours of great treasure, with which the Earl had intended to pay the troops and their Scottish allies. This hoard of 1,500, was held in three casks bound with iron. However due to the prevailing turmoil, no investigation was made for over a year, when an enquiry with jury heard the evidence. Three witnesses stated that they had seen the casks before the looters entered the castle. One John Kynardesle admitted that he was party to the conveyance of these barrels to the nearby Priory for safe keeping after the Earl's flight. He stressed that he did not know whether the treasure was intended for Lancaster or the King. All men denied taking any silver themselves. Many witnesses recalled having seen the casks, but all knew nothing; a wall of silence had been encountered. The Jury also heard how robes and jewellery were removed from the castle. Even the Abbot of Burton was arraigned for taking valuables after Lancaster's flight from Burton. The vague evidence only added to the mystery, which after the passage of time became legend and finally forgotten; until 1831! In that year a party of workmen were engaged in a project to improve the outfall of the nearby cotton mill. Part of that work involved the construction of an embankment to separate the outflow from the main course of the river. This embankment was being constructed with gravel from the river bed.

On Wednesday 1st June, the workmen found a few silver coins in the gravel some 60 yards below the bridge. These coins were quietly dispersed amongst themselves. However throughout the week coins continued to be found in ever increasing numbers. The following Monday the men returned to their work in expectancy of renewed finds. They were not to be disappointed! The further upstream they worked, the greater were their discoveries. On the Tuesday several thousand were obtained. On the following day, they located a mass of coins, about a cubic yard in extent, about 30 yds below the bridge. This was obviously the centre of the hoard, and the source from where the others had eroded.

On the Thursday hundreds of people were in pursuit of coins. Men worked frantically, immersed to their waists with shovels and riddles. Others came to

barter for supplies of silver. So great was the haul that June day, that over 20,000 coins were recovered. The "Farmers Journal" recorded: [NB 20 shillings = £1]. *"At the outset they were sold from 10s. to 12s. a hundred. At this price a great profit might be obtained, they weigh from 20 to 25 an ounce and silver smiths from Burton have been giving 4s. an ounce for them."*

The "Derby Mercury" reported workers were collecting sufficient coins to earn £10 a day. The paper describes that exciting day and those following: *"There were about 300 individuals in the water and about 400 spectators. On Thursday, the quantity of coins collected was not so great and the prices raised from 13s. to 16s. per hundred. On Friday and Saturday the amounts (found) again decreased, although the men worked up to the neck in water".*

Naturally news spread rapidly. So great did the concourse become that excessive drinking led to quarrels and disturbances. To control the throng, the local militia were summoned. At length the Duchy of Lancaster asserted their traditional rights to prevent further breaches of the peace and an order was issued to prohibit further searching. On the 1st July, after further digging on behalf of the Duchy, the excavations were in-filled by order of William IV. It is interesting to note that this order remains in force, and can be seen exhibited in Tutbury Church.

There can be little doubt that this discovery was the treasure of Thomas of Lancaster. A hoard of that magnitude could only have been owned by a great nobleman. Further, no coins were discovered later than the reign of Edward II. Was it the intention of the monks to place the casks in the river for their own procurement, or for safety until Lancaster returned? Or were others responsible? It is undeniable that the Priory was sympathetic to the cause of Lancaster; moreover it had been damaged by the King's army. While it can only be conjecture, it is probable that finding their house slighted, the monks hid the treasure to await more advantageous times. It is also possible that it became lost by accident, but it must be remembered at that time, the river bridge was further upstream. The mystery is unlikely ever to be solved despite the current work by Dr Jennifer Rowley.

The coins were principally of the reigns of Henry III, Edward I and Edward II. Also found were Scottish coins of Robert the Bruce, John Balliol and Alexander III. The latter proved to be the most saleable. While it is estimated that some 100,000 were found, it is calculated that some 360,000 were originally in the casks. Many of the coins found in the main deposit appeared welded together by a ferric compound. This, the writer suggests, could have originated from the iron bands of the barrels. It is likely that some appreciable portion of coinage was removed before secretion in the river. What is certain is that many coins still remain in the river; a repository of the vain hopes of

centuries past. Lancaster fled north, to his defeat and execution. However, the King's victory was to be short lived, as Lancaster was treated as a martyr. Resistance to Edward continued with increasing severity; he was eventually overthrown and murdered in revolting barbarity.

The Succession of Blanche of Lancaster

Despite the debacle, Thomas's brother, became the 3rd Earl and the Honour was returned to him. The son of this Earl was later created 1st Duke of Lancaster. He was recorded as a man of great charm and panache, who had a passion for both courtly and servant women. During his tenure Tutbury Castle remained a rarely visited ruin.

The Duke had a young single daughter, called Blanche. This flower of womanly charms was beautiful, graceful, blonde and had an ample figure. Chaucer in verse, was glowing in his praise of her intellect, graces and body. Blanche of Lancaster was to become the heiress to the greatest inheritance of England. This lovely "Flower of England" presented the ultimate prize for that generation of bachelor princes and nobles. Her calculating father was determined to retain his beautiful asset for only the most worthy and determined of suitors.

The Arrival of John of Gaunt

John of Gaunt was the third son of Edward III. Throughout his life he presented an impressive image. He became instantly infatuated with the charms of Blanche on first seeing her with her ladies. John was not to be deflected by early rejections. In fact it is believed that he only obtained the Duke's final agreement to marriage after an intervention from his father. It can only have been an advantage in such circumstances when one's father was the King!

The marriage took place in 1359 when John and Blanche were both in their teens. Two years after their marriage, her father died, and John himself was created Duke of Lancaster. From then, John of Gaunt exercised the Lancastrian influence within the land. He turned his attention to the abandoned castle of Tutbury to build a fine residence for his young bride. He was also attracted by both the situation and hunting. Tutbury now waxed from ruin to unprecedented glory. No effort was spared to make the castle fit for the wife of the most glittering noble in the land. Mosley vividly portrayed the emerging scene, *"Mouldering turrets arose phoenix like from the ruins. Crowds of attendants were now beheld bustling through the paved courts; knights and squires in gorgeous apparel were now passing through the gates on well trained steeds, whose trampling made the massive walls resound. Mirth and festivity once more resumed their sway, and a state of prosperity, greater than was ever before known."*

In character John of Gaunt was tempestuous and decisive. He had inherited from his father the skills of diplomacy and war, showing great vitality and bravery. but at times he was a brooding and emotional man. At all times he was at the centre of the intrigues and struggles of his lifetime.

Blanche was to bear five children in nine years, although two died in infancy. It was at Tutbury that the children were reared through their childhood. Although Blanche was installed in conditions of grandeur she was not to enjoy happiness. Her beloved husband was only in residence for short periods, being frequently abroad while reinforcing his father's foreign policy with force of arms. She was unable to restrain his turbulent spirit and he developed a long term relationship with one Catherine Swynford, who accompanied him on his almost incessant programme of war in Scotland and France. Never strong in health, Blanche was drawn closer to religion. While John was in France, she died at the age of 26 yrs. It is thought that she died of the Black Death and may have been pregnant at the time. Despite his neglect of Blanche in life, after her death, John displayed much grief.

Queen Constance of Castile and Leon

In France during 1371, John of Gaunt married Constance, daughter of the murdered King of Castile and Leon, the dominant Spanish kingdom. If Blanche had been an English Flower, Constance was a mysterious dark Latin beauty with strong passions. She was determined to avenge the murder of her father. On his marriage, John declared himself King of her native land. To ameliorate the greyness of Tutbury, he refurbished the castle with even greater magnificence. Glistening towers arose, continental gardens and vineyards were laid, while the harsh walls were softened with priceless hangings. It has also been suggested that the Tutbury Bull Running was initiated to satisfy her Iberian tastes. Minstrels thronged the court, which found a response in her love of music and glamour. To this court thronged the greatest and gifted of the time, including Chaucer, who was brother in law to Catherine Swynford.

Despite the material richness of her surroundings, the new Duchess became unhappy, especially as only one of her children survived infancy. Her grief was compounded when John's affections for her died, also in the arms of Catherine Swynford, who continued to bear a succession of his children. The visits of John grew less frequent and his second Duchess sought spiritual solace in the incense laden air of the castle chapel, far from her sunny native land.

The Iberian Campaign of John and Constance

In due course John of Gaunt's nephew succeeded his father and became Richard II. John found that he was distrusted by the new court on account of his wealth and power. Though he continued to pursue vigorous foreign campaigns, these

became more inclined to his own interest.

Many years were to pass before he was allowed to pursue his claim to the Throne of Castile. In 1386, no longer young, he set out with Constance on a campaign to reclaim her native land. In this, Constance's understanding of Iberian affairs was vital. It must now be assumed that her inheritance was the prime reason for the marriage. His eldest child, Philippa, was also with them. She was in her late twenties and had become the confidant of her father. It is recorded that she had inherited her mother's beauty. On arrival in Portugal they found that Kingdom besieged by Castile. King John I of Portugal was delighted to receive the welcome assistance of Gaunt's army and in return supported John's larger plans. This laid the foundation of the oldest alliance in the world, which was further secured with the marriage of Philippa to King John. How useful it would have been to have had a nubile daughter on hand! John was very sad to leave his beloved daughter and trusted friend behind, though this girl of Tutbury later became a popular Queen. Her exquisite tomb is seen in the royal mausoleum at Batalha (central Portugal), where also lies her famous son, Prince Henry the Navigator.

Through three weary years of campaigning it proved impossible to win the success required to gain the Castilian throne. However, John and Constance had become reunited during their travels. At the end of the campaign she sadly left her native land for the last time, while John realized that his last chance of becoming a King had now passed. She died a few years later and was buried modestly at Leicester. After her death John married his aging mistress of a lifetime, Catherine Swynford, so legitimizing his four children by her. He himself died in his late fifties, when it is recorded that his body displayed many symptoms of excess and debauchery.

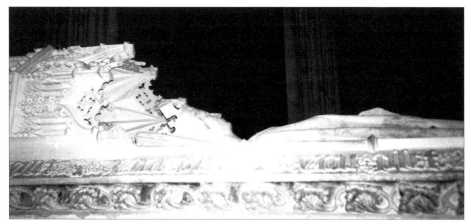

The Girl from Tutbury: The tomb of Queen Philippa in Portugal.

The Foundation of Tutbury Priory

Following the consolidation of his position, Henry de Ferrers founded a great priory below his castle, to demonstrate his confidence in the Norman order and to emulate the great abbeys of Normandy. The Priory Church was intended to be his atonement with God and the ultimate demonstration of his faith.

In his ascendancy he felt the need for prayer to secure perpetual peace for himself and his family and he looked for the monks of the Priory to celebrate Mass and support the family in their prayers. The original monks of the Benedictine Order were brought from the abbey of St Pierre-sur-Dives in the heart of his native land. This abbey had been founded by Countess Lesceline who was William the Conqueror's aunt. It was appropriately finished in 1066. By 1089, Tutbury Priory was sufficiently advanced to be dedicated to Our Lady on the Feast of her Assumption (15th. August).

The foundation charter amplifies his intentions and loyalties, "*In the name of the sacred and undivided Trinity, I Henry de Ferrers, have founded a church in honour of Holy Mary, the Mother of God, near my Castle of Tutbury for the soul of King William and Queen Matilda, and for the health of my father and mother and my wife Bertha and my sons and daughters and all my ancestors and friends. For the use of the monks serving God there, I have given......* (Here the charter continues by detailing the grants across the Honour bequeathed to the foundation, including lands, tithes, rights, venison, pannage and fisheries.)

There is evidence to suggest that in his twilight days he exchanged the call of arms for the habit of a monk, to prepare himself for death. It is recorded that his body was buried temporarily until the chancel was completed, and then transferred to a fine tomb on the right hand side of the high altar. Henry de Ferrers did not see the completion of his priory. It is possible that the great west front was not finished until mid way through the following century.

The Priory of Our Lady, Tutbury

When completed the priory covered three acres. It was dominated by the magnificent Priory Church which included quire, transepts and triforium, with probably a great central tower. The authority on the church Dr Jenny Alexander has contended that the western frontage would have followed the typical Norman design with twin western turrets. The writer suggests that the priory had a similar layout to Southwell Minster in Nottinghamshire. Unusually the cloisters and monastic buildings lay on the north side of the church, this being dictated by topography. In those far off days the priory would have been a haven of tranquillity between the castle and the bustling town below. The precints would probably have been entered through an elegant gatehouse, which led down to the great west frontage.

Throughout its existence, the Priory of Tutbury remained under the title of the mother house in Normandy. During the century following the foundation, Abbot Haimon of St Pierre wrote a letter of the proportions of an encyclical to the monks of Tutbury This document recorded the miracles worked through the intercession of Our Lady during the rebuilding of the mother house following its destruction by fire. Its object would have been to maintain the links with the French abbey. The mother house throughout was powerful and famous, being enriched by pilgrims following an apparition of the Blessed Virgin.

In later centuries sentiments changed. In 1334 on returning returning from a visit to the Bishop of Lichfield the Prior was captured by men who resented the foreign control. Although he was freed, he later cursed those responsible from the high altar. By the late 14th century, when the wars against France aroused strong feelings, laws were passed to suppress foreign controlled monasteries. Tutbury would appear to have escaped through influence and by becoming autonomous.

The Dissolution

During the tyrannical reign of Henry VIII, the sun was to set on the monastic world. After continual harassment, Tutbury Priory was surrendered on September 14th 1538. At that time there were only 8 monks remaining with an acquiescent Prior. The others, fearing the worst, had previously fled. All the wide lands, granges, rights, valuables, livestock and tithes were sequestrated. The Priory lands were granted to Sir William Cavendish who had himself received the Document of Surrender! In this dubious deal he had been greatly "encouraged" by his formidable wife. As the desecration of the great pile began, the lead from the roofs was melted down, marked and delivered to the castle. The bare walls remained until 1583, when they were pulled down to supply stone for Sir William's town house. Was this destruction correctly described by the psalmist, "I will sing a new song unto you," or was it merely pillage by greedy hands. The writer inclines to the latter view.

During the centuries of the Priory's existence the townspeople had been given the right to use the nave as their parish church. This to our eternal joy, secured the survival of the nave, though in a much truncated form. The last Prior, Arthur Meverell, became the first parish priest for a short period. The dissolution had a devastating effect on Tutbury. The fine monastery had been a focal point for visitors and business. The removal of its patronage throughout the Honour led to further loss of influence and created a great void in the life of the area. The priory had also maintained a wayside chapel for the use of travellers on the way to the Forest, this, too, fell into disuse. Today the name of Chapel House is the only reminder of this lost chapel.

The Priory Church of St Mary

The surviving nave of light Hollington stone, now the Priory Church, remains a sight of outstanding beauty, which generations have loved and tended. In the vast interior it is still possible to visualise the magnificence of the church as envisaged by the great warrior baron. The mighty Norman pillars march symmetrically towards the distant chancel. The pillars are capped by sharply incised capitals which support the great arches. Above them rose a triforium, which after the Dissolution became the clerestory. A relic of the triforium remains above the west door.

Exceeding even the pillars in the towering splendour of the interior is the west end, the finest glory of the church. Here the only surviving portion of the triforium rises defiantly within a strident soaring arch. Outside, the full sublimity of the West Front becomes manifest. The great west door is without doubt the finest in the land; its size and execution attest to the importance of the place. The seven orders which recede in concentric steps towards the doorway are elaborately and horrifically embellished by beasts; their abstract faces reflecting the morality of man himself and symbolizing both good and evil. Gazing at the fearsome bestiary in stone, one may imagine the full glory of the portal when newly cut, bright and sparkling in the 12th century sunshine.

Not all of the church is Norman. The south aisle is gloriously Early English; having been rebuilt by Thomas, Earl of Lancaster after the Barons' War. It is likely that the rebuilding was delayed by the Black Death. The aisle now serves as a memorial for those who never returned from the Great War. The reredos is magnificent, being carved from a single piece of alabaster. This epitomises the tragedy and resolve of the Great War. At the initiative of Elizabeth I, the tower was added to enhance the church's role as a protestant place of worship. In Victorian times, the famous G.Street was engaged to give the truncated Norman nave a more complete appearance in accordance with his own interpretations. This resulted in the addition of an apse and a high pitched roof which was obviously an attempt to re-capture the original height of the Norman nave. However externally the high profile is an aesthetic disaster!

The graveyard covers the site of the priory buildings. Over the years great foundations have been unearthed, especially during the 1970s when some interesting objects were found. In one area the writer recalls finding an alabaster capital and elaborately worked and coloured stone, The nature of these objects and the location would indicate that this was the site of the Chapter House. In that area in February 1972, the remarkable discovery was made of an alabaster sarcophagus. This was certainly that of some dignitary because of burial in such a manner, especially in the Chapter House. The skeleton was re-interned along with the new internment! Broken pieces of alabaster were frequently found,

Norman Magnificence:
Priory Church of St Mary,
memorial to a warrior baron.

The Finest in the Land:
Norman West frontage,
Tutbury Priory Church.

probably from monuments smashed at the Dissolution. Such despoilation of the priory remains is a reproach to past church authorities. Nearby were also found skeletons from a mass burial, these could have been victims of plague or from the many wars or massacres that have swept across this ancient place.

The Tutbury Fair

Throughout the life of the Priory, the Feast of the Assumption was an occasion of great celebration. It was an important day in the Church Calendar, as well as the patronal festival. A great fair, which typified Merrie England, was held over several days attracting many itinerant traders, competitors and minstrels. John of Gaunt inherited these traditional events, but he formalized them with a greater colour and glamour. After the Reformation the fair gradually declined.

The attendance of the minstrels was important as they came in large numbers from across the Midlands. They were the aristocrats of itinerant entertainers, enjoying much influence and privilege. Frequently disputes developed in the course of their trade across the country. At the fair these disputes were adjudicated by a Court with its own ritual and officers, including an elected "King". This Court functioned in a similar way to that of the London Livery Guilds. To enforce this regime, John of Gaunt issued an impressive declaration: *"John, by the Grace of God, King of Castile and Leon, Duke of Lancaster, to all who shall see or hear these greetings; know ye, that we have ordained, constituted and assigned to our well beloved King of Minstrels in our Honour of Tutbury, who is, or for time shall be, to apprehend and arrest all the minstrels in our said Honour, that refuse to do the services and attendance which appertains to them to do from ancient times at Tutbury asforesaid, yearly on the days of The Assumption of Our Lady...... Given under our Privy Seal, at our Castle of Tutbury"*. The Court of Minstrels survived until Stuart times, though the last of the Tutbury Minstrels, one Henry Coxon, was buried at Tatenhill in 1739.

If the townspeople and travellers found diversion at the fair, so did the Foresters of Needwood. On the morning of the Feast of the Assumption, the Foresters and Keepers rode down to the Town Cross. From there, preceded by the minstrels, a procession wound its way through the narrow streets to the Priory. The severed head of a deer was carried in the procession, garlanded with a rope of peas. On arrival at church the procession entered for Festal Mass. This custom was briefly revived in the 1940s by the vicar and ecclesiastical historian of Tutbury, Rev.N.Edwards. The Coucher, which codified duties within the Honour, recorded the tribute due to the Prior: *"The Prior of Tutbury shall yearly on the day of the Assumption of Our Lady, have a buck delivered to him of season by the Woodmaster and Keepers of Needwood"*.

The celebration on this Holy Day would have been similar to present customs in rural France. Later in the day the great crowds, after much drinking and feasting, were ready for the Bull Running. In this barbaric spectacle, a bull was released from the priory gatehouse after it had previously had its horns, ears and tail cut off and was covered with grease to ensure that it wouldn't easily be caught. To further enrage the unfortunate animal, pepper was blown into its nostrils. It was then pursued through the streets by the mob until sunset. Only the minstrels were allowed to try and catch the tormented creature. If caught, it was taken to the bull ring in the High Street before being baited to death by dogs. Afterwards the meat was divided amongst the minstrels. If the animal crossed the river the bull was claimed by the Prior.

This wicked custom continued long after the end of the Tutbury Fair or public celebration of the Assumption. In later years it had become the venue for a rabble, of benefit only to local publicans or whores. It is ironical that the end only came when a visiting man was killed in ferocious street brawls. Following petitions to the Duchy, the custom was finally banned by the King in 1778!

The Dove at Tutbury: 18th century engraving of the tramway bridge.

CHAPTER 14
TUTBURY: CENTURIES OF DECLINE

Henry Bolingbroke

Henry Bolingbroke, who was the son of John of Gaunt and his first wife Blanche, had inherited his father's decisiveness and ambition. The little boy, who had been reared within Tutbury Castle walls, became an exponent of the power of arms, which he was also to exploit in extending the boundaries of Christendom. In the east of Europe lay Lithuania, the only appreciable country left in Europe not to have accepted Christianity. From the Tutbury lands he raised a Crusade in alliance with the Teutonic Knights to succeed with the sword, where priests had failed with the gospel.

On the death of John of Gaunt, Richard II decided to expunge the influence of the House of Lancaster from his shaky kingdom. This action was intolerable to Henry, who rose in rebellion and captured Richard in Wales. The King abdicated in favour of Henry and was last seen entering Lancaster's Pontefract Castle. When Bolingbroke became Henry IV, the fortunes of Tutbury began a long decline, which was later accelerated with the Dissolution of the Priory. The town eventually subsided to the status of a large village as the heartbeat of Tutbury became progressively weakened.

While the castle ceased to house the Lancaster court, it remained an administrative and legal centre for the Duchy. Throughout the 15th century, a number of fine buildings replaced much of the former castle. These great halls and apartments reflected ecclesiastical designs, with fine windows and elegant mouldings.

Mary, Queen of Scots

The next important personage to make her (involuntary) home at Tutbury was Mary, Queen of Scots. As a little girl, Mary had been taken to France to escape the threat of the English. She was affianced to the Dauphin and was brought up to be the future Queen of France, being treated as the most ornate flower at that gilded court. At the age of 16 years she was married, while in the following year her husband succeeded to the Throne as King Francis II. Tragically he died a year later after much suffering, during which his young wife gave him comfort.

Shortly afterwards, her presence was required in Scotland, which was in the midst of a protestant rebellion. In 1567 her second husband, Darnley, was murdered and she was forcibly married to Bothwell who was regarded as the murderer. Following a further outbreak of a civil war Mary was forced to abdicate. Most previous Scottish monarchs had suffered violent deaths at the

hands of their subjects. Mary decided to escape such a fate at the hands of the protestant nobles and fled her kingdom. On the 16th May 1568, the Queen of Scots landed on the Solway coast of England hoping to secure the help of her cousin, Elizabeth I. This was to prove a dreadful mistake!

Mary Stuart was a young woman of boundless energy, who loved the ecstasy of the chase. By her early twenties she had already led her army into battle, and made escapes that required both bravery and endurance. She always had the power to inspire her followers, especially by riding at their head with her long auburn hair flowing as a banner.

In contrast to Elizabeth, Mary was a beautiful and desirable woman. Her face was remarkable for her heavy eyelashes, delicate arched brows and full lips. This gave her an alluring, sensual look. Her eyes were described as resembling amber, matching her hair. Elizabeth had always been jealous of her looks and suspicious of her intentions. Mary was wild in her impulses and passions in contrast to the cool, calculating efficiency of the English Queen. She was also a mistress in artistic fields, especially in music and poetry, and a gifted linguist, though her first language remained French throughout her life.

The Arrival of The Queen of Scotland

After her arrival in England, Mary was regarded as a threat to Elizabeth, since foreign powers and English Catholics alike supported her right of succession as Queen of England and the restorer of the Catholic faith to England. Further, if she was restored to her own throne, it was feared French influence would again become a threat. Elizabeth decided to play for time, by retaining this brilliant bird in a gilded cage. It was decided to place her under the care of the 6th Earl of Shrewsbury who owned great estates in the North Midlands. Tutbury, which was leased by the Earl, was selected as her destination. By the end of the 15th century the castle had become obsolete and had suffered from neglect. However the interior was capable of housing her vast entourage, including over 150 guards. To ameliorate the living conditions, rich hangings and carpets were brought from the Tower of London and from the Earl's more lavishly furnished mansions. On the 4th February 1569 the great retinue arrived at Tutbury. As the great gates of the castle closed behind her, her true imprisonment had begun. She was 26 years old. The instructions from Elizabeth to Shrewsbury were clear, *"Use her honourably, but see that she does not escape!"* Throughout, Mary found Tutbury the most loathsome of her prisons.

The Exile Scottish Court at Tutbury

Despite her confinement she still kept an exile court and a household of some sixty, including a priest. She still enjoyed the trappings of royalty. At the head of her chamber was a dais with the cloth of state. She ate off services of silver,

her bed was of fine linen and hung with tapestry. She was even known to bathe in wine. In the stables stood her fine horses together with grooms and farriers.

In this early stage, Shrewsbury's wife, the formidable Bess of Hardwick, became her friend. Both were skilled seamstresses and they started the famous tapestries that became a solace during her captivity. The hangings contain secret devices providing a clue to her beliefs and hopes. The finest collection of them is located at Oxborough Hall in Norfolk, but smaller pieces can be seen at Hardwick Hall in Derbyshire, showing the Thistle of Scotland.

At that time, Nicholas White, a member of Elizabeth's government, interrupted his journey to Ireland to visit Mary. He described his visit to his Queen in terms which were intended to ingratiate himself, and also to imply future warnings, *"She is of goodly personage, yet in truth not comparable to our sovereign. She had withal an alluring grace, a pretty Scottish accent and a searching wit. Fame might move some to relieve her, and glory might stir others to adventure much for her sake. Then joy is a lively infective sense, and carrieth many persuasions to the heart, which ruleth the rest"*.

While she was at Tutbury, an improbable romance was initiated between her and the Duke of Norfolk. This proxy affair appealed to her tastes. Was he not the premier noble of England and also a Catholic? It was a romance which Mary sought to promote as a mistress of enticement. As an intimation of his intentions, he sent her a diamond pendant, which she alluringly promised to hang below her dress, *"Where no man would ever see it."* Her letters to him were signed, *"Yours faithfully to death"*. The following March, due to sanitation problems, she was moved first to Wingfield Manor and then to Chatsworth. There Mary was happier, until Elizabeth heard about the secret romance. The Duke was summarily deposited in the Tower, where he later lost his head, and Mary was returned to the confines of Tutbury. She was confined in a single storey building below the High Tower. Evidence of this was found during excavations in 1988. When the northern Catholic Earls rose in rebellion on her behalf, she was moved to Coventry because of fears of a raid on Tutbury. Following the defeat of the rebellion, she returned to Tutbury for the third time. In an attempt to influence her religious views she was obliged to hear sermons from the Bishop of Lichfield. During this time she was able to enjoy hunting, and according to legend, hawking on Hanbury Hill. Due to an outbreak of the Plague in January 1570 she was removed once again.

The Despair of Mary Stuart

For the next fifteen years she remained in North Derbyshire and Sheffield. As the years passed her cause became increasingly hopeless; a pawn in the game of the European powers. It was the French who had originally striven to restore her

to the throne of Scotland, though they proved to be an unreliable ally; Scotland had now become only a memory. The main hope for her release became Spain, whose object was to restore England to the Faith, with Mary as Queen. As plot followed plot, the web of Elizabeth's secret service, headed by Walsingham, became convinced that she must be compromised and then eliminated.

Throughout this time her health began to decline seriously and she became a faded beauty, crippled and not expected to live. Modern research has diagnosed her condition as Porphyria, a hereditary disease, that causes pain, lameness, mental collapse and eventually death. Her son probably died from this disease and also possibly her father.

The Earl of Shrewsbury had treated Mary with kindness. However he had grown weary in his duties. The worst aspect of his travail was being the constant object of fury from three dominating women! More devastating than the two Queens was his wife, who accused him of having an affair with Mary. The strain was to prove intolerable. At the same time Walsingham was planning his trap into which Mary would walk like a fly into the spider's web. She was again to be detained in conditions of close confinement at Tutbury

The Tragic Return of Mary Stuart

The return of the Queen to Tutbury on Jan 14th 1585 was a tragic scene, as her vivacious vitality had been replaced by despair. She now only desired release from her vale of tears. The Queen was installed in a two storey building adjacent to the south range. This was in a deplorable state and was thus described by her, *"I am in a walled enclosure, on the top of a hill, exposed to all the winds and inclemencies of heaven. Within the said enclosure there is a very old hunting lodge, built of timber and plaster, cracked in all parts. The said lodge is distant three fathoms from the wall, and situated so low, that the rampart of earth behind the wall is on a level with the highest point of the building. The sun can never shine upon it, or any fresh air can come to it. For this reason, it is so damp that you cannot put any piece of furniture in, without it being in four days completely covered by mould. I leave you to think how this must act upon the human body. This dungeon is more suitable as a habitation for criminals than for a person of quality.The only apartments that I have for my person consist of two little miserable rooms, so excessively cold, especially at night, that but for the curtains and tapestries, it would not be possible for me to stay in them. All those who have sat up with me during my illness, scarcely one has escaped without fluxion, cold or some disorder. This house having no drains to the privies, is subject to a continual vile stench."*

Initially she was placed under the care of the elderly, though kind, Sir Ralph Sadler. He became the object of Elizabeth's fury by allowing her out of

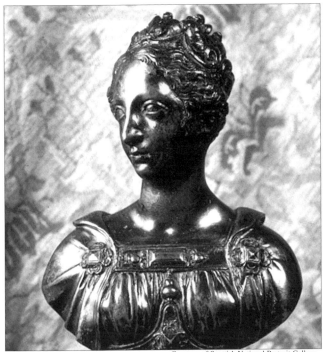

Courtesy of Scottish National Portrait Gallery

Alluring Beauty: Mary Queen of Scots as Queen of France, a bust by Jacquio Ponzio.

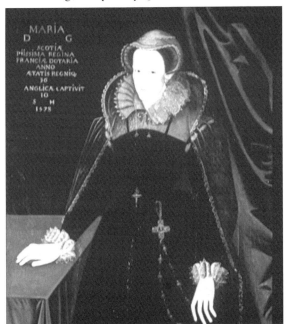

Years of despair:
Mary Stuart in middle age.

Courtesy of Scottish National Portrait Gallery

the castle for hawking. He was replaced by the fearsome Sir Amias Paulet, a dour protestant who hated Mary for her faith. Never before had she met a man so impervious to her charms. In this last phase of her tribulation, she was deprived of the trappings of royalty and the practice of her religion. In the latter, the bigot boasted that he had burnt her "abominable trash", meaning her rosary and missal. She was even forbidden to hear Mass! Her few surviving attendants were forced to attend protestant services or be suspended down the well! However she succeeded in distributing the Maundy to the poor of Tutbury during Holy Week of that dreadful year.

Paulet's surveillance was rigorous; her correspondence was opened and her servants were not allowed into the town or on the walls for fear of sending messages. Over 250 men had been enlisted to act as guards. In these circumstances she became less cautious, being prepared to risk everything for freedom. The intention of Walsingham was to insulate Mary from the world and then introduce agent-provocateurs to implicate her in a plot. The "plot" involved a Spanish invasion leading to the death of Elizabeth, Mary then becoming Queen. Into this trap walked Anthony Babbington, a young Derbyshire squire who was infatuated with Queen Mary, an attraction similar to today's hero worship of a faded actress. The messages were conveyed, at the initiative of Walsingham, by means of a secret compartment in a beer barrel supplied by a brewer from Burton. In reality all the secret missives were read by the master spy catcher himself. The conditions of the Queen's confinement had aroused protests from the French King which resulted in her removal to nearby Chartley Castle, where the trap was to be sprung.

As she left Tutbury for the last time on 4th December 1585, at the age of 43 years, she had already set out on the journey to her meeting with the axe at Fotheringay. Her final visit to Tutbury had secured the demise of all her hopes. As a stooping and feeble figure she must have been one of the most tragic, yet romantic persons to have known the waters of the Dove. Whether she was naturally enticing or deliberately a temptress will never be known. There is little evidence to support a view that she was openly promiscuous, but flirtatious she certainly was. As a scheming politician she was a failure!

The English Civil War

In 1634 Charles I and Queen Henrietta Maria performed a grand progress through England. The Royal couple arrived at Tutbury in time for the Fair, where they witnessed the Court of Minstrels. However they left after two weeks due to the threat of plague. This was to be the last time a monarch came in state and resided in the King's Apartments. They both were oblivious to the tragic events that lay ahead.

After Charles I raised his standard at Nottingham on 25th August 1642, he immediately came to Tutbury before the actual start of hostilities. At the outbreak of the war, Sir John Gell of Hopton (near Wirksworth) declared for Parliament and raised an army with the intention of controlling the area. The local gentry opposed him and held a council of war at Tutbury. After this Tutbury Castle was garrisoned for the King without compromise.

This situation continued until the following year, when a short siege was abandoned. It became obvious to Gell that the castle was impregnable.To harass the defenders and harry their supplies, he garrisoned Barton Blount. Many skirmishes were to take place and the dead were left lying on the lands of the Dove. In May 1645 the King and Prince Rupert entered Tutbury at the head of a great army. This army was intended to turn the tide of the war, an ambition soon tragically extinguished on the Field of Naseby. On 12th August 1645 the King returned for security and rest in his loyal castle. As he left, more as a fugitive than a king, his force was attacked by enemy forces from Barton Blount. By this time the town itself had fallen into enemy hands.

The tide had fatefully turned, but the garrison at Tutbury held out obstinately for the Royal Cause. At the start of April 1646, a sustained siege was begun, the effects of which quickly resulted in fatigue, starvation and disease. The Governor realized that further resistance was in vain as the Cause had been defeated. He surrendered the castle on 20th April 1646.

In compliance with the articles of surrender, the castle was systematically slighted to render it undefendable and uninhabitable. Great gangs of men were conscripted into this work. The wooden framed buildings were quickly demolished, while the great stone edifices were blown up. The once grand establishment lingered on as a ruin, and later a farm, until the 1950s. Charles I was the last monarch to visit it until 28th March 1957, when Elizabeth II came on an official visit to the Duchy of Lancaster's Needwood estate. Her Majesty was to return privately in 1982.

Tutbury Castle Today

The decayed fragments of the long breached fortress give little indication of the former power and glory of the place. Tutbury Castle is enclosed by formidable curtain walls, standing on grassy embankments. The southern range was formerly a turreted complex of fine chambers and apartments with fine vaulting. The roofs and floors gone, the walls starkly enclose a dank emptiness. Where the sounds of the season now echo, once were heard the ring of laughter or the minstrels chords. Of the great hall of the King's Apartments only the wide south facing windows remain, forlorn and forsaken when silhouetted by the setting sun. The inhabited house is a mixture of styles, still containing the Duchy

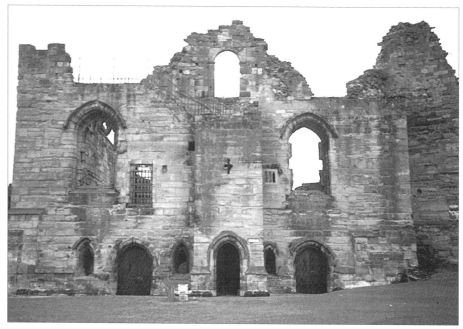

Fine 15th Century Apartments: Tutbury Castle, South Range.

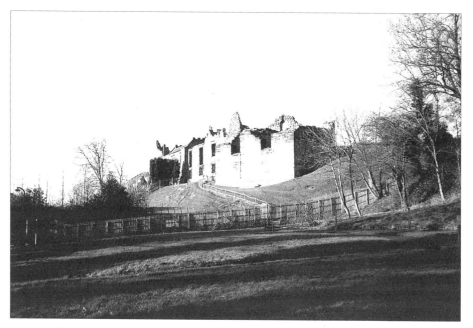

Tutbury Castle: The open windows of the Great Hall and King's apartments.

Courtroom. The most impressive building is the High Tower, whose fine landings, now open to the skies, originally housed a succession of fine chambers and is similar to the self-contained Tower Houses of Scotland. It is thought that this extravagant building was intended for Queen Margaret of Anjou during the Wars of the Roses.

At Tutbury the well is of wide proportions and exceeds 120 ft. in depth. Legend has it that there was a secret passage connecting the castle to the priory. One version suggested that this tunnel led from the well, though exploration in 1955 failed to find any evidence.

Tutbury Town

With the demise of the castle and priory the administrative framework of the Honour of Tutbury decayed, though some of the courts and traditions survived as relics into the nineteenth century. The title of Coroner of the Honour is still marked by tenure of a hunting horn, the Tutbury Horn, the finest relic of its kind. By the dawn of the twentieth century Tutbury had become an anachronism. After long years as a degenerate market town it had become a backward-looking industrial village. However its former importance is reflected in the High Street which, wide and refined, is typical of a market street and is lined by fine Stuart, Georgian and Regency town houses. The rounded gables of the 18th century corner houses are a unique feature of Tutbury. The most dramatic building is the timbered 14th century Dog and Partridge Hotel. This started life as the town house of the Curzon family of Kedleston. It later became a coaching inn on the route of the Red Rover, the fast stage coach which linked London with Liverpool. This hotel has built up a famed reputation in recent years; while the building was thoroughly refurbished and preserved in 1998.

For years the markets retained much of their activity and wealth, but their decay was complete by the 19th century. In recent times an attempt was made to revive the market, but the definitive Market Charter had become lost. In medieval times a great livestock and horse fair was held in a field called the Big Close on the edge of the town; and on the second Monday in October each year, the Statutes Fair, originally an agricultural hiring fair, was held at the Wheel Inn. These traditional elements of the Statutes Fair still existed within living memory and street entertainment lasted until the 1950s.

The coming of industry enabled Tutbury to remain a place of some importance, though now the decline of the traditional industries has hastened its progress to a commuting village with a suburban face. While the population grows with every year, the old communities have become little more than a memory. During the 1960s much of old Tutbury disappeared before the bulldozer, as traditional red brick cottages were ruthlessly razed. This was

achieved by planners without any sense of local feeling, obsessed by a mania for redevelopment. Included in this demolition were many historic buildings and possibly the timbered Guildhall in which the courts were held, found encased within the brick buildings of later ages. However Tutbury remains a place of infinite interest; beneath one's feet lie many mysteries awaiting discovery.

Ann Moore, the Fasting Woman of Tutbury

In those bygone streets lived Ann Moore, who achieved fame by repeatedly claiming to have survived without food from 1807 until 1813. So great was her fame that in 1811 a committee was formed to investigate her claims. A watch was maintained for 16 days without suspicions being aroused. In 1813 a more rigorous surveillance was initiated by Sir Oswald Mosley. After nine days, she became seriously weakened and it was revealed she was a fraud. While this was proven, it was also clear that she possessed an extreme ability to survive without food. In fact during the first examination she would only have received minimal liquid subsistence. Following her exposure, the poor wretch had to flee Tutbury to escape the wrath of her neighbours.

The Cut Crystal Glass Industry of Tutbury

For centuries Tutbury has been renowned for the excellence of its crystal glass. Traditional glass making as still practised here, consists of several specialized trades zealously guarded by tradition and precedent. For long it was dominated by the old families of Tutbury. Today the drab backstreet works continue to produce beautiful glass from lead, silica sand, potassium carbonate, potassium nitrate and borax. The clear, sparkling beauty of the cut glass is matched by its sonorous qualities. In the twinkling of candlelight, few tables can be complete without this fine creation of English traditional craftsmanship.

As we have already noted, timber from the Needwood Forest was used in the manufacture of glass. Documentary evidence records the presence of glass makers at Abbots Bromley in 1472. During the clearance of Bagots Park in the 1960s remains of primitive furnaces were found which dated from the 16th century. In the Bagot archives are found records of the arrival of Huguenot refugees, who were contracted to supply Richard Bagot with glass in return for wood. The excavation of these sites was carried out by Dr David Crossley of Sheffield University, who has written the definitive work on the ancient process. It is now known that the original Huguenots later left to develop their trade elsewhere. Tutbury would have been a suitable location to promote their skills because of the castle and the market. Similar tradesmen moved to Amblecote, near Stourbridge, where the industry still flourishes.

It is known that in 1720 the Tutbury glassworks were operated by the Jackson family, several generations of whom operated the works until 1880. At that time the reputation and volume of trade reached its peak. It was a branch of this family which had migrated to America that produced the famous General "Stone Wall" Jackson. Following the death of Henry Jackson, the glass dynasty ended. The undertaking was later bought by Sir Oswald Mosley, who carried on manufacture until 1906 when the glassworks were bought by Webb Corbett of Stourbridge. This famous firm of glass producers was later acquired by the Royal Doulton Group in 1969, who operated on a large scale until 1980, when the centuries old works closed with the loss of 150 jobs. The future of the craft industry was threatened until the works were reopened following local initiatives. The old factory became Tutbury Crystal Glass Ltd, while the old silk mill became home to Georgian Crystal Ltd. Both undertakings continue the centuries old tradition of Tutbury, though fewer staff are now employed. The old factory in Ludgate Street was not the only works. The Castle Glassworks was opened in Hatton by 1868. In 1897 it was the subject of a royal visit by the Duke and Duchess of York (later King George V and Queen Mary).

The Tutbury Mills
To the north east of Tutbury a secondary stream diverges from the Dove and flows parallel to the main river for several miles. This backwater is known as the Fleam. Following the Norman Conquest, it had been straightened and harnessed to power a corn mill, which was recorded in the Domesday Book. This mill became an important element in the local economy. It is probable that the reduced flow of the Fleam protected the mill from the full fury of the Dove. By 1780 the owner of the mill was John Bott and Co, who also owned silk mills, a major business in the town.

From the beginning of the 18th century the corn mill was powered by two large undershot wheels which still survive, and which were particularly suitable for that sluggish stream. The wheels were housed in two independent chambers which discharged into flumes on either side of the building. This has the effect of surrounding the mill with the invigorating sound of rushing water. Sadly the diversion of water at the former plaster mill site is now causing silting and a reduction in the water flow. The mill continued grinding corn until 1907. In 1913 the derelict building was taken over by Mr E.B.Chapman, who came from a Derby family of tanners and parchment makers. He was a particularly industrious man who diversified the business into horse slaughtering. This was a rich area for expansion since Tutbury was in the heart of the shire and hunter country. His policy was to utilize every portion of the animal's body. One lucrative speciality was the production of horse leather for cricket balls. Horse

Centuries of Craftmanship: Crystal glass blowing.

Tutbury Mill: Old postcard of the demolished cotton mill (and later, gypsum mill).

hair was washed and dried for use in plastering. His son Walter further developed the business to include the supply of leather for the luxurious cars of pre-war days and the production of sheep skins. Mr Walter Chapman designed a series of original machines to improve the productivity of the traditional trade. The mill is now managed by the third generation of the family, but due to changing market conditions, the tannery was closed in 1983 and a high class clothing business and a hotel have been developed on the site. Today the millhouse of fine warm brick reflects the former wealth and importance of the mill. The facade probably dates from the beginning of the 18th century, with elegant windows capped by smaller windows on the top floor. It exemplifies the serenity and richness of English country life in former days.

Above the mill rises the heavy form of Shotwood Hill. According to local legend, this was the site of a Cromwellian battery during the siege of Tutbury. While it is likely that such a strategic position would have been garrisoned, the declining fortunes of the Royal Cause would probably have made a major bombardment from this position unnecessary.

The fortunes of the silk trade in Tutbury were adversely affected by cotton, which was cheaper and becoming more popular. In 1780 an approach was made to the Duchy of Lancaster for permission to erect a cotton mill between the river and the Fleam. The main building was of a vast size consisting of five storeys. In 1829 new water wheels were installed and other improvements to the Fleam were initiated to increase the power available to the mill. In 1865 Mr Walter J. Lyon purchased the mill and during this time it is recorded that 600 men, women and children worked there. The children worked half a day and attended school either in the morning or the afternoon. The cotton mill certainly helped to arrest the decline in the status of Tutbury.

The capacity of the wheels to provide sufficient power to match the huge demand of the mill was a continuing problem. In 1880 the Liberal Party was returned to power at the general election, obviously to the satisfaction of the owners since at that time the wheels were replaced by turbines and one unit was named Gladstone, while the twin unit was named Bass and Wiggin after the successful local Liberal candidates. To achieve further power, great sluices were erected at the junction of the Fleam with the main river and the elegant lines of the present weir were built to ensure a sufficient head of water. Even so the power requirements were still a problem, especially in dry summers at which times some men were laid off to work in the adjoining fields. When the water rose, a bell in a turret above the mill gatehouse summoned the men to return.

In 1888, problems in the cotton industry and the shortage of power resulted in closure and the trade was transferred to Rocester, a massive blow to Tutbury. On 30th May 1889, a letter appeared in the Burton Chronicle, detailing

the sad fate of Tutbury's major industry:

> *"Dear Sir,*
> *I cannot help it, but I must write to you. I have known you for many years and*
> *always found you to be my friend. No doubt you will wonder who I am, but do*
> *not look at my signature until you have heard my complaint.I am getting on for*
> *a hundred years of age, and have been a good and faithful servant. There is*
> *plenty of work in me yet. I am a teetoller and have been so all of my life, and*
> *now I regret to say I am out of work.I have plenty of water to drink but nothing*
> *to eat, my poor inside has nearly gone. Cannot something be done for me?I*
> *have done well for my masters, and will so again, and if only set, I would find*
> *employment for 200-300 hands. Do all you can my dear friends. Call a*
> *meeting, and try to do something for me otherwise I shall not know how to exist.*
> *Truly, I am nearly broken hearted,* THE OLD MILL

The mill was eventually bought by Henry Newton of Statons Ltd for the grinding of gypsum from the Fauld mines and the production of high grade plasters. This undertaking continued to be powered by the turbines, which gave Tutbury its familiar sound, a deep rhythmic moan. The machinery was powered from the turbines by a giant rope 360ft in length, probably the longest in the country. The old mill had many attractive features; an old steam engine hauled the stone across the Dove from the main railway line and the wide mill pond, which powered the turbines, was a feature by the northern entrance to Tutbury.

Other businesses were developed in the derelict buildings. One Henry Spurrier from Marston established an engineering works, which he later moved to Leyland in Lancashire - the origin of the Leyland Motor Co. The mill was also used as a gas works which supplied Tutbury from the middle of the 19th century until Burton Corporation took over the service in 1912.

The gypsum business continued until 1968 when the mill was closed. It was by then in a much dilapidated condition and was later demolished. After nearly a century of work the turbines, still in perfect working order, were broken up. It was one of the last water powered factories in the two counties. The site is now a public open space, though the mill pond has become silted up as the main flow of water is diverted away from the Fleam, and the derelict sluices at the weir in the wide valley below the castle are all that remains of the old mill.

Hatton

The Dove bids farewell to ancient Tutbury and glides beneath the low Grecian lines of Tutbury Bridge, known as the Big Bridge. This crossing of the river has been of importance throughout history. The previous bridge, erected in 1420, was situated some 200 yards upstream. Sir Oswald Mosley described that bridge as narrow and in a bad state of repair. The two counties agreed to a new bridge, which was erected in 1815 by a Mr Johnson of Duffield. The fine bridge,

The Dove in Angry Mood: Tutbury Bridge.

in millstone grit, was a major achievement as it has since continued to carry the heavy traffic on the A511 trunk road.

Across the bridge lies the populous village of Hatton, which has always lived within the shadow of its distinguished neighbour. The original village was situated to the north of the trunk road and was possibly one of the lost villages of Derbyshire. The first Ordnance Survey shows only four buildings on the road from Tutbury northwards to the Salt Box. The building of the present village began after the arrival of the railway and soon included five inns on the main street. The Salt Box Inn was situated on the route of the former main road which historically was a route from the Cheshire saltfields and a strategic way in ancient times, known as the Port Way. It was certainly of pre-Roman origins

The new village is typically Victorian with villas, terraces and factories. The area, particularly the part adjoining the railway, was also known as Tutbury, the village developing as an extension of the older community. Few Hatton residents today would accept the description as of an extension of Tutbury! The church, which was built with the support of the Duke of Devonshire, has recently celebrated its centenary. Hatton remained within the ancient parish of Marston-on-Dove until 1998, when it became an independent parish, the civil parish having been established many years previously. The Nestlè factory was opened in 1901 by the Anglo-Swiss Milk Co, to process milk from the surrounding pastoral areas. Since 1959 the factory has produced coffee, and still trades under the name of Tutbury. While rivalry exists, nowhere along the river do two communities exist in such close union, though they are in separate counties and dioceses and the combined population of over 6,000 make this the biggest settlement on the banks of the Dove.

The North Staffordshire Railway

Throughout the history of the first Tutbury Station, many arguments raged between the children of the two villages as to which of them the station belonged. The station had obviously been named Tutbury because at the time of the arrival of the railway Hatton was a minor hamlet. The North Staffordshire Railway came into existence by Act of Parliament in 1846. The tentacles of this network soon spread from its nucleus at Stoke and led to the construction of the line through the Dove Valley, which was opened to passengers on 11th September 1848 as far as Burton-on-Trent. The vital link with the Midland Railway at Derby was achieved the following year. To ensure a direct route across the flat lands and to avoid the necessity of numerous bridges, the river was diverted in many places. There is still evidence of the former courses of the river, especially around Marston. Much of the aggregate from these excavations was used in the construction of the railway embankments.

The railway company was essentially a local and friendly undertaking, with an exceptionally high sense of 'esprit de corps'. The railway buildings were characteristically built in Jacobean style. However, those who remember the railway recall the condition of the rolling stock as older than that of their competitors. Management of the company remained local. For the last 24 years of its existence the Chairman was Mr Tonman Mosley of Rolleston, who later became Lord Anslow. Mr Henry Newton of Tutbury was also a director. The company became affectionately known as the 'Knotty' due to the adoption of the Staffordshire Knot in its richly embellished insignia. At the height of its operation in 1907, the number of passengers carried was seven million and the quantity of its freight exceeded seven million tons. To facilitate these movements the company owned 220 miles of metals, employed a staff of 5,100 and had 167 engines. Following the First World War, the Government decided that a multiplicity of small railway operators was no longer satisfactory and in the Re-grouping of 1923, the company was merged within the London, Midland and Scottish Railway.

Tutbury became an important station on the line between Crewe and Derby, with passengers changing trains to Burton. The Great Northern Railway also operated a service from Derby Friargate to Stafford. Tutbury Station had a large goods yard, with coal wharfs and extensive marshalling yards. In earlier times there was a facility for stabling nearby. Tutbury Station closed in November 1966 in the mania for closures after the "Beeching Axe". Shortly afterwards, as though to exempt those responsible from future criticism, the platforms and wooden balustraded buildings were demolished. However, on the 3rd of April 1989, history turned full circle when a truncated station was reopened. It is now appropriately named Tutbury and Hatton!

The branch service to Burton in 1881 was known as the Tutbury Jinny, the first locomotive being named after the famous Swedish singer, Jenny Lind who had taken Victorian London by storm. After years of main line service the engine had been given semi-retirement to haul the train across the flat lands of the Dove Plain and had the distinction of returning in reverse. For 111 years, the service crossed the open fields, until her two drab coaches were increasingly sparsely occupied as motor transport grew. The little line had three intermediate stations, at Horninglow, Stretton and Claymills, and at Rolleston-on-Dove. These small wayside stations vied with each other in friendly rivalry. All those of the writer's generation can surely remember their spruce platforms, bright flower beds and trimmed oil lamps which reflected the loyalty of the staff, many of whom had started their working lives with the 'Knotty' line. Horninglow closed in 1940, while the other two following railway nationalization in 1948.

The inevitable demise of the Tutbury Jinny was announced in 1960, when her fate came to the attention of the House of Commons. Mr John Jennings (the member for Burton) recalled a recent press photograph of the Minister of Transport (Mr E.Marples) helping an old lady to cross the road. He continued by asking the Minister to help another old lady. Mr Jennings pursued the cause of this distressed old lady in an emotional appreciation, *"The Tutbury Jinny had been a fast lady in her time, and at some period held the record for the fastest time on the straight stretch of the 4+ miles between Burton and Tutbury. If the Minister came to Burton, I would take him for a ride on this grand old lady of the line, but he had better come early, because she was doomed to die on June 11th. The British Transport Commission was forcing her off the rails."*

Despite these pleas for a new trial before a new jury, the authorities remained unimpressed. Amid scenes of mass emotion, the last train ran on that fateful day. Following closure the line has become a countryside footpath which perpetuates the name of the friendly old train.

The Tutbury Jinny: A humorous Victorian postcard.

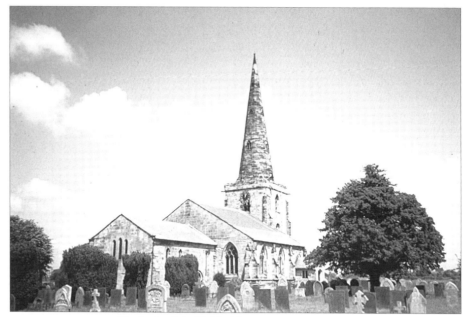

The Lady of the Fields: Marston-on-Dove Church.

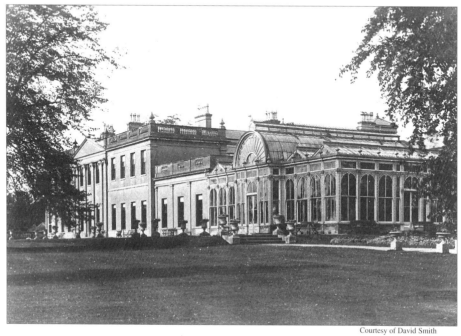

Courtesy of David Smith

Rolleston Hall: The Great Conservatory and Ballroom.

CHAPTER 15
THE FINAL PLAIN: JOURNEYS END

The Land of Two Rivers

Below Tutbury, the wide river highway flows steadfastly onwards into a flat plain. As though the Dove was loath to leave these last pastoral expanses, her course has constantly changed over thousands of years resulting in the deep deposits of alluvial gravel which have been exploited commercially at Hilton. Through centuries, these wide meanderings have produced a succession of oxbow lakes which, combined with the lengths of the river by-passed with the coming of the railway, has created a land of two rivers. One river is clear and living, while the other is the dark forgotten Old Dove. These still waters are a delight for naturalist and angler alike. Here are sleepy lagoons festooned with water lilies and serpentine curves of still open water. Stately swans cruise like galleons, while moorhens jauntily navigate like utilitarian tugs. Giant black poplars and crack willows choke the course, while linear groves of alder shroud the dark putrefying waters. Many of the lengths have been scheduled as SSSIs.

Marston-on-Dove

Within the fields and silent backwaters lies one of the most delightful village churches in this Land of the Dove. Rising out of rural isolation is the sturdy tower of Marston Church crowned with a low spire. With its gentle profile and the secluded location this little church could be described as the "Lady of the Fields". Many of the villages on this final length of the journey have become lost in growing suburbia. At Marston, history has destined the church to lie perpetually in an isolated backwater. Here time passes as quietly as the sigh of the wind across the open fields. At no time does the isolation appear so embracing as when a cold winter sun sinks beneath the distant hill of Tutbury. Then the jackdaws eerily cry as they circle the steeple in the enveloping mist that rises with the darkness. The dominating steeple has soared into open skies since the 14th century, while inside lies Derbyshire's oldest voice. A bell, cast in Leicester by John de Stafford in 1366, bears, in fine Lombardic capitals, the ultimate prayer from pre-reformation times and it still proclaims over the wide fields, the words of the Angelus. The bells of Marston were rung to welcome James I on his arrival at Tutbury Castle. For this duty it is recorded that the ringers were paid 4 pennies each. The other bells are believed to have been cast in the years 1621, 1654 and 1756.

The earliest church here was Norman, erected by the Priory of Tutbury. Only the font and traces of the Norman church remain. The lovely nave is a

superb example of the Early English period. The whole effect is wide and light, as the rays of the sun are reflected on the white Hollington stone of the pillars. The nave is thought to date from the end of the 13th century. The south aisle is 14th century in typically Decorated style. In the north aisle quaintly pointed windows were added in the 15th century. The contrasting styles are merged harmoniously under one roof. The early 13th century chancel, with its narrow lancet windows, has an air of detachment from the nave. The chancel has an attractive south door which allowed access for the priest. The church has for long benefited from the support of the Spurrier family of the nearby Hall.

The village is of hamlet proportions and apart from the Hall, is a collection of farms and cottages. Across the way from the church is found the old vicarage. In these pastoral surroundings one may reflect on the succession of reverend gentlemen who have ministered here; during a period of two centuries, only four were inducted. In fact Rev George Gretton who arrived in 1685, administered here for over 60 years. His successor John Edwards was to remain for 59 years.

Despite the openness of the plain, the neighbouring villages and the daily strain of modern life seem far away. Though a tiny community, Marston has remained for centuries the centre of a parish which included the populous villages of Hatton and Hilton. On the site of the former Royal Ordnance Depot at Hilton a huge housing development is now under construction, which will eventually rival the population of Tutbury and this development has resulted in the division of the parish into new parishes called "Hilton with Marston" and "Hatton with Scropton".

Rolleston

Across the lush water meadows lies the complementary village of Rolleston in Staffordshire. The narrow lane leading to the village was until recently, edged by a chain and post fence like many on the Mosley lands. At the village centre stands the multi-gabled village inn beside the bridge, with the rising spire of the church in the background. On a summer's afternoon, with the brook flowing past, and perhaps the flash of a kingfisher, it typifies the serene English village recalled by exiles far from these shores. The Alder Brook provides life and vitality to the village on its journey from the Needwood Forest to the Dove.

The village was established by the Anglo-Saxons in the 7th century. In the days before enclosure the layout of the village was determined by the communal farming system and until recent widespread building, this layout was still discernible, footpaths radiating from the central open space near the church.

The Lords of the Manor from the Conquest were the Rolleston family. In 1614 the estate was sold to the Mosleys, who remained until the 1920s. Little

did the villagers realize at that time that the halcyon days would soon pass, as their idyllic village became engulfed in the advance of suburbia. The greatest period of building was during the 1960s and 1970s.

In recent years the village has tended to be called Rolleston-on-Dove. This is not correct! When the railway station was opened, a problem arose regarding its name. It was a requirement of the authoritative Bradshaw's Guide that each station throughout the network should have a different name. Since another station in Nottinghamshire was already named Rolleston, the North Staffordshire Railway named their new station, "Rolleston-on-Dove". In time villas and terraces were built near the station and these became known by that fanciful name.

Memories of Rolleston Hall

Rolleston Hall, which was demolished in 1928, was a vast mansion which displayed two contrasting facades. Overlooking the lawns and lakes was an elegant south facing Georgian frontage. The other facade and main entrance facing west was heavily Victorian. Some of the south frontage which contained the ballroom still survives. The hall stood in a park of over 300 acres within an estate which had extended over 3,446 acres in 1880. The mansion was approached by three carriageways, two of these remain, and the lodge and gates on the road to Tutbury are still in good condition. Many of the service buildings remain including the dower house, stud farm, home farm, stables and estate gas works, though all have been put to different uses.

The last Sir Oswald Mosley in his autobiography described the house of his childhood memories, *"That massive building, emblem of Victorian achievement and stability on which the sun was never to set, remains vivid in my memory as it can still journey through nearly every room; the entrance hall heavy with black oak, leading to a wide staircase which branched gracefully halfway and was adorned with family portraits..... Chiming clocks and sweeping lawns forever remind me of Rolleston."*

The grounds of the Hall were magnificent, containing formal gardens, a walled kitchen garden, a vast conservatory and pleasure grounds that led into woodland walks. To maintain this vast landscape some thirty gardeners were employed. The former grounds of the Hall were noted for their collection of trees and shrubs. Many of these fine specimens survive, especially around the more expensive houses that stand in the old Hall grounds. The sylvan grounds spread as far as the churchyard bounded by a high wrought iron balustrade which still remains. Much of the main lake is now a swamp supporting a profusion of willows. However a portion has been restored as part of a public open space preserving the gently arched bridge and cascade which was the

outfall from the lake.

Today a mixture of period houses retain many links with the days of the Mosley estate. Much in evidence are timber framed and plaster houses intermixed with mellow red brick cottages originally built for the estate workers. The old dormered almshouses of 1712 stand attractively by the side of the stream. These were originally endowed by the last of the Rolleston family.

The Spread Eagle Inn, which carries the arms of the Mosley family, stands attractively by the side of the bridge. For many years it provided accommodation and stabling for visitors and with the encouragement of the the the 4th baronet, livestock sales used to be held here. The landlord at the time was appointed after serving in the Boer War.

The Mosley Succession

The Mosley family originally held estates at Manchester, where one of the main streets is named after them. Throughout their history they have produced many characters and displayed many idiosyncrasies. By tradition they named their eldest sons Oswald. One early Oswald gave the church a bell in 1701.

The family were staunch in their support of Charles I during the siege of Tutbury Castle. After the surrender their roof lead was sequestrated for the manufacture of bullets. At the time of the Jacobite rebellion the family were still loyal to the Stuart cause. In 1744, the Young Pretender came to Manchester on a secret mission of surveillance and was entertained by the then Sir Oswald. It took many years before the family became reconciled to the Georgian establishment.

Sir John Mosley, having been ordained, also served as rector from 1771 until his death in 1779. He was noted as eccentric and negligent of his worldly duties. His tenants were allowed to accumulate large arrears of rent which were never paid, while he neglected to enter the Parish Register. He also hated the embers from his hearth being removed by his servants. When removing them himself, he frequently lost his money amongst the ashes.

The family were particularly noted for being authoritative, uncompromising father figures to their staff and tenants. Most of the parish and estate were raised from the cradle to the grave under their benevolent though patronizing gaze. A baronetcy was created in 1782, this being the third creation for the family. The second baronet was a remarkable character who died in 1871 at the age of 86 years. He was elected to Parliament where he strongly supported the Reform Bill of 1832. He was always an abstemious man, who devoted his endeavours to the improvement of literary and theological standards in the nearby villages. He had little affinity with those who did not support the established church.

His greatest memorials today are the great treatises he wrote on the history and natural history of the area. While these remain substantial literary works, they are also unique as a record of a past world. In the preface to his "History of Tutbury" in 1832, he described how his long prepared manuscripts were finally published following the discovery of the Tutbury Hoard of Coins. Possibly of greater value was his "Natural History of Tutbury" published in 1863. Though writing in a style now out of favour, the records and descriptions are of unique value. Through the pages of observations shines the confidence of a dedicated Christian. Not all the Mosley family were so ascetic. Repeated examples have arisen of them being afflicted by excess. His own heir, Oswald, died from drink aged 51 years in 1856.

In the year of the 2nd baronet's death, the fine Tudor house was gutted by fire. The loss was complete with the destruction of a collection of Van Dycks and family archives. Sir Tonman Mosley immediately engaged himself in the building of a huge mansion that contained every luxury and design feature of the Victorian age. This 3rd baronet enjoyed the life of a country landowner to the full. Through the years, his girth grew to tremendous proportions and he had a portion cut out of his vast dining table to accommodate his huge corporation. He was then able to reach all the good things arrayed on his table. He was clearly resigned to his tremendous weight, because when he placed himself on the scales, he always jumped off when the reading reached 20 stone. Despite his size, he was an agile man, who lived to the age of 76 years!

He was succeeded in 1890 by his son Oswald. The 4th baronet was a man devoted to country life and the agricultural estate. He was a large, formidable figure whose real friends were his farming tenants. In his conversations with them he regarded their views as equal to his own. He was widely loved by all his tenancy and staff. On the farms managed in hand, he bred his own prize shorthorns and shires. He also designed and opened a bakery which produced wholemeal bread. His love for all things English and his well known profile resulted in him becoming the characterization for the Punch cartoon, "John Bull". Despite his formal background, he secretly enjoyed this fame as a national figure.

Though kindly, his views were influenced by the high Edwardian era. While a staunch anglican, he was not deeply endowed with humility and compromise. He was a friend of Edward VII, whom he met at agricultural shows. This friendship was to lead him into a situation which demonstrated his obstinacy. The King wished to advance a Canon of Windsor, one Tyrwhitt, into this richly endowed living. To his King, Mosley was obedient; but Canon Tyrwhitt thought that some of the practices in church unduly favoured the Family and decided that they would have to change. Mosley replied by

threatening the devout Canon with removal! The resultant case dragged through the courts for years, but was finally won by the Canon. The final cost to Mosley was many thousands of pounds.

When attending church, Sir Oswald's watch was regularly produced. He became particularly irritated if the sermon was long. Time was important because the highlight of his week was to follow. After the service he would immediately depart in his carriage to visit a favoured tenant for a discussion about livestock breeding. Afterwards he would return to the Hall for lunch, where he would carve enormous plates of prime sirloin. In doing so he would recite the pedigree of the slaughtered beast with the same dignity as the Grace. The great man died in 1915 at the age of 67 after a heavy dinner followed by walnuts washed down with port. Sadly he had become a diabetic - the discovery of insulin was still seven years away - and with his death an era had ended.

Unfortunately, for years he had been estranged from his heir, who had gained the reputation of a rake! In his early years, his son had been discovered engaging in sexual affairs across the area. The old Sir Oswald followed the Edwardian maxim that affairs of this nature should only be conducted with discretion and certainly far from home. "John Bull" was particularly incensed that his son was committing the heinous sin of pursuing the wives and daughters of his tenants. The old Sir Oswald had in his youth been a formidable boxer. His son had also

The Original "John Bull": Sir Oswald Mosley, 4th Baronet.

inherited some of those skills. In a rage, his father threatened to give him a thrashing with one arm. This challenge the impetuous son readily accepted. On the appointed day, before an assembly of servants in the entrance hall, the butler solemnly tied Sir Oswald's left arm behind his back. In the ensuing combat the older man was initially receiving some severe punishment but his old skills and strength rose to the occasion and with one ferocious hook the young Oswald was summarily knocked out.

Later in their tempestuous relationship, his son was expelled from the Hall and took up residence in a town house nearby in Tutbury. There he carried on the life of a rake in the mode of an ancestor known as the "Tutbury Tup". In the grounds of the Hall an exclusive swimming pool was opened by Oswald for his friends to engage in nude bathing and other abandonments with actresses from Derby. Many of these members were local figures, whose reputations and fortunes were ruined in this wild and licentious set. There is no connection with the existing Rolleston swimming club! Long before his succession as the 5th baronet in 1915, his marriage had broken down when his wife discovered many love letters. The new Mosley had little enthusiasm for the estate and agriculture. He is remembered as a stocky figure without charm. While he received the respect of the tenancy, he remained unadmired. Meanwhile his son, the next Oswald, had enlisted for the terrible war engulfing the established world.

While living at Rolleston with his father after the War, the young heir became convinced that the sun had set on the great agricultural estates of England. Embittered by his war time experiences, he foresaw only disaster. He convinced his father to sell the whole estate. This commenced in 1919 and was a comprehensive undertaking; even the Lordship of the Manor and the Advowson of the Living were included. Sir Oswald went to live at Hilton Lodge across the river, though he died of alcholism in 1928 in France at the age of 55. He had become a disillusioned and lonely man.

The Last Sir Oswald Mosley of Rolleston

The new 6th baronet's contact with Rolleston was essentially residual. After the separation of his parents he had been brought up by his mother in Shropshire. Nevertheless, there was a close affinity between him and his grandfather. He enjoyed his regular visits to the family seat, where he first gained his love of working people. In later life he wrote that he bitterly regretted the decision to sell, however he disliked the gloomy Victorian mansion and feared that in the post war years it would be impossible to maintain.

The last Sir Oswald was tall and extremely handsome with considerable panache and dash. He was always immaculately dressed and displayed every confidence and social grace. When young he regularly attended the big

Courtesy of David Smith

Victorian Grandeur: The ballroom from the sale catalogue.

receptions which were traditionally held for the tenancy on rent days. On these occasions he would charm and dance with the young women of the estate. Many were farmer's daughters who would return home elated that they had danced with "young Mr Oswald". Few could have expected more from future life. He was a moderate in food and drink, though he remained a constant womanizer.

He had been greatly influenced by the waste of young life in the Great War and especially despised the system that had led his generation to disaster. It was this background which influenced him through the rest of his life. He was first elected to parliament as the young MP for Harrow. Although standing as a Conservative, he had his own radical agenda, the cardinal principles of which were the establishment of a world society in which the war would never be repeated and to ensure fairer treatment for the rising generation.

Sir Oswald was a young man in a hurry! He despaired of the Conservative leadership and rejected the Liberals. In a dramatic move he joined the Labour Party as the means of securing his policies. His father was outraged. It was an uneasy venture, for while he had an innate sympathy for the workers, many in the party distrusted him. While holding office under Ramsay McDonald, he again resigned when his radical policies to eradicate unemployment were rejected. In subsequent years, historians have acknowledged that if he had

compromised, he could have become Prime Minister in either party.

He later founded the New Party. This was a radical movement which contended that the country's rigid attitudes would not solve the nation's ills. His aim at achieving a national consensus was unsuccessful at the following election. This defeat persuaded Mosley that conventional politics could never prevent the national disaster which he foresaw. He went on to found the British Union of Fascists. This resulted in his extreme unpopularity and internment during the last war. In the 1950s he founded the Union Movement which aimed at preventing immigration and promoting European unity. This party was also a failure, though it gained many votes in some urban constituencies. He died in 1980 at the age of 84 years.

Saint Mary's Church, Rolleston

Of the original Norman church there are few remnants though the north doorway is a rich example of that period. The aisled church of today dates from the 13th century, when the former Norman south door became incorporated into the arcade. The church is greatly influenced by the Decorated period, though the interior is overwhelmingly dark and sombre. The tower again dates from the early 14th century, though the spire is later. The tower and spire mirror the steeple of Marston, though the church as a whole lacks the latter's charm.

The south aisle was used as a chapel by the Mosley family, a squint dating from 1884 giving visual access to the altar. A succession of the later Mosleys are recorded in alabaster. Sadly no plaque commemorates the last Sir Oswald. The writer has been told by the Rector that an approach had been made by the family, but previously the Parochial Church Council had decided against further monuments in the church. The chancel contains the tomb of Robert Sherbourne who was Bishop of Chichester. He was a village boy who later, in 1520, opened and endowed a free Grammar School. This was still open in 1892, when 80 boys were attending. The old school in the churchyard is an attractive brick building of the early 17th century. Across the road from the church lies the former palatial rectory. This indicates the richly endowed Living provided by the Mosley patronage. At least five members of the family became rectors here.

The oldest relic to be seen in the churchyard is the Saxon cross, which is suggestive of both Celtic and Danish influence. Many weathered interlacing designs can be seen around the edges. The cross formerly belonged to Tatenhill, where it laid neglected as part of the paving until retrieved by Sir Oswald Mosley. It would appear that multi-cultural influences were active in the Needwood Forest in those early days of Christianity.

The Final Plain

As the Dove flows through the flat water meadows north of Rolleston, the backcloth of trees under wide skies presents a park-like appearance, without which the scene would be one of barren dereliction. Through the seasons this treescape changes in mood and colour. The open branches of the ash become gloriously silver in contrast with the golden bunches of keys in the late autumn sunshine. The abrupt forms of the willow give a hint of colour even on the coldest spring day. Yet in its profusion and ever changing aspect, the tree of this plain is the alder. These elegant stems of youth, simulate the the dark stocky profile of oak. Throughout the winter their squat shapes, decorated with cones, stand in stark profile in the weak sunshine; while in spring they again erupt with heavy bronze catkins.

Even in the short days of winter the river pulsates with life. When the frost strengthens, the river becomes populated with wild duck. Their peaceful thrusting and casting movements suddenly erupt into frantic thrashing of water and a flash of colour, as the birds take to the wing. Even the river banks secrete life. From their seclusion, a snipe soars into the air with its characteristic zig-zag flight and rasping cry, while the shrill bleep of the moorhen is heard from the darkened masses of foliage. However, it is the lapwing that most closely matches the mood of the landscape. The gathering flocks of winter emit a weird, mournful cry, giving a chilling effect to the wide void. The epitome of this wild unfettered freedom is the gentle whistling flight of geese in formation seen against the setting sun, or the majestic rhythm of swans. It is the sounds of this great expanse of pastures that so characterize the breadth and mystery of the place. The lowing of distant cattle, answering to the herdsman's call, the plaintive calls of sheep and the joyful bleat of their lambs.

Heirlooms of War

The spring of 1940 was arguably England's darkest hour, as a full scale German invasion seemed possible. In the event of the enemy breaking through the east coast defences, a further defensive line was projected across central England. This line ran along the wide Dove Valley, with the object of defending the main rail and road routes to the north. The plans included as a priority the building of small octagonal forts called Pill Boxes. The thick concrete walls were able to withstand tank and artillery shells and provided openings to facilitate fire power in all directions. It was believed that the pill boxes could only be taken by means of an improbable hand grenade attack. However, the writer feels that in the event of a concerted attack the defenders, probably the gallant members of the Home Guard, would have been massacred. The constructions are frequently found near the river, which would have provided an obstacle to enemy advance.

The Otter

The River Dove was always associated with the otter. To protect fish stocks, the number of otters became controlled by hunting. In "The Compleat Angler" we read how control had become associated with pleasure. The opinions of the celebrated author are clear. *"Indeed Sir, a little business and more pleasure; for my purpose is to bestow a day or two in hunting the otter (which my friend tells me is more pleasant than any hunting whatsoever). My purpose is to destroy some of these villainous vermin: for I hate them perfectly..... all men that keep otter dogs ought to have a pension from the Commonwealth to encourage them to destroy the very breed, they do so much mischief."*

The hunting of otters never competed with the colourful and rigid rituals or dress of fox hunting. Hunting was usually carried out with hounds owned by the hunters themselves, which were a cross between a hound and rough coated terrier. The followers remained on the river banks armed with poles to probe the banks and protecting weeds. The hounds chased along the banks and through the shallows until an animal was located and compelled to make a stand. Mosley details the kill: *"In this position* (the otter) *often inflicts ghastly wounds upon its many assailants, but at length is vanquished by the united attacks of the dogs and the spears with which most of the sportsmen are armed."*

Courtesy of David Smith

Otter Hunt: A past sport.

The disappearance of the otter from the Dove led to the end of hunting. While large numbers were killed, it was the reduction in water quality and disturbance of habitat which led to this disappearance. A similar extinction took place over most of the country and resulted in the classification of the otter as an endangered species with the banning of hunting in 1974. Since those days there has been a recovery and the otter is again encountered in some of its previous haunts. This re-colonization, enhanced by good water quality, has been appreciable along the lower Dove. As part of the management plan for the Dove catchment, there is a programme to develope a series of otter havens.

The mink is an animal which has now firmly established itself along the river. This feral escape from fur farms is most unwelcome. It viciously attacks indigenous wild life, while having no natural predators. The principal victim of the advance of the mink has been the water vole. This quiet denizen of the river banks has become virtually extinct. The ferocious mink has become the quarry of the newly founded mink hunt which carries on many of the traditions of the old otter packs. Of course there are those who oppose the hunt; their concern and sentiments are misplaced! The mink is a ruthless killer, which must be destroyed and hunting is the only means of doing so. It must be stressed that the hounds are trained to attack only mink and ignore other forms of wild life. The new mink hunts provide a valuable service to landowners, anglers and naturalists and should be encouraged.

Osier Beds

The low lying pastures, slow flowing watercourses and high water table, were ideal for the growing of the osier willow. This became an important activity, as large beds were established to provide material for baskets and accessories for estate gardens. Osiers were also formerly used to fabricate fish traps. The estates of Rolleston and especially Egginton both maintained plantations in the valley. When established the stools grown on short rotations were cut with hooks in spring as the sap was rising. The harvest was a period of much activity as the women and children came to the plantations to peel the stems before dispatch. The harvest usually lasted for about a month. In former times it culminated with the women parading through the parish with decorated wands of osier. During the parade money was collected to be spent on a feast, beer and other revels. Many of these customs had died out by the 19th century, though the beds continued to be cut until the Great War

Stretton with Clay Mills

As the valley of the Dove merges into the Trent flood plain, the continual movements of the rivers over geological time have resulted in deep deposits of gravel. These have been exploited over a wide area. The workings have

produced the remains of former animals which roamed the valley, such as mammoth, reindeer, bison and ox, as well as implements and homes of human residents from the neolithic and bronze ages.

While the isolation of the river's course embraces both scene and mood, this loneliness contrasts with the converging world. Beyond the plain, the villages which originally drew life blood from the land, have increasingly become overwhelmed by suburbia. As they grow in size their commuting populations look continuously to distant towns for sustenance. Yet with twilight the mantle of rural peace returns and suburbia is temporarily obscured. Fortunately the threat of flooding protects the virginity of the Dove from further assaults by the rapacious developers.

One village which has suffered severely from development is Stretton. The parish was a creation of the Victorian age, being formed from Burton parish in 1873. The initial growth followed the arrival of the railway. By 1895 the first church, originally a chapel of ease, had become too small. In that year, a fine new church with a wide central tower was commenced at the expense of the Gretton family. This was originally a village farming family, who had made their fortune with the brewery of Bass, Ratcliffe and Gretton. A staunch non-conformist had insisted on having his burial as far from the church as possible. After the new church was built, his grave was ironically found adjacent to the church door! When the new church was opened congregations for evensong were enormous; many people arrived on the "Tutbury Jinny" from Horninglow station as there was no church in that area.

For many years the village scene remained, with farms and local tradesmen, but sadly these have been lost to the advance of mortgaged suburbia, distinguished by its sterility and conformity, and the twin community of Clay Mills has become completely absorbed by its larger neighbour. The tentacles of the developer have created an amorphous suburb of Burton-on-Trent and it is now only rigid planning restrictions which prevent this suburban sprawl reaching Rolleston. The current population of Stretton exceeds 8,500.

The ecclesiastical parish was formerly named Stretton-cum-Wetmore, now absorbed within the Borough of Burton, but in medieval times an appreciable township controlled by Burton Abbey. Most of the local lands in Staffordshire formerly belonged to that township and the important abbey.

Dovecliff

Rising above the river to the north of Clay Mills is an escarpment attractively clothed by a hanging wood on which stands Dovecliff Hall, a fine late Georgian mansion. It is built square in brick with five bays of appealing windows. Above the doorways are fine stone pediments. This mansion, now a hotel of high

standard, was for many years the home of the Thornewill family, who made their fortune in the working of iron and were noted for their charitable and social activities. One daughter of the house was Harriet Georgina, who married the first Lord Burton. She was a renowned hostess, especially to Edward VII when staying at Rangemore Hall. Below Dovecliff is a substantial weir. In the centre of this are the remains of a salmon leap. This weir is now scheduled for restoration after years of neglect. Like that at Tutbury the fleam from this weir was excavated following the Norman Conquest to power the Dovecliff Mill, which was initially established by the Benedictine monks of Burton Abbey. The name of Clay Mills is thought to be a corruption of Cliff Mill. There are many references to the mill throughout the existence of the abbey.

Following the Dissolution, the area was economically depressed with the major influence for security removed at a stroke. It was not only the Burton Abbey lands, across the river at Egginton the lands had been held by Dale Abbey. In such times of depression there is always some entrepeneur who will survive. This would certainly have happened here, as Dovecliff Mill continued for centuries. When a building was demolished many years ago, the following inscription, dated 1670, was found on a beam. *"In July, I Robert Pye ground new rye"*. This must have been an unusually early harvest.

In Georgian times the mill became an iron foundry, the water power being used to power the bellows and rolling mills. For a period the forge was operated by John Wilkenson, the famous iron master. Like many employers at that time he paid his workers in tokens, which bore his head, with a man working on an anvil on the obverse. The Thornewills bought Dovecliff and the mill in the late 18th century from the Earl of Uxbridge. The mill later became used for the manufacture of barrel hoops to supply the expanding breweries of Burton. The strong head of water powered a forge which became the major local employer.

Following the departure of the Thornewills early this century, the forge was worked by the Smith family, who also resided in the mansion. By the end of the First World War, closure was inevitable as the small water-driven forge was no longer economically viable. The closed mill was sold in 1924 to a Mr Podmore, who was a potters miller from the Churnet Valley. For this trade the old forge was ideal. He restored the mill to produce flint powder for use in the manufacture of china. In a move to increase the mill's power, the water wheels were replaced by turbines. During the process flint stones were calcined in the former furnaces before being ground down by water power. This enterprise eventually closed in 1963, after which the mill was sadly demolished and the volume of water reduced. Today the clear stream, alive with fish, idly passes unharnessed through the former flumes. Centuries of industry have passed. Here the fleam constitutes the county boundary.

Egginton

At the point where the Dove Valley flows into the flood plain of the Trent lies Egginton. This is another of those quiet villages whose existence has been chronicled in the stones of its church and ancient family. Though untarnished by the accelerating changes, heavy pressures are all around. From this previously quiet backwater can be heard the constant moan of traffic from the nearby A38 Trunk Road, while some nearby views are dominated by the giant Toyota factory. The village, though at the end of our journey, remains typical of the Dove valley. On its southern limits flows the fast Hilton Brook to its consummation with the Dove, while on the opposite side flows the Egginton Brook directly to the Trent.

Egginton is a former agricultural village whose character is exemplified by a pleasant mixture of full bodied 18th century farmhouses and pleasing cottages, most dating from the rebuilding of the hall. The high walls and outbuildings of the former hall kitchen gardens have been pierced to provide access to ubiquitous, though non-intrusive modern bungalows. Although the great estate has passed, the memories of those grand days linger on.

The squat church of St Wilfrid is surely one of the most delightful along the Dove. Only the high pitched chancel contrasts with the sublime. Like many churches of Norman foundation, it was rebuilt in the early 14th century. The compact air of friendly intimacy is enhanced by the low Perpendicular tower. The simplicity of design is carried through into the interior and is exemplified by the low nave with arcades in white Hollington stone, which though of differing dates are wholly compatible with each other. The church contains many relics of pre-reformation ceremonial. There are found a beautiful piscina and single sedilla in the chancel, while in the south aisle there is evidence that it formerly served as a chantry.

It is often in these unpretentious village churches that the best ecclesiastical heirlooms can be found. This is especially true of a fine pre-reformation bell which has hung in silence and darkness for centuries. This bell, inscribed in Lombardic script carries the Marian exhortation, "Ave Maria, Gracia plena Dominus tecum." In a survey of church property during the reign of Edward VI it is recorded that two similar bells had been sold to cover the repair of nearby Monks Bridge. It is interesting to note that another bell was recast in 1778, when it was conveyed to Nottingham by river. The present three bells were re-hung to commemorate the Diamond Jubilee of Queen Victoria. Inside the church are to be seen some of the instruments which were played in church before the advent of the church organ. .

The church has many monuments to the Every family of Egginton and also to the Mosley family who were related to the Everys. This branch of the

Mosley family lived at nearby Burnaston House which was demolished to facilitate the building of the Toyota factory in 1990. The stone facades are now available for sale as a building package!

The Every Family Succession

Following the Dissolution, the ownership of Egginton came into the Leigh family. In the reign of James I, after Sir Henry Leigh died his heiress, Anne, married Simon Every from Somerset. From that time, this quiet place has been dominated by the Every family. The family were not to become a dynasty of political or commercial ambitions; they always drew their inspiration from the traditions of their own soil. The crest of the family is the Unicorn.

The new owner, created the first baronet in 1641, was a staunch supporter of Charles I. He is depicted in a painting by the school of Van Dyck as a tall and elegant man. At the outbreak of Civil War he, together with other loyal squires, attended the conference at Tutbury which decided to confront the local Parliamentary leader, Sir John Gell. Like many he later saw his estate plundered and seized for this loyalty. In 1644 a battle on nearby Egginton Heath was a disaster for the Royalists. As Prince Rupert was returning victorious from Newark, Gell received intelligence that the Royalist cavalry had crossed the Dove and immediately sent his cavalry to engage them. Though greater in number the King's cavalry, being surprised, were routed and found their retreat blocked by an ambush of foot soldiers. Some were driven into the River Trent where they were drowned, while many others were taken prisoner. Probably some Royalists hid in the village - at the turn of this century an ornate officer's sword of the period was discovered in the roof of a cottage being re-thatched.

Sir Simon was ruined and died before the King was finally defeated. The heir, Sir Henry was anxious to reclaim his inheritance. After the death of Cromwell, he was arrested as the leader of rebellion in Derbyshire. The Restoration saved him from the axe and he prospered until his death in 1700. It is believed that he was the first to landscape the Hall grounds. He was followed by three successive sons, the first two being unmarried. They appear to have started the family tradition of naming heirs as either Henry or John. The third son became the formidable Sir Simon, the 5th baronet who was ordained. In his time the old Elizabethan manor house was severely damaged by fire in 1736. Although he was a lifelong Jacobite, he did not rally to the banner in 1745. His excuse was not that of the stay-at-home 'Drinking Jacobites'; he was 85 years of age. However it is believed that he still undertook the perilous journey to the secret meeting with Bonnie Prince Charlie at Radbourne Hall.

The old man died at the age of 93 in 1753 and was followed by two sons. The second of these, Sir John, was also a clergyman. He was determined to

ensure that a fine new mansion was built. It was this 7th baronet who ensured that the activities of an Egginton ghost were recorded. This ghost known as the Spectre, was by repute that of Robert Leigh, an ancestor of Anne. It had previously been thought to have been eliminated by the fire; however Sir John contended that it was still present. The story originates in the reign of Henry VIII when one Robert Leigh, while hiding a bag of gold, was the victim of foul murder. The ghost was said to appear on the seven nights prior to Christmas Eve. Possibly in the dark mysterious days before Christmas, it was easy for the old man to have believed in this presence.

As he and the previous baronets had died without children, the direct line had failed. The estate was inherited by a Derby kinsman who became Sir Edward Every, the 8th baronet. He was essentially a kindly young man who had been brought up in straitened circumstances. Although the unfinished building had already taken 21 years to build, he found the design not to his liking and immediately commenced a radical rebuilding.

It was his son Henry who became the 9th baronet at the dawn of the 19th century. He married, like others in the family, into the Mosley family of Rolleston. In 1829 Egginton was described as, *"A fine estate abounding with fish and game and produces all kinds of grain and excellent cheese."* This Sir Henry was a mercurial character who displayed great individuality. In 1815, the infamous Squire Osbaldeston, Master of the Atherstone Hunt, brought his hounds to the Egginton estate by invitation. When he abandoned the chase after successfully drawing a covert, a dispute arose in which his host accused Osbaldeston of being a poor sportsman. This Master had already gained a reputation as a controversial and volatile MFH. Later, in a rage, he challenged Sir Henry to a duel. This Every readily accepted! However duelling was illegal and his friends prevailed on him to withdraw to avoid disgrace. He later feared that his tenants might regard him a coward. This fear became an obsession, such that when he came to build three rows of cottages in the village, they were built with their doors at the back; so that as he drove past in his carriage he would not see his tenants gossiping about him.

Sir Henry was renowned as being complex and unpredictable. Although the main railway line from Derby to Birmingham already crossed his estate, he objected to the North Staffordshire Railway Co's vital link between Tutbury and Derby. However he later relented and the line was opened in 1849. The eventual legal agreement stated that the level crossing was to be controlled manually by gates. This situation persists today as the covenant cannot be set aside to provide a modern crossing. With the coming of the railway a fine junction station was built, which served both the North Staffordshire Co's trains as well as those of the Great Northern line. Following the railway, the estate opened a

dairy, which became noted for the quality of its cheese.

The volatile Sir Henry had four sons. One invented a machine for sweeping chimneys that saved little boys from having to climb them, while another was a brilliant young army officer killed in the Crimean War. He was succeeded by his grandson, Henry Flower Every as the 10th baronet in 1858, during whose life the fortunes of the house and dynasty reached their zenith. He was destined to lead Egginton up to the threshold of the present century. After his death, the adjoining Every estate of Newton Solney was sold to provide a comfortable retirement for his widow in London. Sir Henry Flower had outlived his heir; he was succeeded by his grandson Sir Edward Oswald Every who was nine years old. It was tragic that during the tenure of this young boy, the fortunes of Egginton were to seriously decline. Sir Henry had a younger son who became ordained and became Bishop of the Falklands Islands, and later an Anglican Bishop in South America. On retirement he returned to Egginton to serve the village church until his death in 1941.

There was a visit by King Edward VII and Queen Alexandra in 1902. The preparations would have been enormous as the staff strove to proclaim the reputation of the Derbyshire household, especially as following the death of Sir Henry in 1893 the house had been little used by the family. For this event the Dowager Lady Every returned from London as chatelaine. In the glittering interior there was no sign of a hidden and sinister spectre which would soon herald the end of these grand days of Egginton. The end was destined to be near!

Egginton Hall has been accredited with two ghosts, one that of Robert Leigh, mentioned earlier; the other of a one armed man who walked from the church to the hall at midnight. After the final building of the new Hall, two Cedar of Lebanon were planted, one on each side of the house. Following the death of Sir Henry Flowers Every, one of the fine specimens fell. This was by legend an ill omen. If the cedars fell, it was said the family would lose Egginton! It is now somewhat reassuring that the other tree which has seen so many changes, remains in excellent condition. For these reasons it is said that the widow of Sir Henry Flower refused to live in the hall after his death.

With the Dowager Lady Every in London and the new 11th baronet a boy, from the early 20th century the house was leased, initially to Mr J. Maynard, who was renowned as a fine huntsman and cricketer. Later, in the years before the First World War, the house was leased to the Dugdale family. During the Great War Mrs Dugdale opened the hall as a hospital for wounded officers. When the weather was good, the patients were brought onto the wide lawns which swept down to the lake. There, despite the torment of their wounds, they could appreciate the tranquillity of this country for which they had given so much. Their pains were to cross the developing century! Many were those who

Courtesy of David Smith

Escape from the Western Front: Egginton Hall entrance hall during the Great War.

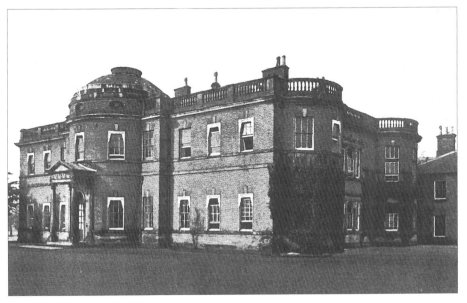

Egginton Hall from the Sale Catalogue: Main entrance and cupola.

through patriotism and compassion worked tirelessly to nurse voluntarily these wounded heroes. The writer's mother was a member of an amateur concert party who visited the hall to entertain the wounded in those terrible war years.

After the Great War the house became home to the Gretton brewery family. On reaching maturity in 1907, Sir Edward Every fought to maintain the family inheritance through the inter-war years despite the growing pressures of taxation and rising costs. These problems were later compounded by the failure of a business in which he had entered to relieve the pressures on his inheritance. At first the business was a success, but it fell because of the financial crises of the 1930s and also an unfortunate choice of business partner. This failure was a total disaster to the family fortunes! These were the depressing circumstances in which an empty house faced the Second World War. Eventually Sir Edward was forced to give up his unequal struggle in 1940, by selling the whole estate which extended to 3,000 acres. This fateful decision was immediately followed by the next World War, when the hall was requisitioned by the RAF. Sir Edward was at that time concerned for the safety of a series of five priceless Gobelin tapestries which had escaped the 1736 fire. He decided to have them stored in Derby, until a friend suggested that he could provide safer storage at Croxall Hall. That house and the treasures were shortly destroyed by fire! Later Egginton Hall was used as a military HQ when Nissen huts were built on the wide lawns. During this period, the controversial "Bomber" Harris was a regular visitor. By the end of the war, disgraceful acts of vandalism had been carried out by our own troops. In some strange act of exuberance, the last troops turned on all the taps in the upper rooms before they left. It was later found that the empty building was waterlogged and several fine ceilings had collapsed. The then owner abandoned any attempt to restore the wreckage and the house was demolished in 1954.

When the luckless baronet died in 1959, he was followed by Sir John, who made many attempts to conserve the constricted family fortunes. Most importantly he decided to remain in his native village. The present 13th baronet, Sir Henry and Lady Every have maintained tradition by residing in the village with their family. He continues to provide leadership in village life including the church. He is a chartered accountant and retains interests in the care of ancient buildings and English Heritage, and continues to maintain the family archives.

The now vanished house was a masterpiece of 18th century design and confidence. It is recorded that following the fire in 1736, work commenced at Egginton in 1758. Soon afterwards the Wyatt family became involved as architects. There were several brothers who were brilliant architects. It has been suggested that the Hall was designed by James Wyatt, but as there was little gothic influence in its stern facades the writer contends that the initial design is

more suggestive of his brother Samuel. It is probable that the 8th baronet employed another Wyatt brother, Joseph, in his radical rebuilding.

Facing the lake, the entrance on the south front was the most impressive feature of the house. A fine detailed doorway surmounted by a pillared portico led into an exalted bayed chamber which projected from the frontage of nine bays. The fine pediment was carved by George Moneypenny of Derby, who also produced some fine fireplaces, one of which included inlaid Blue John. The entrance hall, dominated by fluted columns and white Hoptonwood stone, was impressively lit through a low presiding cupola. The whole effect may have been a modest reflection of Adam at Kedleston (1765). Bays were a dominant feature of the facades at Egginton: in addition to the main entrance, both side profiles displayed two bays. On the north side stood the stables and extensive service buildings. The main drive led to twin Georgian lodges on Ryknield Street, now the A38, which were demolished in 1929 for the widening of the main road. At its zenith, Egginton was described in Whites Directory of 1857:

> "A neat brick mansion with stone balustrade round the parapet and a circular dome. It is pleasantly situated on the banks of the River Dove and has extensive pleasure grounds and plantations of 10 acres, a lawn of 30 acres and the garden of 2 acres. On the south front of the house is a fine fish pond covering 10 acres."

The grounds of Egginton were superb. The house overlooked a 50 acre park which maximized the visual effect of the Dove. The vibrant Hilton Brook was diverted into the lake, which was superbly designed so as to have an enhanced impression of size. At the outfall, the stone cascade still survives. It was crossed by an elegant arched iron bridge which still proudly proclaims its date and origin; "Coalbrookdale 1812". The bridge remains as a listed feature, though the beautiful artistry of the fine railings and armorial bearings have been destroyed. It would be a disgrace if this bridge was to be finally lost! On entering the lake the stream flows under another elegantly arched iron bridge, possibly another product of the famous Abraham Darby foundry in Shropshire. It is interesting to note that when this bridge was being built, Napoleon was limping onwards from the Battle of Borodino to his humiliation in the freezing Russian wastes.

The pleasure grounds were a major feature of Egginton; paths wound through dense shrubberies which merged into the surrounding trees, giving the impression of distance and expanse, where both secrecy and solitude could be enjoyed. The grounds also possessed an orangery, the climax of the formal gardens. The winding paths through the sylvan paradise stretched as far as the churchyard, separated by a wrought iron balustrade which still survives. The advance of nature have now overwhelmed these paths and secluded dells.

The stables and those parts of the hall that survived demolition have now

Egginton Hall Grounds: The 1812 Coalbrookdale Bridge in decay.

been converted into a fine residence by the present owner, Mr K. Ellis. Amongst the remaining buildings a fine new house has been inserted. This is a most tasteful building which accurately reflects the architectural themes of Egginton Hall. The whole undertaking is a fine achievement by Mr Ellis who has demonstrated his skill as a restorer and authority on period buildings. The lake, which had progressively reverted to a swampy jungle of willows has now been cleared as part of the comprehensive restoration of the former grounds.

The Final Reaches

Below Egginton, where the flow of the river is at its peak, there is a major water abstraction plant from which high quality water is pumped to supply the Staunton Harold and Foremark reservoirs. Near the point where the Dove is absorbed into the Trent, she flows under five adjacent bridges which carry the main modes of transport - road, canal, rail and road again; each in turn the most important of their era. The Romans were the first to follow the flat Trent Valley as the main north east/south west route. This road, Rykneld Street, went from the Cotswolds to Doncaster. With the growth of transport in the 18th century, the route again assumed importance as a turnpike road. During work to improve the turnpike in 1769, remains of Roman paving were found. Today the route carries the constant roar of traffic on the modern A38, each carriageway with an

independent bridge, one dating from the widening of 1929, the other from the conversion to dual carriageway in the early 1960s.

In 1766 an Act of Parliament was passed to facilitate the cutting of the Trent and Mersey Canal. The work took eleven years to complete and was carried out by wild gangs of travelling men, who caused depredations on the adjoining estates. The pioneer of the canal was the famous Josiah Wedgwood, who saw the venture as creating a major outlet from the industrial midlands. The route was planned and designed by James Brindley. The canal crosses the Dove by an unobtrusive aqueduct, the many simple arches of which are attractive and resemble a line of pack animals. One of the most pleasing features of the canal is the series of quaint humped backed bridges designed by Brindley

The age of the canal as undisputed leader in the transport field was destined to be brief; in 1837 the Derby Junction Railway was formed. The object of this undertaking, promoted by George Stephenson, was to make an early link with the developing West Midlands. The line crossed the river a little further downstream. The company later merged to create the Midland Railway Co, which became dominant in the second half of the 19th century and also acquired the canal.

Among these parallel channels of communication, it is the A38 road that dominates the prospect. From the road, the monotonous roar of engines belching fumes and the high moan of the tyres continually fill the scene and mind with a terrible tension. Yet lying to one side in a quiet aisle of retirement stands the centuries old Monks Bridge. Despite its position, out of alignment with the Rykneld Street, it is thought that this was the original site of the Roman river crossing. During heavy flooding an early medieval bridge collapsed in 1256. The then Abbot of Burton Abbey, John de Stafford, built the present bridge in memory of his beloved parents. This Abbot was a very powerful man who had been born and raised at nearby Stretton. He never forgot his local roots and secured for his family an interest in the Dovecliff Mill. When the old route became a turnpike road the bridge was widened by six feet. This addition can clearly be seen, as it lacks any projecting refuges. It is best viewed from downstream, as the waters divide between gently humped, ornately ribbed arches. The bridge is a relic of great antiquarian and architectural interest and imparts to the scene a touch of stability and a breath of peace.

Journey's End

Past the cordage of communications, the river now flows over the flat and open Trentscape. The only features of this bare landscape are freely grown hawthorns, willows and the occasional decaying ash tree. It is a barren world and in the rawness of approaching winter even the warmest heart cannot but be

affected by its bleakness. We first saw the wild nymph in the emerging light of an infant spring, when the world was fresh and crisp. Left far behind are the wild hills, romantic dales and soft pastures of her song filled youth. She has now reached the gathering gloom of winter in a bleak and foreign plain.

The confluence with the Trent is best viewed from a pleasant sunken lane which leads from Newton Solney. Here the Dove is submerged without protest in the Trent's severe and unmusical current, though some beauty remains in the gathering melancholy. For a brief moment, the spirit of the Dove persists with a flirtatious smile, recalling lingering memories of youth and past sunlit days. Yet the reality is like the lash of a descending chord. Warmth and light evaporate, the dark cold air invades and the ultimate embrace is received.

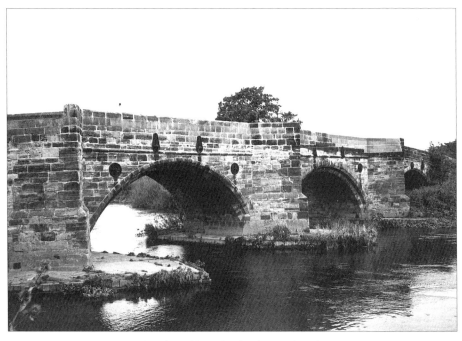

Monks Bridge: Nearing journey's end.